P9-DNB-266

NEW TRIER HIGH SCHOOL LIBRARY

3 3201 00123 0619

WITHDRAWN
New Trier High School
Library

On Technique

UNIVERSITY PRESS OF FLORIDA

Florida A&M University, Tallahassee
Florida Atlantic University, Boca Raton
Florida Gulf Coast University, Ft. Myers
Florida International University, Miami
Florida State University, Tallahassee
New College of Florida, Sarasota
University of Central Florida, Orlando
University of Florida, Gainesville
University of North Florida, Jacksonville
University of South Florida, Tampa
University of West Florida, Pensacola

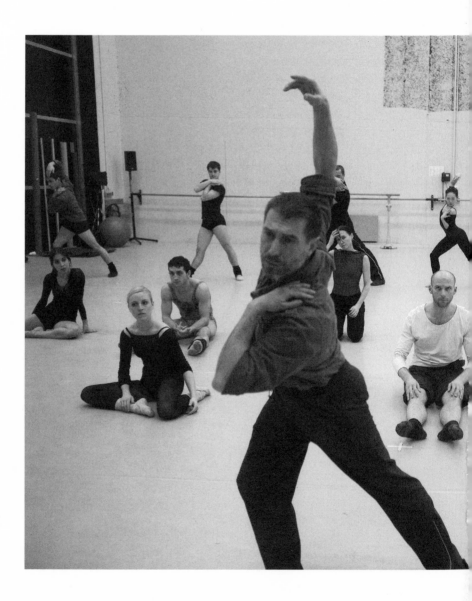

DEAN SPEER

NEW TRIER H.S. LIBRARY
WINNETKA, IL 60093

On Technique

University Press of Florida

Gainesville

Tallahassee

Tampa

Boca Raton

Pensacola

Orlando

Miami

Jacksonville

Ft. Myers

Sarasota

ИΕΨ TRIER H.S. LIERARY
WINNETKA, IL 60093

Copyright 2010 by Dean Speer
Printed in the United States of America. This book is printed on Glat-
felter Natures Book, a paper certified under the standards of the Forestry
Stewardship Council (FSC). It is a recycled stock that contains 30 percent
post-consumer waste and is acid-free.All rights reserved

15 14 13 12 11 10 6 5 4 3 2 1

Library of Congress Cataloging-in-Publication Data
Speer, Dean.
On technique/Dean Speer.
p. cm.
Includes index.
ISBN 978–0-8130-3438-6 (alk. paper)
1. Ballet dancing—Philosophy. 2. Dance teachers—Interviews. I. Title.
GV1788.S17 2009
792.8019–dc22 2009036027

The University Press of Florida is the scholarly publishing agency for the
State University System of Florida, comprising Florida A&M University,
Florida Atlantic University, Florida Gulf Coast University, Florida Interna-
tional University, Florida State University, New College of Florida, Univer-
sity of Central Florida, University of Florida, University of North Florida,
University of South Florida, and University of West Florida.

University Press of Florida
15 Northwest 15th Street
Gainesville, FL 32611–2079
http:www.upf.com

TO:
Tiger . . . burning brightly
and
all of my past, present, and future students
and to
everyone who reaches beyond themselves

CONTENTS

792.8
A 742

FOREWORD

Classical ballet is a distinctive form of dance that embraces music and visual arts and, through its study, enriches our lives.

On Technique represents the sentiments of a group of highly respected professionals whose breadth of experience of the art form extends beyond boundaries to span the globe. Having studied with some of the greatest teachers of their time, their remembrances and opinions on a variety of topics are now recorded for posterity.

To be well informed is to be well prepared, and this book serves this purpose by acting as a reference point for the reader whether they be a

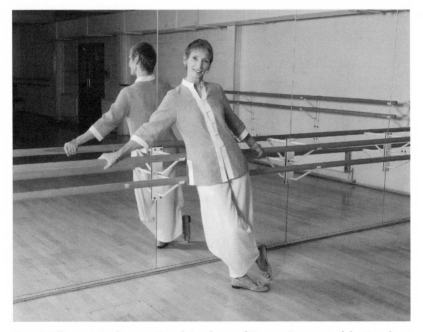

Lynn Wallis, artistic director, Royal Academy of Dance. Courtesy of the Royal Academy of Dance.

student or teacher. The words of wisdom are stimulating and thought-provoking; delivered by these distinguished artists, they are, above all, inspiring.

Lynn Wallis
Fellow of the Imperial Society of Teachers of Dancing
Artistic Director, Royal Academy of Dance

A NOTE ABOUT THE USE OF BALLET TERMS

The reader will notice a variation among the subjects, who sometimes use different names for the same step. One person's "B plus" will be someone else's "attitude à terre." As the teachers come from various technical methodologies (English, French, Russian, and so forth), we thought it best to leave the vocabulary as each subject presented it, even when there may be disagreement in the field about a particular term. The terms are correct within the context of that individual's background and teaching method.

ACKNOWLEDGMENTS

There is truth to the aphorism of wanting to thank everyone you've ever met in your whole life. Each has shaped my experience. If you don't see your name here, it doesn't mean that I don't love and adore you—it's just that there isn't enough space.

A special thank-you to Francis Timlin, who recruited me into the world of dance writing, for taking copious notes during the interviews with the artists, for providing first-rate line editing, and for his ever-sage advice.

To the artists for their cheerful willingness to be interviewed and tell their stories. Meredith Morris-Babb of the University Press of Florida, editor goddess extraordinaire, who left the door open. Kimberly Graves for putting us in touch with Cynthia Harvey. To Bené Arnold and Peter Boal, who cheerfully agreed to be the first guinea pig subjects of the experiment that became the nucleus of this book.

Folks at dance companies far and wide: Doug Fullington, assistant to the artistic director and education programs manager, in particular Judy Kitzman and her successor at Pacific Northwest Ballet, Gary Tucker; Lee Kopp of Ballet San Jose; Erik Jones at Oregon Ballet Theatre; Vassiliki Spyropoulou of the Royal Academy of Dance; Karin Bovisi, ballettmainz; Heather Saxton and André Lewis of the Royal Winnipeg Ballet; the media consultants for the USA International Ballet Competition.

Katharine Kanter for assisting with connecting with Yvonne Cartier. The wonderful Harriet Cavalli, who cheerfully provided copyediting and translations. Mike Wyne, for putting the text through his wordsmith microscope. Blessings to Elaine Durham Otto, for her thorough copyediting.

The diligent and hardworking editors and staff at www.criticaldance.com. Each puts in such a labor of love. You are an inspiration. Azlan Ezaddin, one of its founders, for always making dance-going fun.

My kaffeeklatsch of dear friends and colleagues, Erika DeLap, Julie Grooms, Juni Roberts, Diane Ruzicka, and Russell and Joan Timms. To

the other founders of Chehalis Ballet Center, Rosie Breen and Elaine Waterman. Pam Curnel for being an Oasis in the Desert. Kathleen Herndon Moore for giving me some of my first guest-teaching assignments. All of my dance teachers who each worked so patiently with me and who also pushed and challenged too; I adored every inch of it. And to my precious family, my love.

Glenn Kawasaki: image licensing funding.

Cornish College of the Arts: for taking me many places.

CREDITS

Photos are courtesy of the artists unless otherwise noted. Full information about each image is listed in each caption. A special thank-you to both Ronald Seymour and Martha Swope for their kind generosity.

A note about the Royal Academy of Dance: With more than 13,500 members in 79 countries, the Royal Academy of Dance is one of the world's leading dance education, training, and examining bodies. Its mission is to promote the knowledge, practice, and understanding of dance internationally. It seeks to accomplish this through promoting dance, educating and training students and teachers, and providing examinations to set standards and reward achievement.

INTRODUCTION

DIVINING TALENT

Dean Speer

Ready to go try on costumes at American Ballet Theatre even before I ever got to New York as a young and very ambitious dancer, there was never a thought that I'd be writing a book someday about technique and teaching. Granted, I did arrive early at the conclusion that training students to be dancers was to be my true calling. This calling has continued to shape my life.

The genesis for this book began several years ago when, after interviewing quite a few subjects for criticaldance.com, I realized that their career stories needed to be told. Some ballet teachers may already be familiar and others less known, but their stories resonate deeply.

Choosing which of the pedagogues of the ballet was not as hard as keeping to a manageable number while using varying backgrounds as well as differing geographic locations. I believed it was also critical to bring into the process those who have "worked in the trenches" alongside the average ballet and dance teachers, adding them to the heady mix of legendary teachers and heads of important ballet schools.

This book is designed to appeal to the general reader and to the ballet and dance lover. I hope it will be a help and inspiration to teachers and to dancers and future dancers who may find a bit of themselves in these amazing stories.

All of the teachers featured in this book have a love of dance and the performing arts, and they are passionately committed to passing along their knowledge and experiences to future generations. Each has a solid record of producing excellent students. There is a shared sense of community and pride in what they've accomplished.

Perhaps the heart and soul of this book are the responses by each to the same set of questions about technique and teaching. Defining technique can be elusive, but we know it when we see it. There are a lot of great

books out there on giving class and technique, yet none that I know of approaching it as an abstract concept.

While there are some similarities, it's fascinating that everyone's responses were so varied and diverse. They were clear in their strongly felt views. It was exciting for me to get to know the subjects; it was a fabulous and honorable voyage. Among them, you'll find many nuggets and treasures.

BENÉ ARNOLD

". . . keep learning . . ."

*Bené Arnold was the first ballet mistress of
San Francisco Ballet, and she is professor
emeritus of the University of Utah. She is
one of the most respected and distinguished
ballet teachers in the United States, and in
2008 she became the interim chair of the
Ballet Department at the University of Utah.*

Believe it or not, I was essentially bedridden from four to nine years of
age with a condition known as scrofula, which is a type of tuberculosis of
the glands. They didn't know how it would affect me mentally or physi-
cally. My grandmother and I were living in Missouri at the time, and the
doctor said I should go to a warmer and drier climate, and so we moved
to Los Angeles. You know, dance was often recommended as therapy,
and this was the case for me. I couldn't stand for any length of time, but
went to Ethel Medlin's dance school in L.A., where she did this marvelous

Bené Arnold. Photo courtesy of Ballet West.

combination class. She was simply encouraging. When I didn't have the endurance to do something, she'd have me sit in a chair and she guided me on how to observe the other students and learn visually and also to discern what they did well—the why's and "how's." I think this is where I first got my ability to learn others' parts.

I saw a ballet section in a musical during this time and decided that that was what I wanted to do. I went on to study with several teachers in the L.A. area and went to the summer sessions at San Francisco Ballet School, beginning in 1948. Both Willam and Harold Christensen were there. I joined the company, and in one of my first performances, I danced behind Lew Christensen, who was the Prince in *Swan Lake*.

I was the first ballet mistress of the company. At that early juncture it was not a paid position so in order to earn a living, I taught student classes in the school after I was through with company duties, and sometimes I went back to work with the company at night when I was through teaching. In addition to giving the company its class and rehearsing them, I also ordered their shoes, typed up the schedules, and made programs.

Lew was never quite as strong constitutionally as either Bill or Harold. When I went back to San Francisco Ballet to help with *Nutcracker* in 1962, I was shocked to see how Lew had changed as a result of receiving cancer treatment. It really upset me.

Bill was the best PR person of the three brothers. He could take mediocre dancers and make them look great. Lew needed better trained dancers. Bill could move people across the floor and make the audience connect.

Lew had worked very hard to build up San Francisco Ballet under difficult conditions. We had lots of successes, including State Department tours. But some business manager problems arose. I talked to Harold about some of the things that were happening. Gordon Paxman was leaving for Salt Lake City at this time, and both suggested that I go there. I had already visited Salt Lake City at Bill's request, having staged Lew's *Con Amore* on the University of Utah group. I knew that Bill wanted to build a professional company. Everything started coming around.

I agreed to be unpaid ballet mistress again, which I did from 1962 to 1975, at which time I joined the faculty of the University of Utah. At one point, I calculated the numbers of hours I was putting in and realized I was getting the equivalent of 10 cents an hour, but that was okay, as I

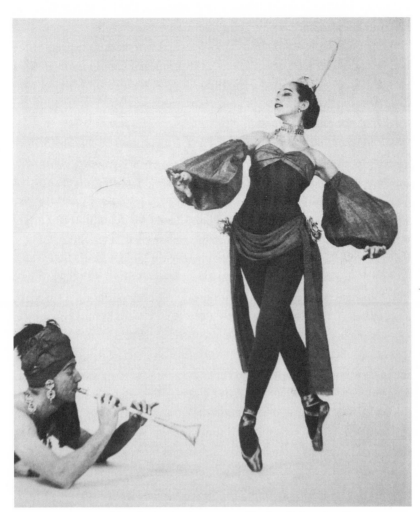

Figure 3. Bené Arnold with Gordon Paxman in "Arabian" from San Francisco Ballet's *Nutcracker*. Costumes by Arnold's grandmother, Eloise Arnold. Courtesy of the artist.

loved what I was doing. One of my best moments was bringing in all of the Christensen brothers—and their wives, Gisella Caccialanza and Ruby Asquith—to teach for one week at the university. This was the first and last time they all had been together for many years.

After I moved to Salt Lake in 1962, I earned two master's degrees at the University of Utah. One is in special education, as I had in mind working with children who had had difficulties like me. I ended up working with deaf children. My other MFA is in choreography. I also have a teaching certificate for public schools.

We worked hard to build Ballet West, including a European tour we undertook in 1971. Bill was unable to go because of the health of his wife. Lew was also unable to go. He was a wonderful teacher—something that he never gets credit for.

And later I began performing again. Bruce Marks and Toni Lander wanted me to play a character part in their revival of the Bournonville ballet *Abdallah*. I said, "But I haven't been onstage in years." They didn't give up, however. They asked to meet me for breakfast, and I knew something was up. They told me that they thought I'd be "perfect" for this part. I agreed to try it, but if they weren't satisfied, I wouldn't be unhappy at being replaced, I said.

Well, I had a ball, and this was the start of a new performing career for me in character parts with the ballet. I got fantastic reviews for my Carabosse in *Sleeping Beauty*. I continued working with Ballet West, and when John Hart became the new artistic director, he asked me to help with children's parts of various ballets and with *Nutcracker*. I also performed Prudence in the premiere of Val Caniparoli's *The Lady of the Camellias*, and I was in the Ballet West production of John Cranko's *The Taming of the Shrew*—I was the fat broad. It was great fun.

At both companies, I was the "number-two gal," responsible for the nitty-gritty. I think my reputation for being "mean" or tough was in response to getting the dancers to work at a professional level; rehearsing on pointe, for example. Bill didn't make schedules or decisions well, so I had to do it. I mean, you could sit around for hours, waiting for him to decide who would do what. You can tell I learned a lot through observation [said with a laugh].

Some changes over the years to his choreography Bill himself made, such as the addition of the Rose pas de deux in *Flowers*. Others were

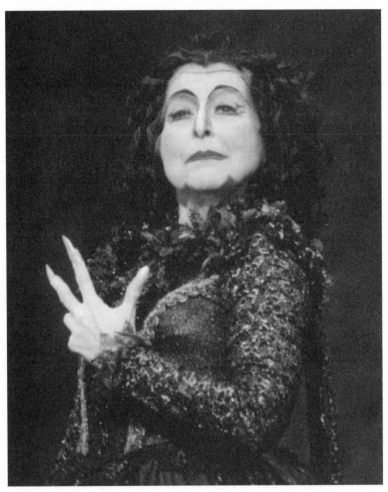

Bené Arnold as Carabosse for Ballet West. Courtesy of Ballet West.

made by those who thought his choreography was too hard. These persons would make changes and then ask Bill if it was okay. Of course he said yes; part of this had to do with his age. With too many changes, I must say, we got away from the essence of what he had done and what people had done in an earlier time.

I decided to retire from the university in 2001, after 26 years on the faculty. Jonas Kåge asked me to direct the Ballet West Academy, which I did until recently. I've relocated to southern Utah—St. George—and am looking forward to more sun and to becoming active in the ballet community, as there are a couple of very good schools and teachers there.

I feel so honored and blessed. I've been awarded the Distinguished Professor title, the highest honor bestowed by the university, and it was at the instigation of the students, so it's even better. I've also received the Salt Lake Chamber of Commerce Award as well as the Governor's Award for Arts.

BENÉ ARNOLD ON TEACHING TECHNIQUE

What is technique?
Technique is the skill (art) needed to create sculpture in motion.
How might you define it?
Technique is the facilitator by which dancers mold their bodies into the capability of a greater extension of their physical ability.
How do you go about imparting it?
Teachers study various methods of training, i.e., Vaganova, Bournonville, Cecchetti, from many teachers. They draw upon their own dancing experience from those whose methods had a positive as well as a negative impact. I add my point of view to make the presentation of this material my own; no "carbon copies." I give the classwork quickly because it is the students who take the class, not me. This trains the student to think and reproduce the combinations quickly. I observe very carefully how they perform the material and follow this with corrections to individuals and collectively. One of the most wonderful parts of teaching is the constant discovery. Sometimes student needs will inspire me to immediately revamp my class. This promotes spontaneous combinations, and I have

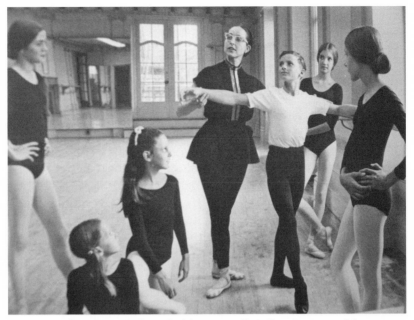
Bené Arnold teaching Clark Reid of the Louisville Ballet. Courtesy of the artist.

given verbal explanations in a totally different way. After 40-plus years of teaching, this brings me great pleasure and further inspires me to continue to keep learning from my students.

Is there a difference between skill and technique?

Every dancer develops some technical skill. The degree of skill is what separates one dancer from the other.

What do dancers need to learn to master technique?

I believe all students need to study music and art. Music instills the quality of how each step is executed, and technique without the quality of movement is boring. Drawing allows the eye to focus on line, perspective, and accuracy.

Listen—Observe—Concentrate—Work—Work—Work—Be Patient. Allow your mind and body an opportunity to absorb and process the class content. Take every correction given in class as something to apply to yourself.

What part do interpretation and presentation play in acquiring a good, solid technique?

Technique is the foundation. Interpretation and presentation are the manifestation of your creative mind and your inherited and acquired artistry. I believe a dancer who develops fantastic technical skills will excite the audience, especially in an abstract ballet. However, some good technicians are unable to give the interpretation and presentation required to successfully perform a Juliet, Giselle, Albrecht, etc. I believe you can learn interpretation and presentation by observation of famous performers and the study of various acting methods. However, real artists dance from the depths of their intellect and heart, and their artistry may become so moving that it is indescribable.

What should a good teacher be expected to do?

The best teacher does everything; it's quite a list. He/she has a lesson plan, gives variety, at times focuses on one step or problem area, and mastering the class produces the "fun." Every instructor has favorite dancers, but I make a strong conscious effort to give some comment to each student at every lesson. They deserve this recognition.

What are the challenges that students most often face?

Dancers become frustrated when they understand the correction mentally but physical development takes its own time. This requires patience.

Come to class to learn. Be open to every teacher because each has something to offer. Listen to what they are saying. I had an instructor who did not like me, but I gained a lot from his classes.

Don't beat yourself up emotionally: if you are not attaining the skill, it may be necessary to move in another direction. I have never regretted my decision to become a ballet mistress, teacher, and mime artist rather than a dancer. It has provided me with an extraordinary career and great satisfaction.

Technological advances and scientific exploration are resulting in the development of some amazing dancers. There are degrees of excellence, and dancers who are not at the top must realize they can still have a wonderful, rewarding career. Beyond the amazing dancers of each era, there exist people like George Balanchine, whose unique understanding of the art form gave him the capability of making the greatest advancements. The dancer who is not technically amazing may still make the greatest

impact on this art. There are not enough professional ballet companies to service the many dancers worthy of company employment.

What are the challenges that teachers most often encounter?

Some dancers expect constant positive reinforcement. Teachers need to be honest but counsel the student in a compassionate manner. A dancer whose dream is not going to come true still needs caring and nurturing support from the teacher.

Yurek Lazowski always separated "giving a class" from "teaching a class." I have observed classes taught by very reputable teachers who never gave a correction to any individual dancer during the entire lesson. Their class structure was good, and dancers gave them wonderful applause. But to me, they had just "given a class"—they had not taught one.

P. W. Manchester pointed out to me that even teachers/dancers who live in major dance centers can isolate themselves from the dance world. She was right. Some teachers rely on material they have taught for years, never make an effort to observe other teachers, and rarely attend company performances given in their own city. Willam Christensen said, "There is not a bible on teaching ballet." Teachers must keep learning, analyzing, and, when necessary, changing their methods. A syllabus is only words on a piece of paper. What you do with it is the challenge.

How do you bring families into the process?

Establish watching days so that families can observe their dancers progress in class. I like to designate the last lesson of each month as "watching day." I try to speak with the parents at the end of the lesson, and I am pleased when parents are able to see that the class is progressing. Parent/student/teacher conferences are arranged whenever necessary. At the end of each year, a conference of all the teachers with the parent/student is given to evaluate progress and deal with any important issues. Conference notes are kept in the student's file.

What does a good class look like to you?

Lew Christensen taught some wonderful classes. In his class there was a great rapport between the teacher, pianist, and student. Everyone was engaged in the lesson. Lew developed classwork to strengthen our individual weaknesses. His entire class had a connecting thread that went from the barre through the center work. His classes were challenging, repetitious when necessary, and combinations were united with the mu-

sic. He believed the pianist was an integral component of the class. Lew, like Balanchine, understood music, and the pianist admired his musicianship.

Musical choice is a part of how the student will progress. Pianists need to be as qualified to be class musicians as the teacher is as an instructor. Lew discussed technique with Balanchine and other great teachers; he was always seeking more knowledge.

Because of monetary problems, CDs are often replacing live music; this is far from the best teaching situation.

Who were your favorite teachers, and how did they help you?

I was nervous as my grandmother and I walked into the Meglin Dance Studio in Venice, California. I did not realize the woman in the hallway was Ethel Meglin. As we walked toward her, I began to feel at ease. Her smile was warm, her eyes joyful, her red hair curled, giving softness to her face. She walked toward us with brisk, decisive steps and without hesitation said, "My talent scout told me to expect you." She was one of the few people who did not stare at me, roll her eyes, or turn away. She did not seem to notice my head leaning to the right side and my hunched shoulders. She signed me up for the lessons, and when my grandmother started to explain that I couldn't stand for very long, she replied, "I know and understand."

We went into the studio. I was so pleased when she walked in to teach the class. The lesson consisted of personality singing, hula, tap, acrobatics, ballet, Russian dancing, and baton twirling. During my first lesson she observed that my pelvis was tilted, causing one hipbone to be higher than the other one (this is how I adjusted my leg length so I would not have to wear a built-up shoe). My legs would not straighten because of short tendons behind my knees, and I had very little muscular development. After approximately five minutes she noticed I was tired, and before I could say anything, she invited me to come sit beside her so that I could observe the other students. She smiled and gave positive comments to the various dancers, complimenting them, and continued with the next part of the lesson. Toward the end of the lesson I told her I wanted to try again. Her positive reaction gave me the strength to get up and join the class. Later, I enthusiastically went to school and told my classmates, especially the ones who had made fun of me, "I am taking dancing lessons." I wanted to take class because Ethel Meglin accepted me with encouragement and

happiness. So each week I went to class, dancing a bit and resting until I could take the entire hour.

Mrs. Meglin was the epitome of "positive reinforcement." One Friday night a month, various classes were chosen to perform in her studio, which had been adapted into a theater for the occasion. In my first performance I felt I had not performed very well, but Mrs. Meglin patted my shoulder and told me I had given a good effort.

She was an artist in teaching dance. She was honest about ability as well as being a diplomat.

She cared about her students and loved and understood how to encourage them to do well. When parents came to her and complained about the crippled girl taking class, she would not back down. She supported my right to be in her class, and gradually the complaints stopped.

To Ethel Meglin, every student was important. Each was special, and she inspired us to do our best. She instilled in me a desire to become a teacher because I wanted to be like her. I wanted to teach anyone who wanted to learn. I wanted to see their potential, not their disabilities. Ethel Meglin is one of my favorite teachers because she didn't turn me away. She invited me into her world and inspired me to devote my life to teaching.

Are technique and teaching evolving?

Professional schools are providing so much help to dancers. The additions of skilled doctors who specialize in dance injuries, Pilates, and yoga have resulted in producing dancers with amazing technical skills.

Some schools are violating the integrity of the technique class by accommodating what the student believes he/she needs. It is the teacher who must continue to lead the student through the rigorous training, and the student must accept the teacher's wisdom.

Ballet departments in universities are assisting dancers as they make the transition from a professional ballet company into teaching positions and other career choices. Parents see university study as a means toward financial stability, and it offers dancers an opportunity to stimulate their intellect while maintaining their ballet training.

GWENN BARKER

"I was so happy that at class later that night, I felt I could do anything."

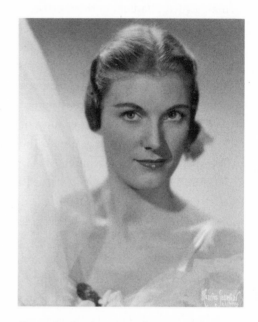

Gwenn Barker (1929–2009) was a soloist with Ballet Russe de Monte Carlo, director of her own ballet school and performing company, and head of the Preparatory Dance Division of Cornish College of the Arts.

Some of my earliest—and fondest—memories of dance took place in London, where I was born. At age six, I was too young for formal ballet classes and was enrolled in what was called Greek dancing (a.k.a. free movement). I loved this class and especially steps of elevation. Then I started ballet lessons. Unfortunately, my parents decided to move to Sussex, 50 miles south of London, so I only had about eight lessons. I remember the

Gwenn Barker. Photo by Maurice Seymour. Courtesy of Ron Seymour.

uniform very clearly: a short white tunic with a red cord around the waist, no tights, but white socks and red ballet shoes.

When I was 11, World War II was declared in England, and we could hear bombers going to London every night. My mother being American and my father English, it was decided that my mother would take my two brothers, my sister, and me to Vashon Island in Washington, where her mother kept house for her brother (who sponsored us).

Since living in London, it had been three years without dancing, and there was nothing on Vashon Island. The original plan was that we'd return to England, but this didn't happen as my father passed on. As the school year was ending, my mother got a job working for the state in Olympia, the state capital. There, I became interested in ice skating until the rink closed two years later. So I decided to join my sister in her dance classes of ballet and tap.

The "training" was not very good, which I eventually discovered when I went to Seattle and took a summer course at the Cornish School [now Cornish College of the Arts]. I really got my eyes opened and realized I had a lot to learn, and I still had two more years of high school in Olympia. Nobody was mentioning a possible career, so off I went to Washington State University, where the only dance offered was modern dance. The teacher thought I was quite good, and when a master class was given by Mark Ryder and Emily Frankel, I was asked what I planned to do, to which I answered, "I didn't know." Well, Miss Frankel told me, "Now is the time to get on with it."

A husband-and-wife team, Marian and Illaria Ladré, who were formerly with Diaghilev's Ballets Russes, had opened a studio in Seattle. I decided to stay in Seattle and study with them for two years. One of the students, Barbara McGinnis Arms, and I became very good friends and shared an apartment, and both of us worked split-shift for Ma Bell as long-distance telephone operators. This enabled us to take our daily class from 3:00 to 4:30 p.m. and work before and after.

We were both determined to go to New York and audition for jobs, so off we went in 1952. I had saved $350. Upon arrival, after a six-day trip by car, we walked to the School of American Ballet to take a class which was close to the YWCA where we stayed the night. The next day we were to have a personal interview to stay at a women's residence on West 13th

Street, the Evangeline. The office manager accepted us immediately, and we moved in right away. As the weeks went by, it was easy to see we needed some income for our classes, room, and board. There was a position open on the switchboard, and we talked the manager into letting us share the job.

In September, Ballet Russe had an audition for a concert company for touring the country. Barbara was accepted, and I was not. Such a disappointment was putting it mildly. On Saturday, September 13, 1952, I had worked in the office all day and was due to take class at 6:00 p.m. and couldn't decide if I should go. I did go and dislocated my right patella during center practice. Evidently I had been pronating for some time but had never been corrected. I was carried out to a taxi and taken to the hospital, where the doctor told me he would put a walking cast on my leg for six weeks. I said that would be impossible because I had an audition on Monday—however, the cast was applied, and I spent the next six weeks watching classes.

I was so interested in analyzing technique and presentation of the dancers in class, it influenced my teaching later on very favorably.

When they took the cast off, I was outside the hospital holding the cast with many well-known dancers' autographs on it, and I had just enough bus fare to get back to the Evangeline. I hadn't been in my room 15 minutes when I got a phone call from the office offering me a full-time job on the switchboard. Perfect—I had no money left, and all I had to do was sit and answer phone calls. I was able to start taking classes within a few weeks and to begin auditioning in about six months.

I studied mainly at Ballet Arts in Carnegie Hall and had excellent teachers, Lisan Kay and Vladimir Dokoudovsky. After my first class with Miss Kay, she said, "You appear to know quite a bit, but you don't seem to know what you're doing." During the pliés she kept saying, "Don't look down" every time she walked by. With her training, I got much stronger technically and really improved over all.

When I began auditioning again, I did not succeed on my second try with Ballet Russe. However, I did get my first job—with the Hale Arlen Dancers, which was a dinner theater engagement in Cleveland. It was a small group of four or five women. I then auditioned for Olga Tarasova, who was forming a company of three dancers. We toured, and I had two solos and was in two pas de trois. We toured the South by car and even

played in Jackson, Mississippi, now famous for its USA International Ballet Competition.

The third audition try at getting into Ballet Russe was a success. At my 5 feet 8 inches, height was always a factor. They had a corps of 16 women and were looking for a tall girl and two of medium height. The audition was at the Ballet Russe School in New York. Leon Danielian and Freddie Franklin taught class. I can still remember trying to do a good grand plié in 5th with my pointe shoes on.

The panel of judges had asked us to wait in the office. The waiting area wasn't very big, and we were all grouped together. The first one called in was Raven Wilkinson, and when she came out and had a big smile on her face, we knew she had been accepted. Then the same for Dzinta Vanags, who was from Latvia. Finally, several of us were called in at once, and I thought, "Oh, no." But it turned out that Mr. Denham *did* want me in the company but couldn't quite recall me and wanted to identify me again.

He asked me, in his accented voice, if I wanted to join the Ballet Russe de Monte Carlo. Of course, I said yes. I was so happy that at class later that night, I felt I could do anything. Weeks later, as we were gathered together onstage for my first opening night, along with Raven and Dzinta, Freddie Franklin took us aside and said, "Look, girls, whatever happens, keep on bouncing."

I was with the company for five years, 1955 to 1960. Some of my favorite parts were the Princess in *Giselle*, Big Swans a couple of times, the Red Lady in *Gaîté Parisienne*, and the Headmistress in *Graduation Ball*. I was the first female to do this part, and it was really very rewarding. Howard Sayette was the General. I must say I *never* got tired of dancing in *Les Sylphides*, even without a special part.

We toured with two buses, one for the dancers and staff and one for musicians and dancers. In about October, the company left New York and went up to New England for performance dates. It was a gorgeous trip, and the fall colors were out everywhere. Trips across the United States were anywhere from five to eight hours, but we *always* left at 8 a.m. Sometimes we would arrive at our destination as late as 3 or 4 p.m., which didn't leave us much time to check into the hotel, get to the theater, rehearse, and prepare for the performance.

On my first tour, I never slept on the bus, as it was such a dream come true to even be there. Perry Brunson sat with me, and across the aisle

were Alicia Alonso and Igor Youskevitch. Alonso was such an inspiration for us, and even though we had to guide her offstage at times because of her decreased vision, when she rehearsed us—which was seldom—she observed plenty. During the second act of *Giselle*, the audience in Los Angeles applauded for the hops in arabesque—very exciting. We were so fortunate to have Alonso and Youskevitch for three years, and I will never forget their Black Swan pas de deux.

I was asked to be assistant régisseur in addition to my regular places in the repertoire on my fifth and last tour. Dressed for *Swan Lake*, I would call for the curtain to open and have just enough time to run from stage right to my entrance as the last swan upstage left. As the swans left the stage, I'd reverse the process to close the curtain.

Another of my tasks was to check each day's program for accuracy—to ensure that what was printed was what we were actually dancing—and a couple of times changes had to be made. One incident I will always remember: Nina Novak and Alan Howard were onstage and in position to perform the *Don Quixote* pas de deux. The curtain was to open, *then* the orchestra played. I called for the curtain to open, and nothing happened. I looked through the edge of the curtain, and there is no conductor. I went to his dressing room, which was right offstage, and there he was, taking a nap, not realizing there was no intermission. He quickly got to the pit, and all was fine—except for me and my nerves.

As much as I loved it, after touring for five years, I was tired and needed a break. Alan Howard was to buy the Academy of Ballet at 2121 Market Street in San Francisco, and he asked me to manage it. I thought, "Okay, why not?" So I did it for a year. Carolyn Parks had owned the school, which had a very large, beautiful studio and was often used by major ballet companies for rehearsals when touring. When the Royal Ballet was on tour and rehearsing in the studio, I found myself actually meeting the dancers I had only read about. Margot Fonteyn arrived and rather apologetically wondered if she could buy some tights as she had forgotten hers. We only sold leotards for the children's classes, so I offered her a pair of mine—a bit too long for her—but she was so grateful and they were returned the next day wrapped carefully in tissue paper.

During my time at the Academy, I performed with Alan's company, Pacific Ballet, and got a phone call from Meredith Baylis of Ballet Russe asking if I could fill in my old places for their San Francisco season. They ap-

parently had dancers with injuries, and I checked with Alan, as he would probably have to teach for me. I even went on tour to the Northwest and had a great carefree time.

I went back to New York where I joined the Ballet Company at Radio City Music Hall. We did four shows each day and five on holidays. I pulled groin muscles doing cartwheels when asked to do them on the "other" side during my first show. After a year and a half, someone suggested that I audition for the musical *Camelot,* as they had heard they were looking. So I took the train up to Boston, putting on my makeup at the station in Boston, and arrived to find that hardly anyone had shown up. They told me they wanted me right away. I had to train it immediately back to New York to get my stuff and join the show. I stayed with it for six months— one month in Philadelphia and then in Washington, D.C.—but developed bone spurs in my ankles.

Back in New York, Roy Harsh, whom I had first met in Ballet Russe and who was working at Radio City, asked me to marry him. We married and settled in the Pacific Northwest in Bellevue, a suburb east of Seattle. We opened Bellevue Ballet School in January 1965 and had only 18 students at first. It grew in three years, and by the time of its second location, we had about 400 students with four teachers. In 1973, we moved to another suburb, Redmond, now famous for being the home of Microsoft, and became the Bellevue-Redmond Ballet School.

I directed the school for 14 years and was artistic director of Bellevue Civic Ballet for five years. Bellevue Civic Ballet became a member of the National Association for Regional Ballet. I then was asked by Lois Rathvon to head the Children's Preparatory Division at Cornish College of the Arts, which I did for 18 years. I've retired twice. I still like to teach and love to coach, but just not on a regular basis.

From about age 16, I knew I would one day teach, career or no career. I assisted my first teacher in Olympia, Mary Sweeney, by helping the younger children understand how to do certain steps, and I seemed able to do this very easily and enjoyed it. I didn't teach a regular class until I left Ballet Russe and lived in San Francisco. After two years in New York and six months with *Camelot,* I started a new life, as I mentioned, when I married.

I first taught using my own system and then added the Royal Academy of Dance syllabus. RAD has a very good syllabus that incorporates part

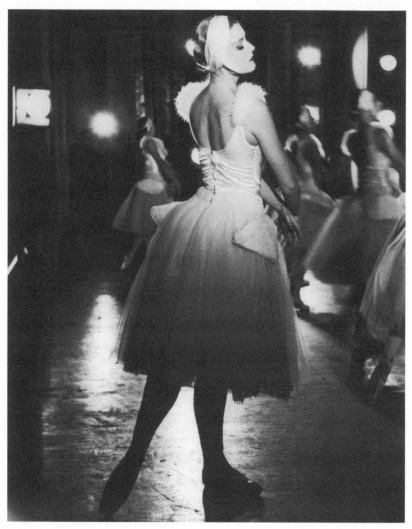

Gwenn Barker in *Swan Lake*, Ballet Russe de Monte Carlo. Courtesy of the artist.

of the Russian, French, and Italian schools and can train a student from age 5 to 21. The first time I saw the results of the RAD training, I was so impressed—here was this group of young ballet students all moving in accord with each other at the barre with the most elegant port de bras and use of the head. I had made several trips to RAD headquarters in London with my friend and colleague, Jan Collum, to take their summer courses for teachers. I thought at first my students might not like the exam system, but it turns out they did. The children always worked so hard. The goal of an exam made them work harder, but getting a high mark was not the only goal. Any syllabus is only as good as the teacher. You have to make it interesting.

GWENN BARKER ON TEACHING TECHNIQUE

What is technique?

Technique is how dancers present classical steps in the type of school they were trained: Russian, French, or Italian. Depending on one's talent, technique can be adequate, good, or brilliant and acceptable for many companies. Some dancers are more suited to character roles that appear in many of the story ballets, but still they must have a good technique.

How might you define it?

Technique is the result of the physical movements executed by dancers of classical ballet. This could also be applied to the other forms of dance.

How do you go about imparting it?

Slowly. Children are often placed in classes that are too advanced. They copy incorrectly and inadvertently take shortcuts. Because of the need for self-correction, frequently dancers and teachers who have gone through injuries and recovery make for a better informed dancer and teacher. It can be hard for "naturals" to understand it.

Is there a difference between skill and technique?

Think of the popular television show *Dancing with the Stars*. Many of the untrained star contestants don't have technique, but they do have skill—the skill of imparting a feeling for dance and movement.

What do dancers need to learn to master technique?

Being observant is very important. Dancers are there to move. It's important that they take corrections well. Musicality is important—if you cannot keep time, it's a problem. An awareness of what the other dancers

are doing is key. Talented people don't always want to be dancers. Desire, discipline, and determination are needed.

What part do interpretation and presentation play in acquiring a good, solid technique?

Presentation starts in the classroom. They are there to learn technique and get some idea of putting the components together. I don't think you can divorce technique and presentation.

What should a good teacher be expected to do?

Early in my teaching career, I had taught a new step to the classes one week before I announced we were to learn a pas de chat today, and one of my more precocious young students immediately countered, "Miss Barker, we learned *that* last week." So I started writing down a lot of things for the classes and made lesson plans to track our work. I spent quite a bit of time on it, and this worked well for me.

What type of class I give depends on who is in class and what they need. Not everything is going to be "attractive," but it might be necessary to do. I've been fortunate to have always had an accompanist; this makes things so much easier, and it's better for the students. I make it a point to make contact with each student in every class and know their names from day one. I do try to give at least one "fun" step per class, usually a different grand allegro, to give them something to look forward to.

What are the challenges that students most often face?

Rolling in [pronating] on feet. Overall placement is the hardest thing to teach. Bodies are unique. Arms are difficult—line from shoulder to elbow to wrist—and they need repetitious and consistent reminding. Either the knees are straight or they are not. How to use quads. Head positions are sometimes instinctive but are very definite for certain steps.

What are the challenges that teachers most often encounter?

The biggest challenge is working with parents. Some are cooperative and helpful, and others are very competitive. Attendance is imperative, and some parents find this hard to manage.

How do you bring families into the process?

I try to discover family expectations. I'm careful not to say something about other teachers or students. I encourage prospective students to come and observe a class—parents also—so they have some idea of what to expect.

What does a good class look like to you?

Where everybody is interested. There is nothing worse than teaching students with no response or looking as if they're bored. This turns teaching into a job when it should be fun and satisfying—and where you don't have to come out of class on your knees. Neat-looking practice clothes and grooming for class are important.

Who were your favorite teachers, and how did they help you?

Freddie Franklin—so charming, always in a good mood, and I always knew his class would be enjoyable. I liked Vladimir Dokoudovsky. He could do 20 pirouettes in class—very exciting to observe. Nina Novak was an excellent teacher, too. She could spot things no one else did, and she gave very interesting combinations. I have already mentioned Lisan Kay.

Are technique and teaching evolving?

I hope technique and teaching become more artistic. It's become too gymnastic. Dancers I admired like Fonteyn and Alonso had amazing artistry; there is not enough emphasis on this at present. Technique is very demanding now, but there should be more feeling. Who can forget Margot Fonteyn's use of épaulement? That lovely neck, use of head, her beauty. The complete package.

DAMARA BENNETT

*"... setting examples of what is important in life ...
teaching as a valuable thing ..."*

*Damara Bennett is director of the School
of Oregon Ballet Theatre. She was formerly
with San Francisco Ballet.*

Tatiana Grantzeva was company teacher for San Francisco Ballet when I was in the company. We had excellent directors and choreographers, but not really anyone who was a great teacher for the company, and so we lobbied hard (myself at the forefront) to get us a company teacher. We were so lucky to have her. I learned a lot about teaching from her, and in a way she taught me how to teach. She almost always taught wearing a turban—which made her look so exotic and beautiful—but when you got to know her a little better, it was amusing to find out there were actually curlers under it.

Damara Bennett. Photo courtesy of Oregon Ballet Theatre

I had my own ballet school in San Francisco for 20 years, only two blocks from San Francisco Ballet. At first I thought we were a bit crazy, but it actually worked out really well. When Christopher Stowell was just beginning his performing career, he agreed to role-play for a program at Theatre Artaud for Career Transitions, which was a program I was helping out with. I asked him to make one of his first ballets for my school. I used to give workshops in Japan, and he came to one of these and got to know me better as a teacher. He even became my neighbor in San Francisco. I was over for dinner one night and found out the apartment upstairs was vacant, and so we lived in the same building.

He had asked me about this job when he was flirting with the idea of perhaps becoming artistic director of OBT, and we talked about the possibilities and what it could be like and what our goals might be. I decided it was my chance to become part of an organization that had a professional company attached to it. My school was associated with Regional Dance America and was an "Honor" company for eight years, and that was a great experience.

When we moved up here, it was in a caravan with my husband and me in one car and my daughter and Christopher in another, including our pets. I experienced a bit of anxiety during the move, as it represented such a huge change for me and my family. I thought while we were driving, "Oh, my god. What have I done?" and "Where exactly is Portland anyway?"—not being that familiar with Portland at the time. I've settled down now and am happy here and particularly like the Pearl District.

Some of my goals for the school include wanting to produce professional dancers, but also those who are well-rounded and well-informed, who will become, at minimum, well-informed audience members. We are setting examples of what is important in life—dedication and a work ethic. Professionalism. This doesn't happen everywhere and requires commitment.

There is lots of talent in the school, and I'm so fortunate that all of the teachers are very enthusiastic and that I have a great team that goes the extra distance. It's exciting to see results of such effective teaching.

One of the continuing challenges any teacher has is to figure out how to give the right combination of corrections and explanations so that the students can understand, respond, and produce it. I love the process [of teaching]. It's fun to see the lightbulb go on when learning has occurred.

Damara Bennett with the San Francisco Ballet. Courtesy of Oregon Ballet Theatre.

We don't follow a rigid syllabus, but my teaching method is based on Vaganova. I've found that it gives a great framework and allows for creativity. It shows us what should be taught first. I've "Americanized" the syllabus. At OBT, we start the kids at age six or seven in Ballet I.

I try to get the students to think about technique and ask a lot of questions as a result. Why does the heel need to be forward? What does tendu mean? This involves the student in the process, gets them thinking, and perhaps prepares them for teaching later.

In the beginning levels, we keep them with the same teachers while they're young, as we've found it helps to keep them focused. The boys have one class by themselves each week, and we make sure they always have something special to do. The training for boys and girls is pretty much the same, but it's great when the boys can have their own class. I do like to have the boys in with the girls as well, as it helps give them a better sense of line; otherwise, they tend to want to throw themselves around.

Performing is a very important part of training, and we work to give the students an experience that's, to me, the difference between a recital and a performance. I think they need real choreography by real choreog-

raphers. It's not just only about showing studio work. It's all part of their education, and it makes me very proud to see my students onstage.

We have a strong parents' association with its own board and fund-raising efforts. They're very supportive and not at all intrusive. They are active with raising scholarship funds.

Many ballet schools teach a "look" or style, and we try to be very clear in our expectations and teaching. We have lots of people from all over the country, and getting them to the level we expect here is a process, and it's starting to improve, but it takes time.

I think dancers need to learn different styles, and we need to bring dancers up to the level of what's expected of them in terms of the repertoire. We do offer modern once each week. Space is an issue for the quantity of offerings.

I'd like everyone to know that I love being in on the ground floor, and I'm excited to have been at OBT from the beginning of Christopher's tenure. I'm proud that while I was a dancer, I was involved in the "Save the Ballet" campaign for San Francisco Ballet.

[Author's note: In watching Bennett give Oregon Ballet Theatre their company class, from the first exercise she was trying to get them on their legs right away. Not with a plié sequence, but with a tendu/sur-le-cou-de-pied and stretch facing the barre. A very nice class, with lots of things to prepare them.]

DAMARA BENNETT ON TEACHING TECHNIQUE

What is technique, and how might you define it?

Technique is what you need in order to express the art form, whether for an abstract or a story ballet. Technique for technique's sake is not important. Either it's correct or it isn't. To me, it's very black and white. It's also how the steps relate to other steps—what steps are connector steps. Technique is also support; it's your partner.

How do you go about imparting it?

It's imparted very carefully. It's important not to get ahead of yourself. A smaller vocabulary, thoroughly understood, is preferred to more vocabulary less well understood. I find there are problems at studios where teachers only teach one class at one level. The results and training of the

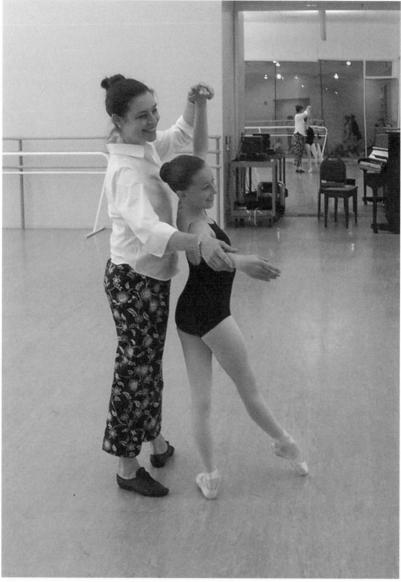

Damara Bennett teaching an Oregon Ballet Theatre School student. Courtesy
of Oregon Ballet Theatre.

students tend to be better when teachers can follow students from one level to the next.

Is there a difference between skill and technique?

Lots of people have various facilities toward various things, such as jumps and turns. Hard-core technique comes from the inside.

Teachers need to demonstrate an unbelievable work ethic. Students need an excellent teacher and parental support. It's critical that etiquette be followed; it makes the students feel safe to know what is expected.

What part do interpretation and presentation play in acquiring a good, solid technique?

Presentation is very important. Students need to see something that speaks to them. Students need to be ready to receive information and have the time to absorb it.

What should a good teacher be expected to do?

I always have teaching notes. I always come to class with a written plan. Some combinations will live in my heart forever. These enable me to pull "from the library" when I need to.

It's important to understand where you are with students, where they've been, and where you are going with them.

What are the challenges that students most often face?

Students misunderstand tendu. That rotation is from the center out. I see a lot of complete misunderstanding. Port de bras happens faster than the legs; otherwise, you get a very uncoordinated look or a heavy sense of drop, such as in a jeté when the arm is there too late.

People misunderstand the placement of the hip to tendu back. The strength in the hips to hold positions comes from slow, careful work.

What are the challenges that teachers most often encounter?

People are amazed that so many classes are necessary.

How do you bring families into the process?

If you don't have parental support, it's an uphill battle. Too many students don't make it because of their parents. We try to make it easy to become the right kind of "ballet parent." We have Parent Observation Days. We want them to learn along with the students. Taking an adult class is good, because they can really understand what it feels like.

What does a good class look like to you?

A good class has a barre that's long enough to get people warm. It depends on the level exactly how this might play out. I give and believe in

lots of tendus, weight changes, fondus. I believe there should be at least two types of pirouette combinations in class and at least two to three petit allegros—little jumps, then big jumps. Class needs to be interesting musically. I would give two adagios if we had the time.

Who were your favorite teachers, and how did they help you?

My first serious training was with Lila Zali in Laguna Beach, California, at Ballet Pacifica. The foundation she gave me allowed me to get scholarships to the School of American Ballet and later to the San Francisco Ballet School.

When I was in SFB, the company training was so poor that I led a small mutiny to get someone good to teach us, and this is when they brought in Tatiana Grantzeva and Terry Westmoreland.

Lew Christensen's classes were hard, but they didn't make sense to me. Tatiana's classes were extremely clear—exercises in ²⁄₄ and ¾ time, mazurkas, lots of relevés. The company got so much better and stronger. She also gave me lots of great tips for teaching myself, such as passing along some combinations that she felt were particularly effective. Westmoreland was extremely musical. Erik Bruhn was also brought in, and he was such a beautiful model.

At SAB, I was impressed by Stanley Williams. Jillana was great. She was still performing at the time and was so enthusiastic.

Are technique and teaching evolving?

I think technique and teaching are evolving. For example, when teachers used to correct, they didn't use the name of the muscles, but now they do. More people are approaching teaching as a valuable thing in itself and not just something you do when you are through performing. The big ballets are not being done as much. The look of ballet has changed. We have to be careful that [good] port de bras doesn't get lost.

PETER BOAL

"I want each student to discover how exciting dance can be."

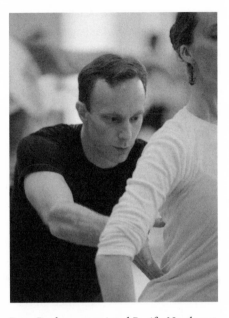

Peter Boal was appointed Pacific Northwest Ballet's artistic director in 2005, after he had retired as a principal dancer with the New York City Ballet and as a faculty member of the School of American Ballet. In July 2005, Boal talked about his vision for Pacific Northwest Ballet, including teaching.

For the company, I'm looking to traditions; to build on what Kent Stowell and Francia Russell have done. I plan on keeping the Balanchine repertory as an essential element of the company. I'm a big fan of Forsythe, Duato, Robbins, and Tharp. With the exception of Tharp, each of these choreographers has already been represented in small ways in the repertory, but I would like to add more of their works. We are doing Robbins's

Peter Boal working with PNB company dancer Kylee Kitchens. Photo by Jerry Davis.

In the Night this coming season, for example. I love the dancers and the audiences here and want them to stay. Some of my plans include outreach to younger audiences.

We hope to have 43 dancers in the company, but are waiting for a visa clearance on one, so it may be 42. You know already about the promotions of Jonathan Porretta and Maria Chapman, but you may not know that Leanne Larsen has been hired as an apprentice and that Jessika Anspach has been promoted from apprentice to corps. Benjamin Griffiths, who was a student of mine at SAB and who is leaving the Boston Ballet, will be coming into the corps as well. Carla Körbes, who was recently promoted to soloist at NYCB, is joining PNB at that rank. She is originally from Brazil. I met her there when I was guesting in *Apollo*. She was cast as Terpsichore though only 14. Through an interpreter—I spoke no Portuguese and she no English—I suggested that she come to SAB, which she did one year later. She's been in NYCB for five years now.

I'm adding ballets by Jerome Robbins as the Robbins Trust allows us. Typically, they like companies to "earn" the right to do his work. Robbins was the most demanding person and possibly the most important person in my development as an artist. I got to work with him for nine years, until his passing in 1998. I was learning *The Prodigal Son* from a videotape—the piece was being reestablished in the NYCB repertory—and Robbins himself asked Peter Martins if he could coach me. As far as I know, this was the only time Robbins coached anyone in a ballet or dance other than his own. There is nothing like the dancer-to-dancer transmission experience and connection. He choreographed six ballets on me, including his last work, *Brandenburg*, which he worked on for two years. When he did *A Suite of Dances* for Baryshnikov, he used me to "pre-choreograph" on before he went to Baryshnikov, as he was nervous about working with Misha. He always treated me with respect. He never yelled at me. Not everyone was so lucky.

I'm expanding on my ideas for outreach. For example, we are headed over to Seattle University for a demonstration to their dance students. We're starting a Friday-night program—it will be a total of four evenings—here at the Phelps Center where someone can pay only $5 to see a preview of the next week's repertory. While I believe our ticketing structure to be quite good, even so, there are those for whom tickets can be expensive,

and our thinking is to give them a one-hour in-studio show for a bargain price and see both the rehearsal process and the dancers right before their eyes.

I love teaching. I was on the full-time teaching faculty at SAB for nine years, where I did 10 to 13 classes a week. The age range I covered was 12 to 19; some were girls, but most were men. Jonathan Porretta likes to remind me that he was in the very first class I taught. Fifteen PNB dancers are former students of mine. I plan to teach four times a week during the summer course.

When I first took partnering—in the advanced men's partnering class—I was 13 but looked 10. In trying to find someone to dance with me, I asked Tina LeBlanc, who said no, and she had to look down on me to say this, but a couple of weeks later Louise Nadeau said yes.

I think it's important to have a regular studio relationship with dancers. I'll be teaching the Tuesday and Thursday company classes and will be doing something new for me—staging two ballets: *Duo Concertante* and *Red Angels*. Francia will be staging *Concerto Barocco* and *La Valse*, and Kent will be overseeing *Nutcracker* and his *Hail to the Conquering Hero*. I've asked Francia to continue teaching company class when her schedule permits—perhaps once a week. She's already gotten lots of offers—to be a guest faculty member at SAB, for example—so I'm hoping she'll be able to fit it in. The dancers really like her classes.

My teaching style can be typified by that I am a very patient and quiet teacher. I want each student to discover how exciting dance can be. I won't force anyone to do it. I teach for everyone in the room. Each of them has an individual potential, and I want to help them discover it. I put tremendous emphasis on musicality.

Looking to the future, I'm committed to finding new choreographers and bringing them to the public. I'd like their work to be more widely known in Seattle and for the rest of the country to see what wonderful work we do. It really is an amazing company, and the standard of excellence is at the highest level. Perhaps we might be able to have a smaller touring company. I want it to be democratic, with opportunities for everyone, not just for principals.

The board has put tremendous trust in me, with no particular measurable goals or objectives. I have consulted with Kent and Francia a lot,

and while I did plan this coming season, I floated two drafts of it before them first. When Kent saw the first, believe it or not, he said, "Too much Balanchine." When they saw the second draft, they said, "That's it."

Company size is perpetually an issue. I think that two productions a year that require 65 dancers is fine, but the rest of the time, smaller is good. Fifty may be optimal, and 90 is too many. I don't think I could have a personal working relationship with that many.

My wife is very organized and has unpacked and put everything away already. I'm still unpacking my office. Our children all dance and wanted to do so on their own. Our youngest daughter will be taking classes at the Bellevue location in the class for her age group, four to five. The two boys took ballet in Stamford, Connecticut, and plan to continue.

We were lucky to find a large house on Capitol Hill, so my commute is only a few minutes. The former owners, who are in their seventies, took an hour and a half to show us all of the details of the house. One then asked about the Boal name, saying that he had known someone on the East Coast with my surname. Turns out he went to school with my father at Exeter Academy in New Hampshire and at Harvard Law School.

PETER BOAL ON TEACHING TECHNIQUE

What is technique, and how might you define it?

It's being able to look into the "toolbox"—knowing, taking, and using a vocabulary and understanding the tools for applying it. For example, knowing exactly where tendu front is, where 90 degrees is, what is the angle "box" of elbow to head and neck. Knowing how to offer these tools to an audience.

How do you go about imparting it?

It's not about teaching or pointing out to students what's wrong, but what is right and the process by which the student can understand it— finding what registers for them. Sissonne fermé to the side is very difficult to impart, but I've found that everyone could do it with their arms and hands, so sometimes we first practice it this way and then translate it into legs and muscles later. I wrote a piece as a tribute to the great SAB teacher Richard Rapp, and in it I referred to his use of clock images, such as having the legs start and return to certain points of the clock. This can be a very useful reference.

Is there a difference between skill and technique?

There are no shortcuts. Students need to explore and then refine these new movements. Skill is the accurate execution of technique.

What do dancers need to learn to master technique?

They need technique coupled with artistry. I recall the contrast of learning jumps from Mr. Rapp's classes compared with Stanley Williams's classes. Rapp was vocabulary—not an ounce of artistry. Williams built upon that. Musicality is certainly important, as is the observation of others. We all learn from each other. Some students and dancers are "concept" people who can easily get the vocabulary but not the execution.

What part do interpretation and presentation play in acquiring a good, solid technique?

Those who are repeatedly told *how* to do it are not as exciting as those who make the choices for themselves. It's best as a collaboration, by providing opportunity with guidance. Live music is essential.

What should a good teacher be expected to do?

Lesson plans depend on the age of the students. There are times when it's important to respond to how the last combination went, and I may want to do this. You must allow flexibility in class and not be too pedagogical. It's amazing how rewarding a challenging class can be.

That they master difficult combinations is what makes the class enjoyable. Of course, syllabus is important, especially for younger students. Even while adapting to the needs of each group from class to class, the overall structure remains the same.

At very advanced levels and with company class, center adagio, while valuable, although not popular, is hard for women in pointe shoes (for them to control their ankles from wobbling as they stand flat) and therefore sometimes I don't give one, as I'd rather work on other things that I feel would be more beneficial.

What are the challenges that students most often face?

Rolling over on feet. To build control over this one, try standing in coupé—and let go of the barre. It's critical to give tons of pirouettes—fast, slow—and to emphasize musical elements. The concept of class should include that of performance and of the stage. For example, what angles will the audience see? I encourage thinking of moving away from the mirror and finite lines and thinking of their dancing as making infinite lines.

What are the challenges that teachers most often encounter?

There needs to be an established level of organization, respect, code of conduct between teacher and students—and once established, then rules can relax. Teachers need to consistently reach all corners of the room—and students need to listen to all corrections. Volume level is important. Williams would speak very quietly, yet he focused all attention on himself. Loud can also work. Teachers should constantly "read" the students and ask themselves, "Is it working?"

How do you bring families into the process?

Our parents here at PNB watch one day a month. These "watch days" are very well attended. It helps families to understand the training process to see the child in class nine times before the recital. We give Dance Chance families tickets to performances throughout the year.

These are opportunities to share the thrill and challenges. They spread the word of what is great about dance as a profession.

What does a good class look like to you?

It's where everyone takes away something positive. And where everyone sweats. Academic education was honed and reiterated through dance class. A good teacher and a good class will understand the need to relate the material to performance onstage. I find that a sense of geometry is important.

Who were your favorite teachers, and how did they help you?

Richard Rapp had a special method. He was a great teacher for the intermediate-level students and a great inspiration for coming into his classes at about the age of 11. He taught you methods to instruct yourself. He was like a draftsman, giving you very clear images and very exact instructions on how to dance in a technical sense—very exact. An example is for rond de jambe à terre. He used to say, "Bring the toes to two o'clock, now to four o'clock, and in where the hands meet. Or for quarter rond de jambes, to make the shape of a pizza slice. He would just make up these incredible images right on the spot.

Are technique and teaching evolving?

They're certainly evolving. The standard used to be two pirouettes. Now it's three or four. (By the way, making two is no longer an issue when you can do three.)

A great teacher is still a student—someone who learns from students and who makes changes in response to how the students are learning.

YVONNE CARTIER

"Developing an artistic sense at the core of their being."

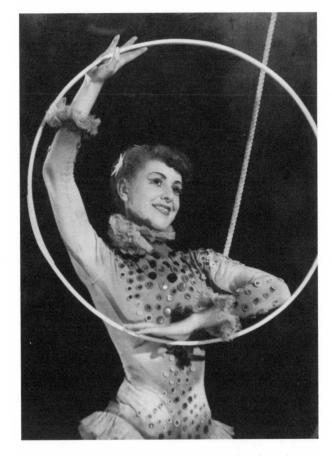

Yvonne Cartier performed with the Royal Ballet of London and was a mime in Paris for more than 20 years.

Yvonne Cartier, in 1952, in Walter Gore's *Hoops*. Photo courtesy of the artist.

I began dancing in my home country of New Zealand upon the advice of a doctor. Three of my toes had been accidentally cut off and then surgically reconnected when I was four. The doctor recommended dancing as the ideal exercise for reeducation.

An Australian theatrical company was holding auditions of young dancers for their projected tour of New Zealand. This coincided with my mother's interview with the principal of the ballet school that had been recommended to her. I was then four and a half. Madame Valerie Valeska was just leaving to take a group of her students to the audition, and she invited my mother and me to accompany her. At the end of the audition, the director wanted to know what the little one could do. Both my mother and Valeska said, "She has never had a dance lesson in her life. She can do nothing." I said, "Yes, I can. I can recite a poem." I had learned poems by listening to the children in the kindergarten next door. Eventually my parents were persuaded to let me join the company, and I was given a contract. I was put in a costume and sent onstage, and I went through the learning process in public. The moment I had learned the ballet, they'd call a rehearsal and change the choreography. I was spoiled by the older members of the company. My mother decided this was not good for me, and after the Wellington season, we came back home. This was my first professional engagement.

Valerie Valeska, who had studied in Paris with Anna Pavlova's partner Alexander Volinine, was renowned for her dance recitals. They were quite professional with wonderful décor and costumes. From her, I learned about theater. You would perform at all costs. When the Royal Academy of Dancing examinations were first introduced to New Zealand, the teachers learned the syllabi with great enthusiasm. This was a wonderful opportunity for linking in with the rest of the world and raising the technical standard in the schools. Felix Demery was the first examiner for the RAD, and I did my first examinations with him. Eduardo Espinosa also came. He represented the French school and had his own syllabus, which we found very exciting.

When I went to secondary school, I could no longer go into Auckland, as it was too far. However, nearby, there was a young Englishwoman, Dylise Askin, who taught the RAD method. But 18 months later, she married, so I had to find another teacher. It was at the Nettleton Edwards School that I found my wonderful Bettina Edwards. I worked with her

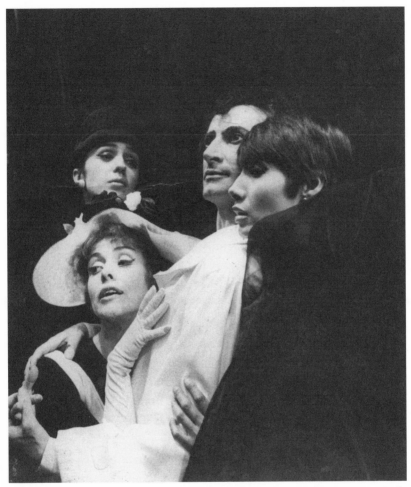

Yvonne Cartier with Marcel Marceau and company in 1965, in his *Don Juan. Left to right:* Sylvia Gaillard, Cartier, Marceau, and Rosenda Monteros. Photo by Leon Herschtritt.

until I had completed my technical training, and it was under her guidance that I won the RAD scholarship to study in London.

I first connected with Marcel Marceau when I saw him performing in the Arts Theatre in London. I was enchanted by the magic of this man. When I was in New York with the Royal Ballet, a friend of mine who knew Marceau recognized him as he was walking past the Metropolitan Opera House, and he introduced me to him. I said, "When I leave the ballet, I would love to mime." And Marceau gave me an open invitation to come to Paris to study whenever I was ready.

When eventually I reached Paris, Marceau was away on tour. So I began my mime studies with Etienne Decroux. For about six weeks in the summer we did nothing but walk, analyzing walking. And I realized that he was doing research, whereas I was impatient to study mime on a wider scale. One of the girls in the class said, "My boyfriend has a school, which he opened last year. Perhaps that might be closer to what you are looking for." She was the future Madame Jacques Lecoq. And so I joined the Lecoq school when it reopened in September. Years later, when Marceau eventually returned to Paris and was ready to reform his company, I joined him for his production of *Don Juan*.

It was exciting to work with Marceau. It was magic of the theater in its purest form. He rarely used props or accessories. With his gestures, his body, his face, his whole being he would tell his stories. He created his own world onstage. He walked against the wind, up ladders, and down staircases. He would skate, he would put on masks, clothes, gloves. But there was no wind, no ladders, no stairs, no masks. It was all an illusion, but you believed that it was real, and the public hung on his every gesture.

A couple of comparisons on being a mime versus being a dancer: you don't get such sore feet or skinned toes. And you get as much applause at the end of the performance, if not more. I thought in a different way when I was doing mime. You still use your whole body for expression, as in dance, but it needs concentration on the smallest gesture or head movement. If you're being a character, everything has to tally. Do you make a gesture before or after you breathe? Do you turn your head, or do you incline your head? Everything matters a great deal because there is no speech. If you're working in silence and wearing masks, you can't

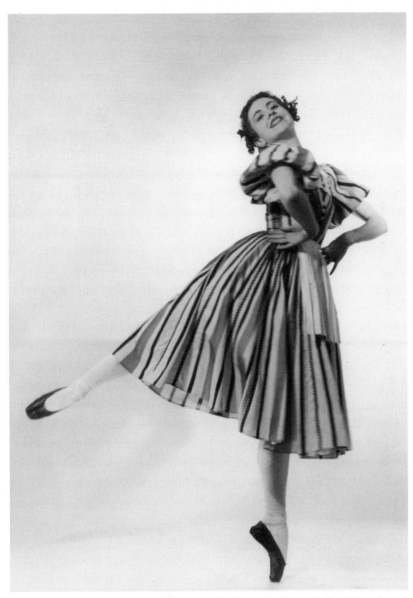

Yvonne Cartier in *Pineapple Poll* by John Cranko at the Royal Ballet. Photo by Denis de Marney.

necessarily see the people you're performing with. You have no means of knowing what they are doing, so you develop a sixth sense.

The use of the mask gives another dimension to the mime. It's interesting to work with because the mask has a fixed expression, and the use of the body and the movements of the head animate and give it life. One of the things I loved about mime was the challenge of performing without props and within a tight framework and within these imposed limitations, achieving the desired dramatic or comic effect.

We also used to say that the public for mime has to have the same qualities as the mime. It must not be passive and just sit there. The public must have imagination and lend itself to the fantasy of the mime. In effect, the public must be as sensitive and as imaginative as the mime. In this way, you get a terrific feeling between the audience and performers, where they share as with Marceau the anguish of the mask maker who couldn't take his mask off. It's almost hypnosis. You draw the public onto the stage, so that they are waiting for your slightest gesture or movement. It won't work if the public just sits there and says, "Enchant me. Interest me." Could that be why classical ballet is in such dire straits? Because the public says, "Excite me." Perhaps they no longer come to share and participate.

If you look at the films of Jacques Tati, they are very much related to old pantomime. There are many scenes where you see people talking, making gestures, arguing. You're too far away to hear the voices, but you know what they are saying. In one film, everything happens by accident. He is changing a tire; it rolls down the hill and gets covered with leaves. As he retrieves the tire, people come out of the nearby cemetery and they shake his hand, mistaking him for one of the principal mourners, because the old tire looks like a wreath. This is humor out of nothing. "Mime in ballet," as Beryl Morina explains in her book of that title, is based on what was called "la pantomime blanche" of the nineteenth century, where the spoken word is replaced by gesture. The gestures must be clear, precise, not blurred or lacking definition. "I You See" (French syntax) should not just be a pretty port de bras. There is a rhythm, as in speech. In the nineteenth century, people were used to this form of theater, thanks to players like the famous Jean-Gaspard Deburau. The mime used in the ballets of the Romantic period—*Giselle, Robert le Diable*—was a more elegant form of that popular mime. The public understood the gestures that replaced

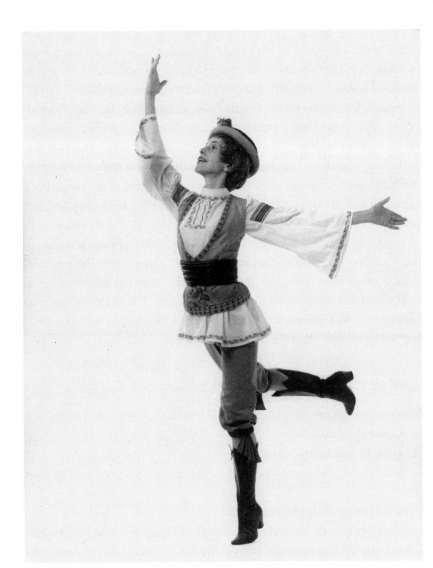

Yvonne Cartier as Franz for the 1970 centenary performance of *Coppélia*. Franz was originally done as a pants role, performed by a woman at its 1870 premiere. Courtesy of the artist.

words. It was part of their everyday life. The Italians still use gesture to replace words or to encapsulate thoughts.

Today, the tendency is to cut out the "ridiculous old mime" of the nineteenth-century ballets. However, there are choreographers who are not afraid to use a modern form of mime: for instance, Sir Frederick Ashton in *A Month in the Country* or his delightful *La Fille mal gardée*, Ninette de Valois's *The Rake's Progress*, or Antony Tudor's *Jardin aux Lilas*.

Pineapple Poll was an interesting ballet to have been in. The choreography was by John Cranko, set to music by Gilbert and Sullivan, adapted by Sir Charles Mackerras, costumes by Osbert Lancaster, and was first performed March 13, 1951. It was for the Sadler's Wells Ballet, a company of young dancers ages 16 to 25. Cranko was their resident choreographer, age 23. In 1951, it was presented for the Festival of Britain and in Seattle. I was cast as Pineapple Poll.

I started to teach whilst in the Royal Ballet. We had 12 new ballets to learn in three weeks. I'm very analytic, and I enjoyed helping people— if they asked me—with their interpretations. After the 1968 revolution with the public theaters having been shut down, I began teaching quite a bit more. I was thrown about on my own and taught myself to teach. I learned as I went—from and with my students.

YVONNE CARTIER ON TEACHING TECHNIQUE

What is technique?

An acquired skill.

How might you define it?

Technique is the means by which one realizes the expression of one's art.

How do you go about imparting it?

There are several important methods of classical dance: the French School, the Bournonville School (derived from the French School), the Italian School, and the Russian School. Most teachers having studied one or more of these methods will naturally employ their own early training experience, enhanced by their professional career and the teachers and choreographers who have enriched their knowledge.

However, there seems to be a new generation of teachers emerging

through the specialized schools and universities: highly qualified but with a minimum of theatrical experience.

Is there a difference between skill and technique?

Technique is an acquired skill. Unfortunately, it can be limited by a dancer's physique. However, dancers develop great skill in concealing their limitations through sheer artistry and stage presence.

What do dancers need to learn to master technique?

They must be encouraged to be interested in all aspects of the arts and theater and the world about them. They must, of course, be observant, noticing details, distinguishing between what is important and what is not, what is genuine and what is superficial. Developing an artistic sense at the core of their being. This will be their guide throughout their career.

What part do interpretation and presentation play in acquiring a good, solid technique?

As I mentioned above, technique is the means by which one realizes the expression of one's art. Therefore, if one has something to say, one will find the means to say it. I don't think that technique and expression should be separated. The drive of the artist to express himself will provide him with the necessary technique. Technique on its own is arid.

What should a good teacher be expected to do?

The first duty of a good teacher is to give the student a love of the art and a passionate desire to learn. If the students really want to learn, they will be open to the training and guidance offered. It will be a partnership, not a confrontation or a head-on collision or a battle of wills.

What are the challenges that students most often face?

Probably trying to "run before being able to walk." Patience is necessary both for teacher and student. One must persuade and understand one's body in order to overcome the various difficulties that arise during training. One must avoid injury. Using force is dangerous.

What are the challenges that teachers most often encounter?

A teacher must always be able to adapt the class to the needs of the students present, challenging them when necessary, demanding precision, musicality, artistry, always a little more than is comfortably within their reach, until the desired results or progress are obtained. This is not always easy, especially when teaching mixed levels of age or abilities.

It is important to remember that not all students will become professional dancers. Those students must not be made to feel they are failures. Their dance experience should be positive and constructive, and it should be their own decision to try some other aspect of the arts or something entirely different when the time is right.

How do you bring families into the process?

The normal practice in France is to have Open Days, when family and friends are welcome to watch classes. This provides an opportunity for the teacher and parents to meet informally. If there are problems with certain students or their parents, the director of the school or teacher will arrange a meeting with those concerned.

What does a good class look like to you?

A good class has a good atmosphere, a joie de vivre, a sense of achievement.

Who were your favorite teachers, and how did they help you?

I was very lucky. I always had the right teachers at the right time, and I loved them all.

DANCE: Valerie Valeska, Dylise Askin, Bettina Edwards, Winifred Edwards, Claude Newman, George Goncharov, Vera Volkova, Audrey de Vos, Peggy van Praagh, Errol Addison.

DRAMA: Maisie Carte-Lloyd and Helen Griffiths.

MIME: Etienne Decroux, Jacques Lecoq, Marcel Marceau.

MUSIC: Edwina Knox.

Are technique and teaching evolving?

One wonders in this day of hyperextensions and the pursuit of extreme technical sensation whether one is training artists and dancers or circus acts. If a dancer isn't able to get his or her leg up to ear level, or preferably behind the head, he or she won't be hired. The fact one is chosen for one's body type and physical prowess means that the doors are being closed to a lot of real talent.

The interpretive artist of subtlety and elegance, and real technical virtuosity in the classical dance, is giving way to a hyperextended, lax-muscled phenomenon, who distorts the classics as I knew them. No one does an arabesque at 45 degrees because it expresses a certain emotion or attitude of mind anymore; arabesques are now as high as possible in any circumstances, it would seem.

We all know that before she was accepted at the Paris Opera School, Sylvie Guillem trained in gymnastics. Does this mean that now all schools where dancers are trained must have special preliminary courses in gymnastics before allowing children to enter a classical dance program? It is not that I don't appreciate circus acrobats and trapeze artists—I do. I admire their courage and the beauty of their performances. I once had a trapeze artist in my adult professional class. She had a fabulous line, strong back, wonderful développés, beautiful port de bras and adage, but she could not "dance."

I remember the famous adagio during a performance by the Peking Opera: The woman in a perfect arabesque on full pointe balanced on her partner's head. Then she actually did a promenade, turning 360 degrees while remaining on full pointe and still balanced on her partner's head. It was fantastic, incredible, breathtaking. Is this what we should be training our dancers to do? I don't think so. But are we training our public to expect it? Does a six-o'clock arabesque help me to understand the act 2 pas de deux in *Lac des Cygnes*? Does it not distract from the poetry and beauty of the choreography?

When I was a student in London, I went to every ballet performance I could. I remember the wonderful repertoire of the Marie Rambert Company. Ballets by Ashton, Frank Staff, Antony Tudor, Andrée Howard, Cranko, Walter Gore, and the wonderful dancers who interpreted them: Sally Gilmore, Paula Hinton, Maud Lloyd, Celia Franca, Harold Turner, Lucette Aldous. The wit, the drama, the humor of Rambert's repertoire are gone forever. A lot of the repertoire of the Sadler's Wells Ballet, now the Royal Ballet, happily still remains.

I may sound as though I am against "progress." Not so. I am just trying to make a plea for the art of theatrical dance, as opposed to circus-act sensationalism. There are so many injuries these days, owing to the stress of the exaggerated technical requirements imposed (and often self-imposed) on dancers by the choreographers and company directors today.

KAREN GIBBONS-BROWN

". . . alignment of dreams with realities . . . "

Karen Gibbons-Brown is artistic director of the Fort Wayne Ballet in Indiana.

I started in ballet when my mother took me to a local dance school in Pittsburgh. She had always wanted to dance, but wasn't allowed, and she wanted me to have the opportunity. We then moved to South Carolina, where I eventually auditioned for *Nutcracker* but didn't get into the production. I learned I needed a whole lot more than the training I'd had, and I decided that I really wanted to pursue dance seriously.

Miss Ann Brodie put me in the most beginning levels, and I retooled myself. So in this sense, I was a late bloomer. I was inspired by *Gradua-*

Karen Gibbons-Brown. Photo courtesy of the artist.

tion Ball, thinking it was wonderful. Miss Ann became too ill to teach for about a year, and her close friend from American Ballet Theatre, Michael Lland, came to Columbia to fill in. He was one of ABT's ballet masters, and he took a sabbatical to work with her school and company. He was very helpful to me and even offered me the opportunity to study at the ABT School. Of course, I was all set to go to New York, but my parents were reluctant to see me go, so we worked out a compromise. I had to finish high school and promise to go to college full-time if I could not "make it" in the world of dance. I was so fortunate to have fabulous teachers: Leon Danielian, Maria Swoboda, Nancy Clemens, Michael Maule, and Patricia Wilde.

After two years in New York, I decided to go to San Francisco. I studied at the Conservatory of San Francisco Ballet and danced with the Theatre Ballet of San Francisco. I also got some exposure to modern dance. Some of my teachers in California included Merriem Lanova, Antonio Mendes, and Alexander Nigedoff.

I was fortunate to work with Léonide Massine in his *Le Beau Danube*. I did Pavlova's *Dragonfly* and her *California Poppy*. I just loved it. Cannot imagine why people think it wasn't such a good piece—it is.

I married a businessman whose hometown was Kingsport, Tennessee, and I commuted to New York and Columbia, South Carolina, to perform and study. I worked with Bristol Ballet and director Constance Hardinge. Bristol Ballet encompassed being a school, a training program, and a performing company. Constance Hardinge was instrumental in the regional ballet movement. Her vision of my future beyond performing was to become a director. Consequently, she introduced me to the "Who's Who" of regional dance and was determined to teach me administrative skills.

I always knew that I wanted to teach, and I started at the age of 15, teaching tap. I began my own school in Kingsport and guest performed in Chattanooga regularly for Bob Spaur. I was active with the Tennessee Association of Dance and continued to make guest appearances until my second child came along. Five years later, I had become a single parent, and Fort Wayne Ballet needed a director. They had had four directors in four years and were looking for stability and, I believe, direction. After interviewing and talking with the board and community, I felt I could make a difference, and I am now in my tenth season. I've remarried, and

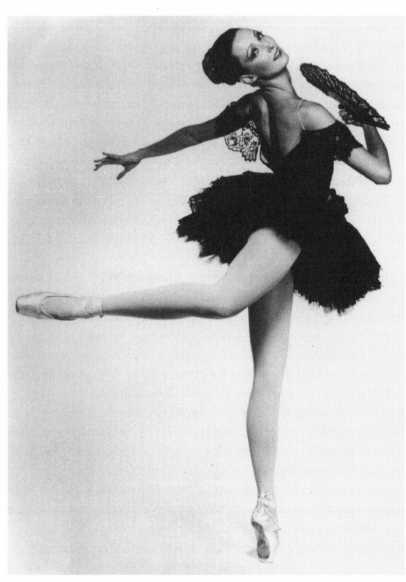

Karen Gibbons-Brown en attitude. Courtesy of the artist.

my husband is a trained musician and an arts administrator in our community.

I'd advise aspiring dancers to look at me as a good example of how you can become a dancer if you are from a small town. It doesn't really matter where; it's your desire to be successful.

I've been able to turn things around here in Fort Wayne. When I began my tenure, there were only 87 students, we had building problems, and we were $150,000 in debt. Donors were saying we were not being fiducially responsible to the community. So my challenge was how to make us viable in the community. I felt this required several things: (1) outreach (which requires trust), (2) a strong academy to increase numbers in student company to feed the professional company, and (3) an expanded audience base.

I have taught at least one class at every level, six days a week. My being artistic director morphed into also donning the mantle of being the executive director. This put a needed business and artistic face to the organization. We buried the debt in less than 18 months. We now have a solid business plan that includes an endowment campaign for our fiftieth anniversary. We have no cash-flow issues. And there are 350 students in the school.

It is a challenge to retain students with potential. I found it helpful for me to teach a lot of everything. Then I limited class sizes (12 for lower levels; 15 for upper levels). It can be a challenge to do the right thing for the students—maintaining standards—yet make it work financially. We've inaugurated satellite programs and avocational programs, unless they've auditioned for the vocational track. These approaches seemed to have worked in my community.

I love the process of developing dancers. As I said earlier, I always knew I wanted to teach.

KAREN GIBBONS-BROWN ON TEACHING TECHNIQUE

What is technique?

Technique is a refinement of natural movement. A strong technique is a required security on which we rely to develop our artistry.

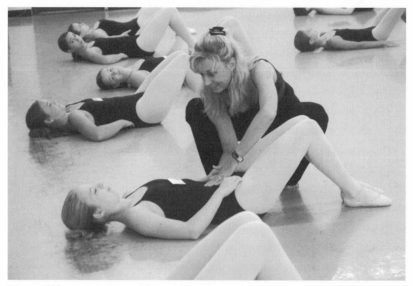

Karen Gibbons-Brown working with young students on core control. Courtesy of the artist.

How might you define it?

Technique is the knowledge base that allows one to create quality movement both kinetically and aesthetically. It is not elusive but, rather, more scientific than someone watching a class or performance might ever imagine. When all is said and done, technique is the means to the end.

How do you go about imparting it?

That is an interesting question, as I feel there are many roads to the mall; you just want to arrive safely. I am grateful to have had a teacher and director that required me to study the three main syllabi of classical ballet. Taking my own background, experiences, and the codified syllabi has been important in finding my voice and shaping my philosophies on dance and dance education. With that knowledge, I must then evaluate each body in the classroom as an individual and find "the key" within the framework that will best allow the dancer to excel. If we teach without a broad knowledge base, we teach to a syllabus and not the student. Good dance education is just that—teaching to the students. There is more than one credible syllabus to achieve quality dance, but clear technique transcends.

As I prepare a class, I plan a specific theme or element on which to focus. Once I get into the classroom and observe pliés, I often change the

focus depending on class needs. The expectations and basic structure of the class do not change, but the specific focus may. For me, the student is the inspiration of teaching. As class progresses, I make a point of giving each student a personal correction and something positive about them along with a challenge on which to work. There are, of course, group corrections as well. The combinations are given to consistently challenge the student to rise to the next level, either technically or artistically.

Incorporating an everyday mainstream example or analogy helps a student to understand and make a connection. Teaching is a constant process for all of us. My students teach me something new every day. How could I be more inspired and fortunate?

Is there a difference between skill and technique?

Everyone dances. Even the youngest of children have the skill. It is a matter of refinement of technique and consistency of quality that separate the pedestrian from the student, the student from the professional.

What do dancers need to learn to master technique?

To master technique rather than simply move adequately, one must develop a consistency of productivity, an internal sense of musicality and timing, thoughtful processes, self-evaluation, and "the eye": that ability to observe, then assimilate and internalize. Passion is also important. Passion to excel, search, discover. I would debate whether passion can be learned, but I do think it can be acquired.

What part do interpretation and presentation play in acquiring a good, solid technique?

In addition to the above components, I feel it is necessary to be a student of life and learn something new every day. Visiting a museum, attending an orchestra concert, reading, experiencing: all of these not only give you information to relate to as you develop your technique but they also feed your soul. That is essential to developing into an artist.

What should a good teacher be expected to do?

There is a long list of things that is the expectation of any teacher. The separation from a teacher and a really good teacher is about the enjoyment. One must really enjoy the sharing, the learning and discovering, the process, and the partnering with a student. Without the enjoyment, it seems a bit hollow. Every body is different. We must help the student discover no matter where they may be in their journey.

I think humor is also essential. Dancers spend all day working so hard

to defy what is considered natural and can become rather self-critical. Although I sometimes feel like a standup comedienne, humor often relaxes a student to see things differently and achieve the next step.

What are the challenges that students most often face?

Fear, whether that is fear of failure or fear of success. Creating art with your body makes one very vulnerable, and that can often be a fearful place.

Students often need to relearn the definition of perfect. There is no such thing. Just when you think you have perfectly mastered a double pirouette, you push for three, and on and on.

And there is the immediate gratification angle. Refining technique and creating art is just not immediate. This is particularly difficult for students to understand. Sometimes the best gift is the gift of time. Expectations—whether the student's or the parent's—often do not allow for the mental luxury of understanding that dance is not an exact science. It is an art that is often in the moment and takes trial and error to refine.

What are the challenges that teachers most often encounter?

Having been in this field for a while now, I think it is often challenging to uphold the integrity while staying fresh. We cannot just jump on the newest bandwagon to make dance broad. It is our responsibility to approach making dance broad from the context of classical technique as the base and all else is adding tools to the toolbox. Staying networked with other professionals as we all do our mission work is a challenge as well.

Yet another topic I find I must address is alignment of dreams with realities in a positive manner. I do believe that this field is broad enough for one whose passion is here, and success is not just found in tutus and tiaras. There are so many components to this field that allow a greater success with a strong working knowledge of dance technique; dance history, costume design, and movement-analysis systems to name a few. Sometimes the required alignment is the parent's dream, and sometimes it is the student's dream. Either way, partnering with the family creates a more successful student regardless of the aspirations. To guide and nurture those realities is a tremendous responsibility as well as a challenge.

How do you bring families into the process?

Bringing the families into the process is actually a part of necessary education. I feel quite often the most challenging component is commu-

nication. There are so many communicative styles to address, so finding common ground can be a challenge. This is also an ever-evolving process.

Through the years, I have tried some things that have worked quite well and some that have not been as successful. At this point, the evolution is a multifaceted approach geared toward different styles and different family cultures. Allowing families to feel that the environment is safe is addressed through open houses for new and prospective families. Observation windows to be used at any and all times allows for the continued comfort of families. I like to offer parent observation week inside the classroom twice a year. Hearing clearly and having an opportunity to ask questions and see progress allows for positive communication and reinforcement.

Having visiting faculty or master teachers present panel discussions with question/answer sessions reinforces the "field standards," as does bringing in professionals in related topics (for example, nutrition, injury prevention, college opportunities).

Whether the student is avocationally or vocationally tracked, sending home student evaluations and progress reports with the offer of parent/student conferences at the end of each semester (or whenever needed with an appointment) adds to the open communication with families. I keep individual student files regarding any communication or information on the student including injuries, allergies, attendance, conference notes, and the academic dance work for the vocationally tracked student.

With that said, I have found one of the most effective tools has been a monthly school newsletter. That mailed publication is full of dates to remember, gift ideas, an "Ask the Dancer" column, and other pertinent information.

What does a good class look like to you?

A good class would contain opportunities for both challenges and successes in the timeframe of the classwork. The student then has the opportunity for that "aha" moment. Connecting the classwork to choreography, history, and other dance forms offers a common thread or theme, even when your lesson plans have been altered to the immediate student needs. I am quite fortunate to have a gifted accompanist for my classes, so I incorporate dance history and music into the classwork regularly. With

my accompanist, the students can explore movement qualities differently than with recorded music. Helping a student find that common thread is so important, as it makes dance immediately more relevant.

Who were your favorite teachers, and how did they help you?

Interesting that I find this a difficult question. My mentor is Jeremy Blanton, who has always offered me advice and encouragement. The one who most shaped my philosophies was Ann Brodie. You see, when I was 12, I auditioned for Miss Ann's *Nutcracker*. I did not make it into the production, and I realized in that audition that although I was a "star" at my school, I was not getting what I needed to dance. My mother met with Miss Ann, who was quite clear with my mother. I had been so badly trained at that point that to continue was a waste of time and my parents' money. However, if I truly wanted to learn, I could come to the school, be taken off pointe, and begin at the beginning with the six-year-olds. I desperately wanted to dance, very much to my mother's dismay. After much pleading with my mother, I began at the beginning and relatively quickly worked my way up to the "junior company."

Twice a week, the junior company had a teacher from Cuba, Aldolfina Suarez-More. Ms. Suarez was absolutely the hardest teacher I ever had. She was challenging and demanding. I loved it. As demanding as she was, I couldn't get enough. I was so far behind, and she never ridiculed me or belittled me. I was treated like the other lovely students in the school. She expected—and received—the best we each could offer. Her class did not involve the stroking that is often expected today, but it was not negative, either. She did tell me when my work was not of an acceptable quality. She also told me when it was acceptable or improving. While she did not give me false praise, I knew that when she did offer me a compliment, it was truly sincere. She believed in me when it seemed that no one else did. Never say never.

Are technique and teaching evolving?

I worry about this every day. I do believe it is a calling. I often counsel students regarding dance careers and suggest that if there is anything else they like as much or better, then perhaps they should reconsider dance as an option. I feel teaching is the same. If there is somewhere else you would rather be, then reconsider. Our field and our students deserve the best one can offer, and that is difficult to do without focus.

We must be careful with all the pyrotechnics and kinetic capabilities that we do not lose the artistry. Studies show us the body can do more than we ever believed possible. Dancers now have the capability to know so much more, gain more control over their bodies, and even extend their performing careers. While all of that is wonderful, our society does not allow for the gift of time. Development comes with time. Often the student and parents do not allow the dance professional to teach in an effort for immediate gratification. It is our responsibility as the dance professional to uphold the integrity of our art. We must hold steady to the truths that we know to be rather than accommodate what is perceived as the need of the moment.

There are more opportunities now than there have ever been. Technique is indeed the means to the end, whatever that may be for the individual: perhaps a performing career, a career in a related subject, or the chance to become a truly wonderful patron of dance. Teaching dance will always be a challenge. It will be a challenge to be understood and accepted by those not in this field. This is as it has been and will continue to be.

Our goal is to hold true to our mission with strength and integrity. The joys are boundless.

GLORIA GOVRIN

"Ballet is a very clever art form—just eight or nine move-
ments can produce a trained dancer."

Gloria Govrin has been a soloist with the
New York City Ballet and associate director
of the San Francisco Ballet School. She is
now the school director of Minnesota Dance
Theatre.

We lived in Newark, New Jersey, and I had a mother who had wanted to
be a dancer. She was a very arts-savvy person and found a Russian teacher
whom she took me to when I was only two and a half. I was lucky she was
a good teacher. I next went to Fred Danieli, who had Marie Jeanne teach-
ing for him. I didn't get to the School of American Ballet until I was 12.

Gloria Govrin. Photo courtesy of the artist.

I took one class and knew SAB was where I wanted to be. I was put into level C. My mother's philosophy was that if you're the best in your class, then it's time to change classes, and if your school is not training you to standard, then it's time to change schools. She was very mindful of getting the best training.

When I was only 14, Mr. B watched class and wanted me to go to Australia on tour, but I was too young, and when he found out how old I really was, he said it would be too much trouble, having to have my mother along as a chaperone, tutor me, and obtain a visa. I worked hard to graduate from high school—going to summer school and never taking time off—so I could graduate at 16.

It was a joy and a highlight of my life to be able to work with Mr. Balanchine. The first thing he choreographed for me was one of the variations in *Raymonda Variations*, which is really a waltz with variations, in 1961 when I was 18. He did the whole variation in only 45 minutes. He treated dancers very kindly and would work with us to make us look good. He expected loyalty, dedication, and hard work. He made the role of Hippolyta in *Midsummer Night's Dream* for me. I was kind of like a short-distance runner in that it's all jumps and entrances and exits. He revised Coffee for me in *Nutcracker*. I laugh every time I recall that he told me he had wanted to do a ballet version of *Salome* but was not sure how much he could have had us take off.

I love ballet, and I try to have the students here share in that joy. You have to be very focused and, in a very real sense, leave everything else behind. It means that you have to keep "climbing the mountain." I try to inspire the students to work harder and know there is a lot more in the well if they are not digging deep enough.

I retired from performing in 1974 and am now in my mid-sixties. I decided at 50 to get back in class. I was at Pennsylvania Ballet and can still recall the feeling that came over me when the pianist struck the first chords and I remembered what had been missing from my life. As a teacher, I consider myself a taskmaster and ask a lot from the students. They know it's possible. Effort counts, although results often come later. The body learns through repetition. With command of the body and native intellect, you can learn choreography. I believe we can focus on only one thing at a time and that it's better to be simple. Class should be about basics.

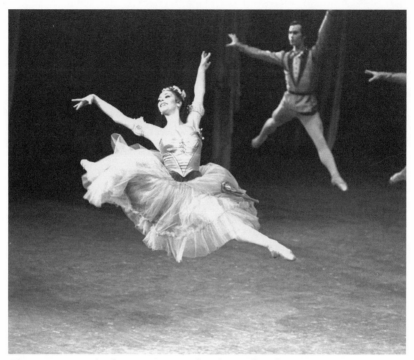

Gloria Govrin in the first movement of *Brahms-Schoenberg Quartet,* a piece choreographed for her by George Balanchine. Photo by Martha Swope.

We want the girls to look feminine and everything they do to look "beautiful," otherwise they can get buried in among the competition. We look for footwork, pointe work, extension, musicality, and strength. All of the teachers watch each other's classes, and we borrow and learn from each other. I try to be very aware of all the students and their strengths and weaknesses. I want our students to be hungry for ballet and ambitious. I want them to eat, drink, and sleep ballet. They all have a good attitude. I love talent and talented people. Being surrounded by people who are better than you—it's what makes you reach. I can take no credit for people's talent. I love and revere ballet.

We have to keep standards high in order to keep attracting talented people.

What is technique?

Positions—trying to do the codified syllabus of ballet as close to perfection as possible. How you approach teaching will affect the result.

How might you define it?

Technique is the means of getting there.

How do you go about imparting it?

By asking for it. Teachers underestimate students. They don't keep insisting and going back to make it better. It's always the journey. You can never achieve perfection, but it's the goal. Teachers need to ask for it.

Is there a difference between skill and technique?

Students may excel at one thing but may not turn or jump as well. Some of it is natural coordination. You can have the worst technique in the world, but the moves are in the body. It's a natural phenomenon. Others may be skilled, but don't always have the natural coordination.

What do dancers need to learn to master technique?

Being observant is most important. You can't learn without awareness of everything going on. Younger students learn by imitating. Moving well

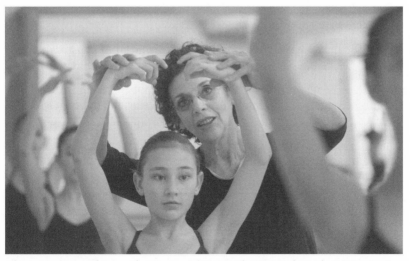

Gloria Govrin working with Minnesota Dance Theatre student Elora Wiggins in 2009. Photo by Tom Wallace, courtesy of the *Star Tribune*, Minneapolis-St. Paul.

is innate, organic. Everyone has their own way, like a fingerprint or voice-print. You can ask for bigger movement, connecting the plié for a better quality of movement, but everyone has their own look and way of moving.

What part do interpretation and presentation play in acquiring a good, solid technique?

They are separate. Artistry comes from musicality; it's a sense of style. Some look stylish, while others look ordinary in the same dress. With style comes imagination. You can't teach it, but you can try to bring it out. How you feel about movement, music—your personality, all comes through—and comes from within. You can try to get students to learn to phrase steps better, but it's all very personal. You have to have a feeling for it and listen.

Mr. B used to say that music had become background and people tune it out and don't know how to listen, but this is exactly what you need to do. Just the other day, in the class for ages 11 to 14, our pianist played the music for the Black Swan's fouettés, and not one child knew it. They don't know history. It's a different kind of world. We're getting further from the classics, and children don't know what they are doing ballet for, where it came from, and how it applies to them. We take things for granted and don't realize that much is left out of children's education.

What should a good teacher be expected to do?

Serving the needs of the students. The students guide you by what they need. You have to gain the students' trust. They have to believe in you. Yet class is not about the teacher putting on a show. Teachers should not be afraid of giving something difficult because it might not be fun. You don't give class to be popular. Mr. B said, "Give them what they need, not what they want." One day, they may need to work particularly on tendu battement or rond de jambe en l'air and not necessarily pirouettes. I give them permission to fail so that they can figure out how to work through problems.

I've gotten thank-you letters from former San Francisco Ballet School students expressing their appreciation for how hard they were worked. Nobody rises to the top without a huge effort. The merger here in Minneapolis was between one professional and one community ballet school, and initially it was like a duel.

My first month was very difficult. It's about quality. I had to convince everyone that we were training very carefully and that the more advanced levels needed to come five days a week. That they couldn't ask me to be anything less than what I am, and how we could ask students to be more. I hand-picked a class, and within only two months they had skipped one entire level because they had never had these kinds of demands placed on them before. They're having fun because they are accomplishing something. I watched a class here earlier in the summer, and the children all looked bored. I told the board I wanted to put the light back into the children's eyes.

What are the challenges that students most often face?

Learning how to hold turnout from the top, using the muscles beneath the hips. Turning out thighs in order to strengthen everything they do. Ballet is based on turnout. Parents here had actually been sold a bill of goods, being told that turnout wasn't "good." Without it, you can't execute anything.

Another is rolling in—how they are standing on their feet, and not turning out legs. Pilates will not solve everyone's problems. Core strength comes from turnout. Ballet is a very clever art form. Just eight or nine movements can produce a trained dancer. Balanchine's method and Vaganova's are the same. He didn't invent anything. Everything she wrote is everything he taught us.

Grand plié in first position is also a challenge. It's harder than second, which is easier to do sloppily.

A comment about frappé: It is a hard step to do right. The brushing alongside with the big toe should always emphasize out, out, out—not in. Sur-le-cou-de-pied should be a hair from the floor. Tendu battement was Mr. B's thing, and it's mine—everything starts and ends in fifth position. If you could do the perfect tendu battement, you could dance.

What are the challenges that teachers most often encounter?

Not to get frustrated; being patient. Things don't happen immediately. It's the effort. Constantly remind them. Within a few months it will be in their bodies. Be vigilant; minds wander. Sometimes they won't remember, but it will come back. Don't be too hard on ourselves. Sometimes we give a class that doesn't seem to work. We can sometimes be accused—and this has been thrown in my direction—of being interested only in profession-

als. Actually, we're most interested in teaching *every* serious student, and there is a difference. It's important to communicate with students and to let them know it's a two-way street.

How do you bring families into the process?

Always say the proof is in the pudding—this is what parent observation is for. We need to be honest with parents and students alike about the future, and we want them to have a positive experience. After all, they are the future of ballet, regardless of whether they actually become dancers or not. If people are frustrated, they will not be supportive. I don't believe in recreational ballet—a two-track system. They need to make a commitment, and this commitment has to be done in class. The goal is not just to perform but to learn ballet and to love accomplishment. Reach for a level that you can be proud of. Be as good as you can be.

What does a good class look like to you?

I like starting with a good barre right away. No "yoga" moves; this feels like wasting time. Class needs to move along. Students shouldn't be standing around listening to the teacher talk. This helps them learn combos quickly and moves them along quickly. Every class should have everything. Petit allegro is essential. I prefer an hour and three-quarters class; an hour and a half just isn't enough.

Kids should come out exhausted. If they haven't moved, they will be bored. Always look at the result. Don't be hard to judge. Students need to be engaged.

Who were your favorite teachers, and how did they help you?

Mr. Balanchine. He taught me what things made me a better dancer. How to change, how to look at things, and how to learn. People often look at something but don't see. An artist can look at a bare tree and see the spaces in between. His classes were not as much fun, but they were *so* instructive. He taught us what we were doing and why. He made me the teacher that I am. He had the luxury with us of not having to give a complete class if there was something in particular he wanted to focus on. It was fascinating. He made such an impression on me that his words are always coming out of my mouth. I quote him all the time. He told me that I needed to know these things about technique and teaching because one day I would teach, and he was right. He was so interested in women and pointe—it felt like a discovery.

Are technique and teaching evolving?

I fear that they're disappearing because people don't want to work so hard anymore without someone pushing. They need someone to inspire them. When people get excited—and it's possible—they'll want to give 110 percent. Teaching, however, doesn't seem to be going in that direction. Choreography for women is less attractive. Choreography is geared toward men, with the women being hauled and carried around. Little pointe work is required. Everyone seems to be following Forsythe. It's becoming monotonous to me. I feel like I'm often watching the balletic equivalent of the *Road Warrior* movie. We need more ballets like Ashton's, Balanchine's, and Robbins's. Women are losing out. Men are excelling, and women are disappearing. It worries me. Unless there is repertoire that makes you a better dancer, they won't acquire it.

I'm concerned for the future if the standard repertory is not continued or if we don't have a brave choreographer. A corporate mentality has taken over. However, people are tired of "stuff"—the audiences want quality. As I said, ballets have become monotonous. They're like run-on sentences, never stopping from beginning to end. And then nothing is memorable. The excuse is that they want to attract a younger audience—they want "sexy." I think it's actually all rather sexless. How are we educating our audiences? Is there variety? It's critical to be aware of what you're doing to your dancers and how they are being developed. There is too much of an attitude of the "disposable" dancer. Pieces don't stretch dancers, and then dancers leave at a very young age. Nothing happens, and they just lose heart. Someone needs to turn it around before it disappears. At City Ballet, we used to build audiences by doing *Swan Lake, Firebird, Afternoon of a Faun,* and *Western Symphony* on the weekends, and then midweek we would perform *Agon, Episodes,* etc.

It's kind of fun being out here in the Midwest. Some may consider it to be the middle of nowhere, but it's extremely liberating. I don't have to be looking over my shoulder.

CYNTHIA HARVEY

". . . anyone can do anything with hard work . . ."

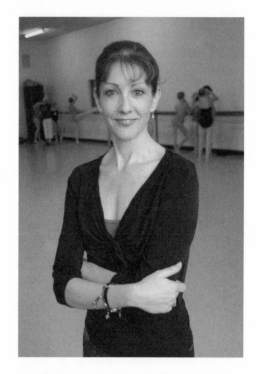

Cynthia Harvey has been a principal dancer with American Ballet Theatre and the Royal Ballet in London. She currently teaches in Europe and around the world.

I first became interested in ballet by watching Margot Fonteyn and Rudolf Nureyev on *The Ed Sullivan Show*. According to my mother, I could not reach the TV, but begged to dance as I tip-toed about trying to emulate Margot in *Corsaire*. I can't imagine doing it any justice, and my parents must have wished that I would sit down so they could watch the masters in action.

Cynthia Harvey. Photo by Alex Cyreszko.

My sister and I had tap/acrobatic and baton lessons for a very short time in Novato, California. Later I attended the Parks and Recreation ballet classes where the teacher commented that I was bored and that my mother should send me to a "real" ballet teacher. This led me to Christine Walton, who was my mentor until I went to New York. She ran the Novato School of Ballet and was a dancer with Alan Howard at the Pacific Ballet in San Francisco. She had about 20 students, if I remember correctly, and in the early days we had live piano accompanying class, which was marvelous for such a small studio. We gave community performances a couple of times a year.

Mrs. Walton was constantly trying to learn, and she instilled in us that there was the correct way of doing things in classical ballet and that anything else was "cheating." She also had a great aesthetic sensibility and knew what looked best on each of us. I think from early on she sensed that my style and line were not "Bolshoi." We learned the Vaganova, RAD, and Cecchetti syllabi, but did not do exams. She extracted the best from each syllabus to meet the challenge of teaching us.

As a child, I was encouraged to audition for other programs, and I briefly attended Ballet Celeste in San Francisco, run by Merriam Lanova. Ballet Celeste was a children's ballet school that performed a great deal and had guest artists dance many of the leading roles. However, I soon returned to Mrs. Walton, where I found her open-mindedness and thorough training suited me.

At age 12 I joined the Marin Civic Ballet, a member of the Pacific Ballet Association, whose director was Leona Norman and later Norbert Vesak, where I could train with Mrs. Walton and yet attend rehearsals for performances that a regional ballet company did during the year. I was included in their *Nutcracker* every year until I eventually worked my way up to dancing the Sugar Plum Fairy. I also attended the San Francisco Ballet School, School of American Ballet, and National Ballet of Canada's summer programs.

I first arrived in New York to live in September 1973 after having been offered a scholarship to attend the then "Scholarship" class at American Ballet Theatre run by Patricia Wilde and Leon Danielian. I also went to Professional Children's School at this time. I did not complete my schooling as I managed to gain a place in ABT as an apprentice in April 1974. It was actually John Neumeier who came to ABT to stage *Le Baiser de la fée*

who wanted me to dance one of the ice maidens that enabled me to garner an actual contract. Someone left when he did not use her, so I was given her place. That was often how it worked. So, by July 1974, I had a place in the corps of ABT.

Very early on I was given roles of the Friends in *Giselle* or *La Fille mal gardée* or whatever ballet had dances for four to six dancers. It was when Rudolph Nureyev came to stage *Raymonda* that things took a turn for me. He picked me to learn a pas de trois that soloists and principals were doing, and he wanted me to understudy the two girlfriends who each had a solo in the ballet as well as danced pas de deux with Clark Tippet or Charles Ward. I believe in the cast I was learning the alternate men were Kirk Peterson and Charles Maple or Warren Conover.

The idea was now in Lucia Chase's head, and I was given the peasant pas in *Giselle* eventually and the pas de deux in Eliot Feld's *At Midnight*, which I danced with Terry Orr. All this while I was still in the corps.

Then Mikhail Baryshnikov staged his *Nutcracker* in which Jolinda Menendez and I were able to perform the Snowflake lead girls for the telecast. Finally came *Don Quixote* in 1978. During the previous summer Misha had been piecing it together. I was available along with several others to work during our layoff. This was something that I relished, but it was apparently not supposed to be done as it was against the union rules to work for nothing. I tried to make the point that it was our summer layoff and that I felt it was my decision what I should or should not do during my time off. Nevertheless, Misha had taught the flower girl's variations to me, and I suppose what I remember mostly was him saying to Elena Tchernichova, one of our ballet mistresses, that he had no idea that I could do some of those enchaînements.

Well, standing on the sidelines in the corps is not conducive to being seen in any other light. I think it was a turning point for me as both Elena and Misha then pressed Lucia to allow me to be first cast flower girl. I think they tried several others in the place as well, but I had a good day when she watched, so she had a hard time refusing. By now I had been in the corps for four years and had done most of my demi and solo roles without too much embarrassment.

Don Q was to be my good-luck charm. Later that year, Jurgen Schneider, our ballet master, suggested that I should just keep an eye on Kitri and quietly practice it along with Patrick Bissell, who should do the same

with Basilio. This paid off in April 1979, as none of the dancers playing Kitri were able to dance on April Fool's Day in Washington, D.C., and I was rounded up to do act 2 with Marianna Tcherkassky doing acts 1 and 3 with Jonas Kåge. Fortunately, I did not let the side down and had a good time doing it, though I knew act 2 the least well of all.

This afforded me the opportunity to request that I learn the entire ballet officially so that if this happened again, I would be further prepared. I think Lucia responded that, of course, I could learn it, but don't expect a performance. I was discouraged that after all I had done, I was still in the corps, but was happy when in the summer I was promoted to soloist. Misha left around this time to go to New York City Ballet. I was happy for him, but it was bittersweet because I thought that my champion was leaving.

During September 1979, Natalia Makarova was injured and I think Gelsey Kirkland was unavailable, and Anthony Dowell suggested to Lucia that I do Kitri with him. This was at the Metropolitan Opera House and in a season where I was also to do Myrta in *Giselle* plus a huge amount of other work as well as my corps duties. With no dress rehearsal (to be honest, after dancing several other roles in the ballet, it did not really matter to me), I was dancing my first full-length ballet on the Met stage in New York City with one of the world's most celebrated dancers.

The experience was fantastic from the curtain up. Dowell was wonderful. So supportive and helpful. Here was this great man who had danced with so many wonderful dancers, and he never once said that I should do this like Natasha or Gelsey or anyone else. He made it fun for me, and I believe we had a good rapport. The corps de ballet sent me the most gracious note and floral bouquet saying that I gave them the feeling that anyone can do anything with hard work and that I was their inspiration. That was one of the nicest things that was acknowledged and recognized. Needless to say, the experience was terrific, and although the ballet is more than just a killer, it was fun to do with the support of everyone around me. In between this, I was given the chance of dancing in Japan with Fernando Bujones. He had seen that I wanted to do more, and I will always be grateful for his help in allowing me to be his partner on guest appearances.

In 1980, Natasha decided to stage the full-length *La Bayadère,* and again she had to convince Lucia that I should do Gamzatti in the first cast

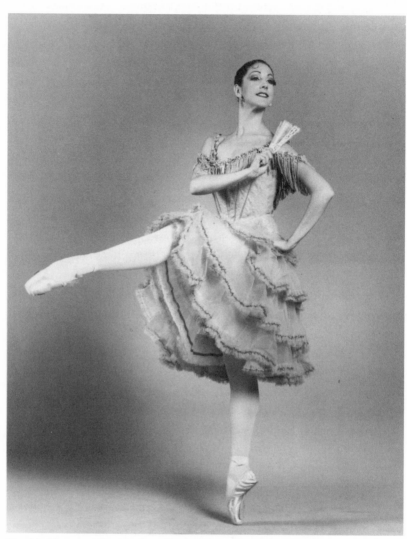

Cynthia Harvey as Kitri in *Don Quixote*. Courtesy of the artist.

alongside Anthony Dowell as Solor and herself as Nikiya. I had no previous feel for dramatic parts, and Natasha worked very hard to get me to understand jealousy and desperation. She was a huge influence. Anthony Dowell had a history of a shoulder problem, and in reality Gamzatti probably should have been danced by Cynthia Gregory or Martine Van Hamel first, but luckily my height suited him better.

At the same time, Kirk Peterson was trying his hand at choreography and used me along with some of the others at ABT to demonstrate his talents. This was vital in my early days. Here I had someone taking a special interest and creating things on me that expanded my horizons. When Misha returned to ABT after his time with NYCB, things would be very different. I believe that Misha felt that hard work and respect to him would have its own rewards—OK, and maybe a little talent. I owe a debt of gratitude to him that I only hope he realizes. He has immense integrity in his ballet knowledge and onstage. He taught me so much not simply by things he said but by example. I have often felt that although the public might have been tired of seeing me, Robert La Fosse, Susan Jaffe, and Cheryl Yeager dancing so much, Misha was of course trying to put his mark on the company, and we were malleable, open-minded, and hard workers. I benefited the most as I was able to dance with him a great deal first as a replacement for Natasha in *Swan Lake*, the day after I made my own debut in the role opposite Ross Stretton, and later dancing with him on the Baryshnikov and Company tours as well as with ABT. Finally by his approval in my dancing Kitri opposite his Basilio for the video of *Don Quixote*, I was given a secure place in ABT and in 1982 a promotion to principal status. By then, I had danced seven full-length ballets. So I was never an overnight success.

Regarding memorable performance experiences, where to begin? Having had a long career and a short memory means that others may be better equipped at recalling things for me. Anyway, there have been several memorable times. My first *Don Q*, for previously mentioned reasons. My first *Swan Lake* was at the Kennedy Center in Washington, D.C., and up until the day before the first performance, I was rehearsing on my own with no partner, as Ross Stretton was still legally with the Joffrey Ballet. Every now and again I would borrow someone to do the pas de deux, but on the whole I had no idea of continuity until the performance itself.

I did have inspiration, though, in the person of Elizabeth Taylor, who sent me champagne and a great note. She was performing in the theater next door to the opera house. I told Miss Taylor how anxious I was—feeling unprepared—and she was downright encouraging in assuring me that I had waited my whole life to do *Swan Lake* and that I would be fine. How did she know that would have a great effect on me? I can't say that I enjoyed the performance, due to nerves, but at least I was not booed off the stage.

Some career highlights include guesting with Stuttgart Ballet and being coached by Marcia Haydée as Juliet in the Cranko version of *Romeo and Juliet*. It was flattering to be asked, as I was not exactly known for my dramatic interpretations. I seemed to have been generally well received in Germany, where they had no previous expectations of me. My first *Sleeping Beauty* with the Royal Ballet with Jay Jolley, a friend and American colleague, was special to me. I was given some coaching by both Dame Ninette de Valois and Sir Frederick Ashton. I felt comfortable and excited about doing this ballet. I suppose the heritage inspired me, and one knows when something suits one, as they say in England.

Guesting with Julio Bocca in Argentina was amazing. He is a national hero there and is treated as such. That treatment extended to me as did some of the flattering adulation. Dancing with Julio was always terrific because of the energy and the commitment he put behind everything. Also, he would get so many curtain calls that I could rest just that little bit extra before starting my solo. Same applied to Misha and Fernando Bujones. When I danced *Giselle* for the first time, I knew that Anthony Dowell was out front and that Natasha had given me some wonderful clues on act 2.

Finally, I recall my last performance with Wes Chapman in San Francisco for the Opera on the stage in *Die Fledermaus*, appearing in the party scene on New Year's Eve 1996. I danced act 3 *Sleeping Beauty,* and when it was all over, Gary Chryst, who was also appearing, stopped and paid a verbal tribute to me onstage, which was sweet of him and very touching. He arranged that the other dancers, Wes, Evelyn Cisneros, and Tony Randazzo, present a floral tribute to me, which was unforgettable.

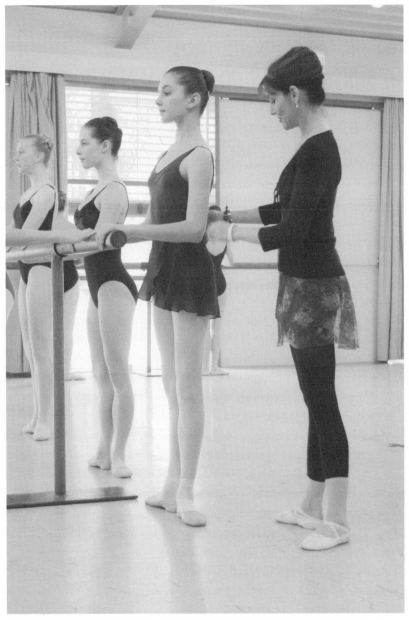

Cynthia Harvey guest-teaching in Australia. Photo by Maxine Kohler.

What is technique?

Technique to me is the detail that is applied to create the ultimate ease of expression.

How might you define it?

I'd define it by saying what it is not. Technique is not multiple pirouettes or high extensions. It is the accuracy of the classic vocabulary.

How do you go about imparting it?

First, I try to draw upon the years of methodology or training that has been influential upon my own path of knowledge. This includes ideas and concepts acquired from teachers with whom I have studied. I feel that one has to show a young student how to stand properly. Then it is important to show them what is beautiful and, conversely, what is not. There is little chance of facilitating the beauty without maintaining their posture and placement.

I tell students that it is not worth doing a class if they plan on cheating or taking the easy way out to avoid the work involved to get the pure and honest result. There is a constant assessment of the individual and how they adhere to the combinations and corrections. From observing the students I can make adjustments to the way in which I may be teaching certain areas of the work.

Is there a difference between skill and technique?

There is a difference between skill and technique. One can be skilled at jumping (and, I might add, not be a dancer). To be an able contortionist is a skill. As a dancer, it helps if you have a skill that can be utilized, but that alone won't enable your technique. Insomuch as one has a skill pertaining to a particular type of dance, they only interconnect if that skill has a requirement within the style of the piece.

What do dancers need to learn to master technique?

Ideally, a dancer must be able to focus and listen. They need to learn the difference between correct and incorrect in order to have an aesthetic sense. Although one wishes to create an illusion when dancing, one cannot avoid the basics. Those basics enhance the illusion. Practice must be foremost to make the difficult look easy, and a student needn't be afraid to take measures to further their technique.

I think that another less considered aspect is that a dancer needs a

strong core to move from and to understand how to move from that center. The upper body needs to be free of strain in order to move in a manner that allows the dancer to be liberated. That, in turn, enables them to move quickly and accurately when required. The arms and the shoulder area should be relaxed as well. Using space is important, but it must be done dynamically and with no effort.

Musicality is hugely important to impart the dynamics mentioned above. Musicality (and let's not neglect rhythm) is one of the most important aspects in acquiring the appearance of a strong technique.

What part do interpretation and presentation play in acquiring a good, solid technique?

In the beginning of a student's learning process, it is not always easy to play with interpretation or have the confidence to present oneself. Emphasis is often placed on technical ability in the early years. Introducing students to live dance performance offers them a chance to use their imaginations with regard to how they might interpret the same piece. This virtue takes place over time. Eventually, you cannot overlook the presentation, and for the advanced student, you must try to allow them the freedom to express themselves within the confines of style. By the time a dancer is ready to join a company, the technique and presentation/interpretation must be intertwined.

What should a good teacher be expected to do?

The job requirements of a good teacher vary in the school or company with which they are associated. Lesson plans are usually expected of vocational schools, and they must meet the criteria of the government and other funding bodies, as in Europe. You can plan all you want, but when you arrive in the studio and you see a student struggling with a problem, you cannot simply say that you must move on from that area and return to the plan.

It seems to me that it is important for the teacher to impart a sense of joy to a student. A dancer should be allowed some independence of thought to empower them so they understand how to achieve what they are striving for. I would hate for a student to fail because they could not think for themselves.

It is not bad practice to be nurturing and to try to consider how the students are feeling. Another thing a teacher can do is to learn from students. Often I have had the opportunity to observe dancers or students

practicing on their own, and they have found a kinetically sound solution to a problem that I could not necessarily discover myself. This is like a lightbulb going off. A teacher should also try to introduce to the dance student as many other art forms and life aspects as possible and use examples of how they pertain to the world of dance. Differences in musical rhythms and styles should be taught to a student.

Although one should teach a general class to a group, a good teacher should celebrate and find individuals' personal strengths. The learning process never stops for the teacher or for the dance student. Finally, a teacher must listen and observe.

What are the challenges that students most often face?

In this world of instant gratification, one of the challenges I see students facing is the feeling that they must acquire some sort of perfection of physique and technique within a very short space of time. Dancers can lack the patience now to apply themselves—and parents too often place a great deal of pressure on them (and the teacher) to move their child to a higher level before they are ready.

With the constant need to focus on corrections, the student can become negative, which is not conducive to further development. Ambition to be famous, as opposed to being the best you can be, seems something of a misinformed target to some students.

What are the challenges that teachers most often encounter?

One challenge that a teacher can have is keeping a balance between giving too much of themselves and offering the dance student the opportunity to think independently. A student shouldn't be mentally indebted to a teacher. Another challenge is trying to get parents to see that you are perhaps better placed to understand the difficulties and requirements to be a dancer than they are.

There are challenges in any profession where you are in charge of a young person's mental well-being and progress. There are limitations in trying to help a student due to imposed health and safety rules.

A great challenge in the community dance scene as opposed to the vocational dance world is the lack of pianists willing to accompany the dance class. The spontaneity that a live accompanist creates is so beneficial to a student. I believe that having a class pianist teaches a student to really listen.

Ultimately, having enough time is the greatest challenge of all.

How do you bring families into the process?

There has to be inclusion. As a teacher, you need the parental support, and more importantly, the student needs it. Allowing them to observe their child in performances and classes puts them in a place where they can see their offspring's progress. Periodic assessments are also a way of ensuring that families remain in the picture.

What does a good class look like to you?

A good class can be dependent on mood, and therefore it can be deceptive. Many dancers feel that if they are sweating, aching, and straining, that they are getting a good class because the "blood, sweat, and tears" aspects are tangible. For me, a good class is one in which there is a progression in the warm-up. The barre work should begin somewhat slowly and move toward the center practice with challenges that can include aerobic activity. These movements should not be placing an inordinate amount of shock on the body.

A good class is one whereby the body gets warmed up from deep within the muscular and skeletal structure and not superficially. There should be a large consideration toward rhythmically interesting and dynamic enchaînements. A good class is inclusive of participation for students to assert themselves and not so rigorous that they cannot achieve any part of it. A good class is one in which the teacher is not competing with the students in any way.

Who were your favorite teachers, and how did they help you?

I had two favorite teachers. My original teacher, Christine Walton, and later David Howard were big influences. Christine had the most amazing open-mindedness as a teacher. She was always looking for ways, not always conventional, to get her students to achieve a result. She gave the impression that she was also learning and desiring to learn. She taught me about beauty of line and movement. She taught me that cheating wasn't an option to achieving the ultimate result. I believe her ethos of honesty and purity is worth fighting for in the class in order to make a better dancer.

David Howard taught me to really dance. He saw that I was considerate and careful. He pushed me to take risks. He taught me about dynamics . . . to make the things that Christine taught me actually show. There was no point in making the difficult look easy if it also looked boring. David helped me to understand what was required to be more interesting.

He showed by virtue of his exercises that you could play with the steps and timing to make it fun and thus more interesting.

Are technique and teaching evolving?

There are times when I cannot envision technique getting any more extreme. I do think there is a place for pushing the boundaries, and I appreciate a dancer who does this, but never at the expense of artistry. Personally I want to notice and be moved by a dancer rather than be aware of their physical assets alone.

With so many interlinked courses available to dance students now, the job of the teacher should be easier. The teacher can get reinforcement from physical therapists and doctors, who in turn are able to explain and assist students in achieving their objectives.

In terms of teaching, I would like to see more emphasis placed on linking steps such as glissade, chassé, and pas de bourrée. In my travels, I have seen a dismissal of these steps in order to master the bigger steps in the effort, presumably, to gain athletic prowess. This is a shame and actually hinders the motive behind the attempt anyway. I would also like to see that the port de bras is not relegated to the last thing on the list of class considerations.

I hope that teaching continues to be a profession where the art form is passed down through the generations—in order for styles to be maintained. I also hope that teachers are allowed to take the time to get to know their students as individuals and not simply as people who make up the numbers in the room.

FINIS JHUNG

". . . everyone has potential . . ."

Finis Jhung performed with the Harkness Ballet and is currently a master teacher in New York City.

I was born and raised in Hawaii and am of Korean-Scottish-English descent. I started dancing at the age of six, as I liked the wonderful old black-and-white Hollywood musicals that we used to see and decided that was what I wanted to do. I began at a neighborhood school, but never learned a proper barre that I can recall. The only real ballets I ever saw were performed by the Markova/Dolin and Slavenska/Franklin troupes. I remember Dolin doing an adagio solo, *Hymn to the Sun*.

I also learned the hula, which equipped me to dance in public, ranging from dancing the hula at a store opening on Waikiki Beach, to almost falling off the stage when the lights went out at a beauty pageant where I did a pas de trois to *Invitation to the Dance*, to dancing both the hula and

Finis Jhung. Photo by Andrew Terze.

a ballet solo at nightclub parties. At home, by myself, I'd put on *Swan Lake* and dance around the house for hours. I quit ballet in junior high because of peer pressure, but started back again in high school—just a 45-minute class that was once a week—and began with hopping across the floor holding my leg up in second position and then dancing duets that included a little bit of everything. The experience was frustrating, as I couldn't really talk to anybody about my dancing (for fear of being teased) and the training was limited. By my junior year in high school, I knew that I wanted to go to the mainland, and in order to do so, I had to find a university that offered ballet and financial aid. I had never done a full class up to this point.

I got a small scholarship ($160) from the Exchange Club in Salt Lake City to attend the University of Utah's ballet program. What a gift this program was for me—I got to see and take class with Michael Smuin and Kent Stowell. I wasn't good enough to be in the *Nutcracker,* and I can still remember sitting in the audience eating my heart out. But within a few months, I was performing.

Because we were financially strapped, I was forced to stay in Utah and didn't see my mom for three years. However, these were the most wonderful years. The combination of academics and ballet and performing was heaven for me. Mr. C (Willam Christensen) and Barbara Barrie (she was English) were my teachers. Each summer we danced in an opera and a musical. Michael Smuin and I took a 7:00 a.m. ballet class with Miss Barrie, and then earned money by painting university buildings in the hot Utah sun. I loved Mr. C—he was great for men—always had such great gusto and charisma.

I auditioned for Los Angeles Ballet at the Greek Theatre in Griffith Park and didn't get in, but I got to meet Eddie Villella for the first time. After graduating with a BFA, I went into the National Guard and became a PT demonstrator. I ended up in Fort Leonard Wood, Missouri (Little Korea), as a clerk/typist. I was the fastest they'd ever had. While there, I received a telegram from Rodgers and Hammerstein because they needed an Asian dancer who could do double tours in *Flower Drum Song* on Broadway. I quickly got in shape, flew to NYC for a weekend audition, got the job, and returned to the army to complete a few more months of service. The day I was out of the army, I flew back to NYC. I learned the

dance on Saturday and was put into the show the following Monday. The show ran from February through May and then went on the road.

When the show played San Francisco, I was reunited with Smuin and Stowell, who were dancing with the San Francisco Ballet. I auditioned for the company, was hired, and went right into Lew Christensen's *Nutcracker*. I stayed at SFB for a year and a half. At first, dancing there was difficult due to changes I had made with my technique and dancing. I had been studying with Valentina Pereyaslavec, a famous teacher from the Ukraine. I loved her in classes in New York—they were so inspiring. But she demanded textbook positions and finally completely "took me out of my body," and suddenly I couldn't move. Things like double tours, which I didn't even have to think about doing before, became hard. I joined the SFB a technical mess. When I did the ribbon dance in *Nutcracker* with Smuin, I just couldn't balance my air turns. It was terrifying to bounce all over the Opera House stage. I gradually got it back. I found Harold and Lew to be very dry compared with Willam. Coincidentally, *Flower Drum Song* was being shot in Hollywood, and I was asked to be in it. I got to work with the legendary movie choreographer Hermes Pan, and this was another childhood dream coming true—to go to Hollywood and be in a movie.

In 1962, some of us San Francisco dancers (Smuin and his wife, Paula Tracey, and Stowell) felt it was time to move on. James DeBolt, whom I had danced with at Utah, was in New York and knew Bob Joffrey, and I told him that I was very interested in joining his company. I left SFB in Seattle, and Bob Joffrey told me to stay there because he was going to be doing *Aida* in Seattle and if he liked me he would use me. I had to wait a week—at a dumpy motel in Seattle—with very limited funds, which was scary, but it worked out, and Bob put me into the opera ballet along with Helgi Tomasson, Vicente Nebrada, Nels Jorgensen, Gerry Arpino, and a very young Francesca Corkle. Mr. Joffrey asked me to join the Joffrey Ballet in New York. This was the beginning of their Harkness relationship.

One of the first pieces I was cast for was Alvin Ailey's *Feast of Ashes* and also Brian Macdonald's *Time Out of Mind*. All of us were into Joffrey's mind-set of hard work. It was a great time at the Joffrey. Stanley Williams taught us, and we toured to Portugal, Russia, the Near East, Afghanistan, Iran, and India. I want to put to rest the story that Rebecca Harkness

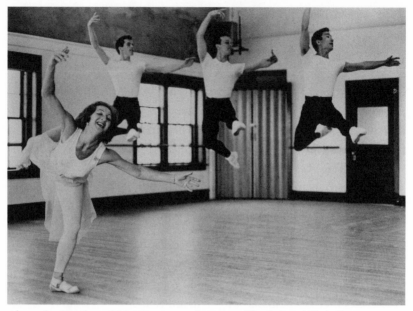

Alexandra Danilova, Helgi Tomasson, Lawrence Rhodes, and Finis Jhung.
Courtesy of the artist.

"stole" the company away from Joffrey. Mr. Joffrey was very picky and
wanted everything very square and could be confining. He had to know
everything about everyone and control everything. Well, we had a small
revolution of our own while on tour to Russia, and lots of people left.
Jeannot Cerroni, the company manager, told Mr. Joffrey we were leaving,
so it was not a surprise. Harkness was willing to make a company for us,
which included Helgi, Vicente, Larry Rhodes, Lone Isaaksen, Brunilda
Ruiz, Marlene Rizzo, Suzanne Hammond, and others.

Erik Bruhn was a guest with us, and he was my mentor. I learned how
to properly do makeup from him, and I watched how he warmed up for
each show. He was incredible, and he has informed my teaching. Later,
when I taught in Denmark, I learned why Bournonville choreographed
the way he did—the Danes had only a small stage, and there was no place
for them to go. We had the good fortune of working with choreographers
like John Butler, George Skibine, and Ben Harkarvy, but ultimately we
didn't have a good enough repertory. I danced with the Harkness Ballet
from 1964 to 1969, and I served as the company's "exotic," but I really
wanted to dance "white tights roles," too. Smuin told me in 1956 that that

would never happen because I was short, bow-legged, and Asian. However, on tour to Barcelona in 1966, during a shiatsu treatment, the masseuse told me that my wishes could come true if I started practicing Buddhism. So I did, reciting a mantra every morning and evening. I started to feel better, and this became sort of a turning point. *Dance Magazine* did a biography on me, and gradually things got better at Harkness Ballet. I went to Mrs. Harkness, asked to be promoted to principal dancer, and got it. Anton Dolin gave me a break, too, by giving me the pas de chat variation in *Variations for Four*.

In 1967, David Howard was brought to the United States to learn the Joanna Kneeland Technique. David's RAD background allowed him to translate her work and make it acceptable to us. We did a therapeutic barre and started to learn her movement principles, including spiraling and opposition. While in Monte Carlo, David became our company teacher. I also got to take a private class with him every day, and he would come back after performances and give me notes. I was so lucky, because with David I rediscovered my own body. During this period, I was a devout Buddhist and I decided I should devote my life to world peace. So, in 1969, after our New York season, I quit dancing and worked as assistant to a private investor, taking and typing letters. In order to test my faith and prove that I could be happy being just an ordinary person, I burned all of my stuff from my old life, including films of Bruhn dancing. I was happy to do so, because I felt I was doing something useful—devoting my life to world peace.

In 1972, I had to get another job, as my employer closed his office. My Buddhist leader suggested I teach, so I contacted Wilson Morelli, who had a studio downtown. I found I had to relearn ballet from books, as I couldn't remember the names of steps. I started off with four students. Then dancers from Paul Taylor and the Joffrey started coming, and others like Billy Forsythe and Martine Van Hamel, and the numbers grew. Two years later, I moved the studio to 72nd Street. At that time, only David and Maggie Black had their own studios; there was no Steps. Gelsey Kirkland tried my class, and soon many ABT and City Ballet dancers were coming over. I took over Maggie's old space, which is where Steps is now located. And then I made a final move to a beautiful loft on Broadway and 77th. This space relates to the IBC, as it turns out it was originally Thalia Mara's New York studio. Her daughter told me this. They used to make tutus

in there, and now I understand why pins would stick up between the old boards and prick the dancers' feet during class. The 1970s were good years. I married a Japanese woman who was also Buddhist. Our first child died in infancy; our second, Jason, is now 30 and works in the production department at Major League Baseball.

Feeling flush with the success of my studio, I began a chamber ballet company that lasted from 1982 until 1986, and I put $100,000 of my own money into it. The best thing I can say about this experience is that three couples from the group got married and are still married with children. Our final performances were of *Napoli*, *Sunflowers*, and *Flames of Paris*, plus new choreography by my company members. The mid-1980s were harder. I was divorced, my ballet company had to fold, and my studio rent kept increasing. I was fortunate that Richard Ellner, the owner of Broadway Dance Center, invited me to join the faculty. This turned out to be a good move. *Jerome Robbins on Broadway* came out at this time, and so many people showed up to take classes that they had to take a number.

I would characterize my teaching style by stating first that I believe that everyone has potential, that there is an answer to every problem, and that the teacher's job is to give people the key to changing themselves. A great part of my teaching is all about working correctly with the standing/supporting leg and using the supporting side of the body to initiate movement. I encourage students to become more confident by better understanding how their bodies work and move in space. In my instructional videos, we sometimes work on things in slow motion and use the concept of spiraling for teaching pirouettes. I also encourage students to look at steps, not in isolation but as one continuous motion.

At the same time, life is getting faster. We must learn to dance faster in order to keep the public's interest. Balanchine was right; we must dance faster—and bigger. Dancers (and the audience) need the exhilaration of moving rapidly through space. I have spent hours studying Mikhail Baryshnikov in slow motion video, and he never stays static—he's constantly spiraling, constantly moving. I thought, "Why not teach this way?" Everything in ballet is truly en dehors; all movement is equal and opposite. As long as you have a left side to equal a right side, you will never lose your balance and fall. I believe that if dancers learn the preparations, the right one will execute the position. I also like to think in terms of verbs, of the action. To me, the word *plié* is not a static position; rather, it means to

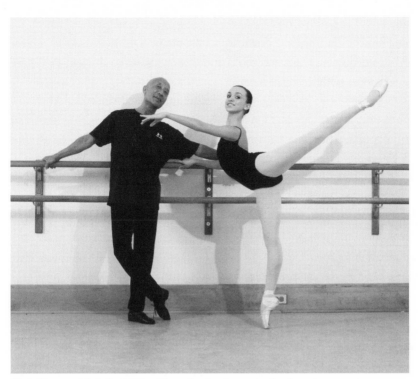

Finis Jhung with Saige Miller. Photo by Stephen von der Launitz.

bend your knees. So, when working on turns, I always say to push down on turns. Recall the way a toy top is set spinning: It turns when you push down on it. So it's pushing, spiraling, turning. By revealing the truth of the action, I hope to enable dancers to develop technique that is beyond emotion. They can dance with freedom because they have trained their muscles correctly. It doesn't depend on how they feel; they will dance well in spite of themselves.

I was pleasantly surprised to be asked to conduct the Teachers' Workshop at the USA IBC. I'm not a keeper of the flame—not a Cecchetti or Vaganova syllabus teacher. I look outside the box. We know how bodies move in space. Placement and learning all the preparatory movements are two of the biggest things I focus on. I've found that most teachers are too nitpicky about the wrong things. And some have axes to grind—none of which has anything to do with their students. We all need to look for the big picture. I should jokingly say, "They need to take my workshop."

I like Broadway theater. I enjoy watching great actors. Dancers need to

go see Ralph Fiennes onstage. I very much like to read, particularly about people who do things and who solve problems. I go to museums. I have an adult son who is a great friend and helper, and special friends who are lovely to be with.

Teachers need to be enablers. Proceed organically. Look at what you have and work with it. Don't inhibit your students. Don't be afraid to think outside the box. Be constructive. Do lots of port de bras in class to get the body moving. Above all, remember that ugly ducklings do become beautiful swans. Don't be afraid to let your students be ugly as they experience the movement. "The journey of a thousand miles begins with but a single step" is one of my favorite Buddhist sayings. Also, "Let us begin from this moment on."

FINIS JHUNG ON TEACHING TECHNIQUE

What is technique?

It's a specific way of doing something that brings the desired results.

How might I define it?

Technique is beyond emotion. Being able to balance, turn, and jump should be "in the muscles." It's not the weather, it's not the music, it's not what you're wearing—it's you. Either you know how to do it or you don't. And when you have such a technique, then you are free to develop your artistry.

How do you go about imparting it?

I have formulas for balances, turns, and jumps. I try to give explicit directions. For instance, you may not know a thing about cooking, but if you follow a good recipe to the letter, you will cook a fabulous meal. I give recipes for movement: Here are the things you need to do in order to turn, and this is the order in which you do them. Follow the instructions to the letter, and you will be successful.

Is there a difference between skill and technique?

A skilled dancer is someone who is an expert in movement. This is a dancer who has acquired a degree of proficiency through training and experience. A skilled dancer displays a mastery of technique. The dancing is easy and unforced, and it flows like water. Further, a dancer with great skill displays remarkable artistry.

What do dancers need to learn to master technique?

First of all, a passionate hunger to learn—a strong desire to learn everything there is to learn about the art of ballet. Technically, a dancer needs to learn proper posture, placement, and alignment and understand mechanics and physics (how movements are made), muscular involvement, use of energy and weight, and timing. Artistically, a dancer needs to study acting, look at lots of pictures of dancers, and watch videos of great performers.

What part do interpretation and presentation play in acquiring a good, solid technique?

All ballet dancing is designed for the stage. Having a performance outlook goes hand-in-hand with acquiring a solid technique. I tell my students that the only difference between working in class and dancing on the stage is that when you perform you are wearing a costume and dancing in front of a paying audience. Otherwise, it's all the same. There should be no difference in the way you dance in class or onstage. The classroom is the stage. Dancers need to work at the same energy and projection level that is required for performance.

What should a good teacher be expected to do?

The job of the teacher is to enable all students to attain their personal best. Every technical and artistic difficulty must be overcome. It is the job of the teacher to find the answers to the "unanswered" questions. The teacher is the problem-solver, and must find the way to unlock the secret potential in all students.

What are the challenges that students most often face?

It is the job of the student to prepare all movements. The audience sees the results. Too many dancers today rush to display the results—a high battement, multiple turns—and ignore the preparations that produce these results. As a result, they look like they are "dancing on top of the floor," and their movements lack weight and balance. Students need to investigate and master all preparatory movements.

What are the challenges that teachers most often encounter?

My main experience has been teaching "open" classes in major New York City studios. Students don't need to register for these classes; they can attend whenever they are able. The level of students is always mixed. You may see some students several times a week and others once a week

or once a month. As a result, I concentrate on the basics. Through the years, I find myself simplifying more and more, paring the class down to the essentials. In each class, I try to make sure that the majority of the students have understood at least some of the preparatory steps for turns and jumps and going across the floor. I approach each class as an adventure into unexplored territory.

How do you bring families into the process?

Since I have mostly taught open classes to professional and amateur adults in NYC, my only experience with parents is when I have given private lessons or when I teach workshops out of town. With private lessons where the parent observes, I will often ask the parent whether or not she (it's usually the mother) can see the difference as the student applies my corrections. I will then sometimes give instructions to the parent, as then the parent can help "coach" the dancer when they return home. I try to make sure they agree with what I'm asking the dancer to do and whether or not they understand the process. It's important that we're all on the same page and working together. For instance, I just coached a young man who is going to London to play the lead in the hit musical *Billy Elliot*. We mainly worked on grande pirouettes, which he really hadn't done before, and I felt like I was teaching both parents. I kept asking them whether or not they could see the difference in what he did after I corrected him and whether or not they understood my instructions. He lives out of the city and practices in his home studio. His parents have been able to help coach him at home.

What does a good class look like to you?

Everyone follows my instructions and improves after each session of analysis and correction. At the end of class, they are visibly happy and exhilarated and leave with a smiling "thank you."

Who were your favorite teachers, and how did they help you?

Rosella Hightower was the first teacher I saw who didn't stand with perfect turnout and had a very low-key manner. She kept speaking of "équilibre" (balance). She seemed to be feeling her way through her body and balancing herself as she taught. She spoke calmly, with a soft voice. She was introspective. She seemed to always be testing her weight and balance. This approach is a large part of my teaching today. I keep asking my students whether or not they can release the barre and get off the heel

so they are ready to relevé. I always ask them to do part of each exercise without using the barre. To me, it's all about balance. You're either on your leg or off your leg. You either stand up or fall down.

Are technique and teaching evolving?

Technique and teaching have improved through the years, as many good professional dancers have become dedicated teachers and set higher standards for their students. Most dancers from serious schools are well placed and technically equipped. However, I do find that a lot of these talented and technically proficient dancers lack artistry and projection. Perhaps it's a reflection of the culture of our times. I see a degree of coldness, an indifference, in some performers which I find hard to believe. But there they are, onstage in New York City, dancing as though the paying audience doesn't exist. It's amazing. If I were the director of that company, I would never allow that to happen.

RONI MAHLER

"... set yourself up to be happy."

*Roni Mahler has been a principal with the
National Ballet of Washington, D.C., and a
soloist with American Ballet Theatre. She is
on the faculty of the Juilliard School.*

I got started in ballet when I was six. My mother took me to study with
Madame Maria Yurieva Swoboda in New York City. Madame Swoboda
eventually sold her school to the Ballet Russe de Monte Carlo, and I later
joined the company.

My first professional performance was so very memorable. We were
beginning our tour in Los Angeles, and I was making my debut in the
corps de ballet in *Les Sylphides*. Waiting onstage before the curtain went

Roni Mahler. Photo by John Gerbetz, courtesy of Ballet San Jose.

up, I'll never forget the air of magic created by the sets and lights and costumes.

By creating the chance for me to dance character roles, Dennis Nahat has given me a second career, first in Cleveland and now with Ballet San Jose, where I also function as his artistic associate.

Madame Swoboda recommended me as a teacher to a studio in Wilmington, Delaware. I took the train every weekend to teach two classes. Sometimes I was also asked to substitute at the Ballet Russe school.

I like teaching at dance conventions. I feel lucky to have been given really good information from the day I started ballet, and I want to pass it on, if it can help.

My teaching recordings were an extension of that thinking. I made the LPs in two versions—one with music only and one as a spoken class. Harriet Cavalli would choose the music, and I created the exercises. I find the value of the spoken class is that it would take teachers nearly a year to get through the entire set of ballet exercises.

I've run into people in many places who remember me from these records, including someone who was in line behind me at the airport.

RONI MAHLER ON TEACHING TECHNIQUE

What is technique?

Technique is the vehicle that moves you around the stage so that you can communicate with the audience. It gives you the freedom to dance. It serves as your "wheels."

How might you define it?

Freedom. When it's really good, it makes the dancer free. When not, the dancer struggles. It's great when I, as an audience member, am not worried about it. It's a sense of line, of how *not* to make a high extension look or seem disjointed and disturbing. You can have an extraordinary facility but not register with the audience. Your dancing needs to resonate with them. Facility is not technique; it fades.

How do you go about imparting it?

It has to be individualistic. Everybody is different. A true teacher knows how to guide every different body—to stand up, not fall down— and to make people care about what you're doing onstage. Many are not

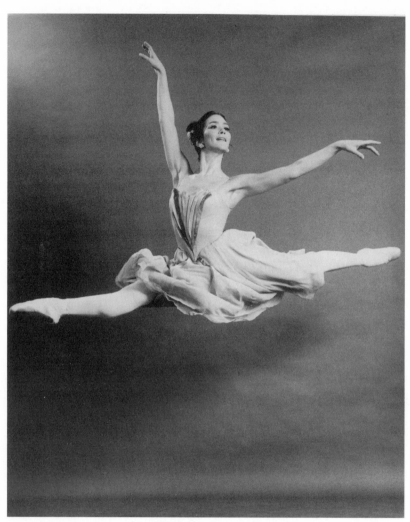
Roni Mahler. Courtesy of the artist.

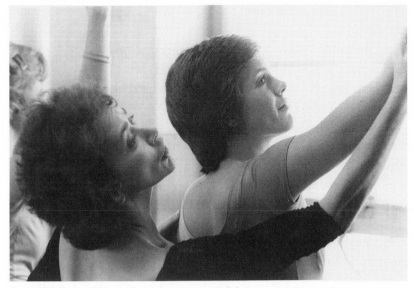

Roni Mahler working with student Jonna Bolah in 1974 at Kansas State University. Courtesy of the artist.

schooled in the use of upper body, and this can be disappointing onstage, as the upper body shows you what to look at underneath. Otherwise, dancing becomes the Olympics. So you can do triple tours and entrechat huit, but let's stay away from making it gymnastics.

Is there a difference between skill and technique?

The patina comes from years of being in ballet class. When I was teaching at Kansas State in the mid-1970s, a gymnast came to me two weeks prior to her floor exhibition wanting help. I said OK and had her follow me in a simple walking and port de bras exercise—two steps for each position of the arms; forward, up, side, down. Her arms were like two sticks—no connection with her chin or center. I told her the only way to help would be to enroll in Ballet 2, which met twice a week for sixteen weeks for thirty-two sessions. If she did, she would begin to have grace, but there was no way to give this to her quickly.

It's a process of osmosis—better arms, head, hands. It has an effect on people, and you cannot quantify it or schedule it. Looking and being balletic means having the right carriage and grace. Some students soak it up,

while others don't. And if their teacher doesn't have it, they're soaking up the wrong thing.

What do dancers need to learn to master technique?

Music is very important. I believe every dancer should learn how to read music and play an instrument. And they need to learn how to create staccato and legato with their bodies.

Focus and physical intention are also essential. Demi-plié is the "secret ingredient." An awkward glissade often means an ill-timed demi-plié. And you have to really cover space at the same time you are sculpting the limbs and working on turnout, balance, and coordination. You can't "add on" the moving later. Starting to move on count 8 is critical. I like to say, "Eight or be late." And a double preparation can become intrusive.

What part do interpretation and presentation play in acquiring a good, solid technique?

You don't have to start interpretation young. It's best to work on coordination of head, arms, legs—and that's enough for young dancers. You build on the ability to move and coordinate and then perhaps give them small solos that make them think differently. Maria Swoboda also taught us character dancing. Everyone needs it. Teachers need to carefully choose interesting performance pieces for their students at the right time. Madame Swoboda did this for me, and I gained so much from it.

What should a good teacher be expected to do?

I never prepare a specific lesson plan, yet I often notice that exercises and combinations somehow seem to relate to one another in a way. For example, it seems that suddenly it has become "rond de jambe day." I look at what seems to need work. It's important to create exercises that will push and challenge. These need to be tempered with "feel good" steps.

What are the challenges that students most often face?

I see swayed backs and misaligned pelvises. Students need to work on demi-pliés in fifth position that don't "roll in," especially the back foot.

Barre should be used to prepare the standing leg for control and balance in the upcoming center work. Try not to take class with a head that is always staring straight ahead. Hyperextension of the legs is a big issue. Proper pelvic alignment, perhaps coupled with certain Pilates mat exercises (which worked wonders for me) can help retrain the legs to pull up before they lock back.

Passé without sickling the foot is another challenge. And you cannot dance without a strong back. The trick is giving both barre and center work that actually build that.

What are the challenges that teachers most often encounter?

Not teaching only the most talented students in the class but giving your attention to all. Not trying to change lazy, unfocused, or argumentative behavior. Focusing on those who've come to learn. (Sometimes the others eventually come around.)

The pace of the class is equally important. I don't like taking the time to show an entire exercise "a tempo," so my students—and pianist—know that I demonstrate a combination quicker than it is.

How do you bring families into the process?

You've asked the wrong person. I don't deal with parents, as I have trouble being diplomatic. I don't run a school because of that. But I do know that having a shield such as a registrar or a front desk person to be the first person they go to with questions and concerns is critical.

What does a good class look like to you?

Where everybody is busy all of the time and where they are both sweating *and* smiling. You have to set yourself up to be happy. A professional dancer is probably going to be in daily class for at least twenty years, so know that not everything is going to work perfectly every time. Don't get into a funk if something is not perfect. Be and stay positive—and don't give up.

Who were your favorite teachers, and how did they help you?

Maria Swoboda trained me, and I'll always consider her my main teacher, although I did begin to take classes from others later. She prepared me to work on my own and gave me so many great life lessons. She was a good teacher, but she could be cruel. She developed excellent coordination of our arms and legs as young children. Because of her style, as much as I loved her, I resolved to be the anti-Swoboda in terms of my own teaching approach.

Edward Caton scared me to death, but he got me to work. Bill Griffith was another notable teacher. I still use combinations that he and Swoboda gave in class. When Dennis Nahat brought Griffith to Ohio to teach the Cleveland Ballet in the mid-1980s, I was lucky enough to take his classes from a teacher's point of view.

Then there was Freddie Franklin, who could simply *will me* into being able to do successive arabesque turns. And how musical. Watching him teach a role is an education in itself.

Are technique and teaching evolving?

Today's dancers are more athletically amazing than ever. But then there is always the issue of dramatic interpretation, nuance, phrasing, subtlety . . . artistry, if you will. I think the thing we want to avoid is "doing class onstage." That means training the top of the body right along with the bottom and right from an early age.

DAVID MORONI

". . . reminding them of dance's artistry . . ."

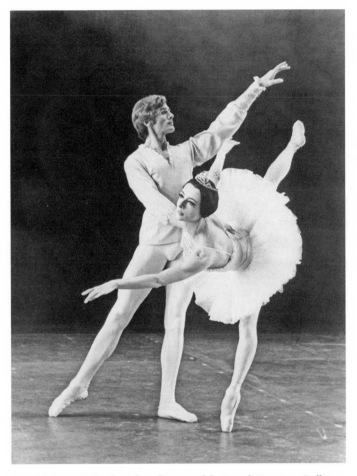

*David Moroni is the founding director of the Royal Winnipeg Ballet
School, Professional Division.*

David Moroni and Christine Hennessy in Todd Bolender's
Donizettiana (1968). Photo courtesy of Royal Winnipeg Ballet.

I started ballet when I was 11. The family next door was involved, and I was a fairly athletic child—and I liked to jump. I loved my first class right away with my teacher, Nesta Williams Toumine, at her studio in Ottawa, which is where I'm from. Toumine had been with Léonide Massine's Ballet Russe de Monte Carlo, and both she and her husband, Sviatoslav Toumine, brought a great deal to the city. My early training was Cecchetti, and it was hoped that the Toumines were going to form a professional company, but it never happened. So I auditioned for all three Canadian companies: Les Grands Ballets Canadiens, National Ballet of Canada, and Royal Winnipeg Ballet. I chose RWB, where I was a frequent partner of Christine Hennessy, who had come to us from the Joffrey. We developed quite a partnership and, in fact, medaled in 1968 at the International Ballet Competition in Paris. RWB won gold as the best company.

Some of the highlights of my performing career include getting to work with Agnes de Mille in her ballet version of *Brigadoon*, which she called *Bitter Weird* here. I was the minister in her *Fall River Legend*. Agnes was not just about steps but about the total dance/drama/theater package. I also worked with John Butler and Brian Macdonald. I had the lead role of Herr Drosselmeier in John Neumeier's French-Canadian *Nutcracker*. This was very fortunate in my transition from dancer to teacher, as it kept me in touch with performing. At first I thought it was going to be mostly a walk-on part, but at the first rehearsal it became clear it was going to have actual dancing in it. Fortunately, I had been taking class every day since retiring from performing. In fact, they saw me in class and asked me if I'd be interested in doing it, as all the other parts had been cast. I did it for several years, and it gave me the opportunity to really develop the role.

About the Royal Winnipeg Ballet School: Arnold Spohr, the artistic director, and the board realized they needed to develop their own dancers. I always thought I'd be more successful as a teacher, and in 1970 I began to develop dancers for the company. Developing dancers is a slow process, and I wanted a group to be ready that first year. We started with 10 girls and 10 boys, then developed lower levels and met in the middle.

Our Professional Division training is based on the Vaganova syllabus, and we were fortunate to bring in the great Vera Volkova, who became the teacher of my life. It was like a thunderbolt. My first class with her, I was so tense. She told me just to relax, and we hit it off right away, because

David Moroni, C.M., founding director of Canada's Royal Winnipeg Ballet
School, Professional Division. Photo by Bruce Monk, courtesy
of Royal Winnipeg Ballet.

she felt I understood her. I have reams of notes about her teaching. I im-
mediately wanted to write everything down. To this day, I still travel with
the notes all the time.

RWB School has two divisions. The Recreational section is very popu-
lar. All the teachers are qualified in Cecchetti. And the Professional side
is largely the Russian syllabus. At first, having a professional school was
such a tremendous challenge. There was no infrastructure from the be-
ginning, and now we have a beautiful building with 10 sprung-floor stu-
dios and a residence that's connected by a skybridge.

Our students have done very well. Evelyn Hart won gold and the grand prix medal at Varna in 1980. David Peregrine won bronze, and our pianist, Earl Stafford, won gold. Fouettés were not Evelyn's "thing," and so she didn't do them in her Kitri's variation from *Don Quixote*, and the jury panel was curious about that but thanked her for reminding them of dance's artistry—what dance was all about. We had no idea we would win anything, so it was doubly exciting and rewarding.

One my favorite accompanists for class was the incomparable Harriet Cavalli, who was one of the best class pianists *ever*. She did it with such gusto and energy. I'd work her fingers to the bone, and at the end of a long day, she was always ready and poised for more.

DAVID MORONI ON TEACHING TECHNIQUE

What is technique, and how might you define it?

It's the means by which dancers acquire movement in the classical idiom—the mechanics of dance, its vocabulary. It's a vehicle through which dancers develop the body to express the music and the emotions through dance. It's very demanding, but must be performed without emanating any of the difficulty of producing it. It must be clear, strong.

How do you go about imparting it?

Volkova's analogies were tremendous. I often use visualizations. An example is thinking of a quiet pool of water and how a pebble dropped will create an expanding ring. Arms can expand and grow in the same way. It's making simple connections. Musicality is very important—a pulse that eliminates the mechanical.

Is there a difference between skill and technique?

Skill is often used to get around technique. Sometimes dancers have a lazy approach to the rigor required to develop technique and try to use skill only. Technique alone is no good either. We need to marry the two in order to get the best result.

What do dancers need to learn to master technique?

Technique calls upon the artist to master a blend of the physical, the artistic, and the expressive components of the art. Here are some outstanding points:

1. A personal sense of discipline, plus an ongoing desire to improve upon the rigorous and demanding rules of the classical tradition.
2. The ability to take corrections, to read and absorb the qualities of the choreography.
3. Having an open approach to new or traditional ballets.
4. Repetition without letting boredom settle in.
5. Maintaining a fascination for movement to music (or otherwise) while remaining the ultimate instrument of physical expression through dance.
6. Being observant, humble, and trusting of those who possess a broad knowledge of the art of teaching and choreography.
7. Developing a healthy sense of confidence and maturity.
8. Respecting the need to attend classes on a regular basis in order to continue to hone all the necessary skills such as flexibility, speed, strength, coordination, agility, musicality, ballon, turns, adagio, etc.

What part do interpretation and presentation play in acquiring a good, solid technique?

Everything needs to be woven together through musicality. The Vaganova system is exacting but with beautiful port de bras. Music moves you through the movement and compels you to bring it forth.

What should a good teacher be expected to do?

It's all-encompassing. All of the factors that affect class dictate how class is taught. I believe you have to clearly have in mind what the focus of the class will be. You also have to consider workload. For example, if I know the company has a particularly heavy performance schedule, I might ease up a bit—not on the standard, of course, but on what might be given.

Tone of voice is important. You can't be screaming at them all the time. You have to know, too, that not everything works for every student. You need to be sensitive and also use psychology: some days it's not the day to pick, while another student may be dormant. We must be caregivers. We are responsible for every student in class, and we need to make some sort of positive connection. You need to know when or when not

to do something. Dancers turn off the screaming. Nurturing comments are better. The teacher is serving the student, not the other way around.

Students appreciate being direct, positive, and honest.

What are the challenges that students most often face?

Rolling over on their arches and turning out too far. Turnout needs to be nudged, not forced. Some bodies won't do it. We need to be realistic about physiques. Students range from those who are tight to those with bodies like Gumby.

How the students approach class is very important, and we need to be sensitive to students' body language without being domineering. Company dancers get very tired. I've got this great Volkova small-jump exercise that's perfect for suddenly waking them up and bringing them into focus. It's in threes but with a port de bras that makes them think. It's fun.

What are the challenges that teachers most often encounter?

Students who are in the wrong profession. As we start so young, teen years can cause a lot of depression or feeling inadequate. Perhaps some students need to be redirected into other idioms. We interview parents to apprise them of body changes as they evolve. It's important to be honest about what you're dealing with.

A big challenge is money. Also dealing with injuries: students should be encouraged to keep their teachers apprised; we are not mind readers. Students should be dancing for themselves and not for their parents or others.

How do you bring families into the process?

The majority of families are very supportive. Most understand that they know very little. The best recognize that their child is learning life skills as well as dance technique. Like academics, we feel compelled to be instructive, and the teachers understand the rules of the game.

What does a good class look like to you?

Where the material has been understood in such a way that it is coming back at you. They understand and apply corrections previously given. Where students generally understand the rules of the game and they are playing by them. When they are prepared mentally and physically—good grooming and dress.

Who were your favorite teachers, and how did they help you?

Volkova brought the truth of the simplicity of the rules of the game. It has to come from the inside—from the music, from the character. Madame Toumine was also very influential, imparting a great sense of drama and theater.

Volkova's analogies were tremendous. She used visualizations. For example, having us imagine a quiet pool of water into which a pebble is thrown, and how the ring ripples and expands. She'd then admonish us to move and expand our arms in the same way. Simple connections. Musicality was also very important to her—feeling pulse, which eliminates the mechanical.

One of our guest teachers was Galina Yorbanova, who brought in Vaganova throughout the syllabus. Julia Arkos (Kirov) had the most beautiful port de bras I've ever seen. There are many decades of experience on the staff, who are truly effective in setting the bar for RWB School.

Are technique and teaching evolving?

There is so much emphasis on technique that we are in danger of forgetting the art. Where there is little respect for technique—often coupled with little respect for the art—it creates an unsatisfactory feeling as well. Let's merge technique and art.

DENNIS NAHAT

". . . ability to transcribe the unseen . . ."

*Dennis Nahat is the artistic director
of Ballet San Jose in California.*

I've been choreographing since I was 11 and had to make up dances as a
student in Detroit. I fell into it more at Juilliard. While I do work at it, it
comes fairly easily and readily to me. I don't have steps in mind in ad-
vance, although I do dream patterns in my sleep sometimes.

I know the dancers, and there is some give-and-take in the process.
The individual steps are not all that important to me. What is important

Dennis Nahat. Photo by John Gerbetz, courtesy of Ballet San Jose.

Dennis Nahat as Mercutio in Antony Tudor's *Romeo and Juliet* at American Ballet Theatre in 1970. Photo by Martha Swope, courtesy of Ballet San Jose.

Dennis Nahat teaching today. Photo by John Gerbetz, courtesy of Ballet San Jose.

is what looks good on the dancers, so I do have them in mind when choreographing. Most ballets I do are ones that I need to do for the company, filling in the needs of the repertory. I have many ideas on the shelf—and have had for years—which are waiting for the right time. I have to weigh the needs of the box office, audience, repertoire, and dancers.

My version of *Nutcracker* is special, as I like to tell the story really clearly. As Herr Drosselmeier, I come out in front of the curtain and explain where the *Nutcracker* came from, its history. In our version, there is no Land of Sweets. Instead, in act 2 they travel from land to land, bringing

the Nutcracker back to his native land. There are 10 scenic changes, and I've added other Tchaikovsky music to lengthen some of the dances. The Nutcracker is actually the transformed son of the Tsar and Tsarina, and they celebrate his return to Muscovy and Marie's bringing him home. I wanted the story to be more realistic, and so I felt more dancing was needed. I prefer to tell the story from beginning to end and include a lot more dancing.

Our mice come out of the woodwork—literally—and include all lower-division children from our school, for about 150 mice total, between all casts. They get bigger and bigger. The production is a collaboration with scenic designer David Guthrie. I've done the part of Herr Drosselmeier for 26 years, and Karen Gabay is marking her 25th year as Marie. And it's the 25th anniversary (2004) of our wonderful conductor, Dwight Oltman.

Ballet San Jose has been a big part of the rebirth of the arts in San Jose. I feel it is on a roll right now. We've gone through some tough times, but the company never dies, and we find ways to make it work. I believe dance can and needs to be flexible. Dancers are very resilient. Our staff is the smallest it's ever been, but the dancers—32 of them—are performing beautifully, and we're also pleased to be able to augment with extras from the school for *Nutcracker*. There are six casts and seven Tsar/Tsarinas. I like lots of rotation and for everyone to help out. We even have Roni Mahler and Raymond Rodriguez in the show.

One of my more notable anecdotes is the time Noel Mason and I danced together in the Joffrey Ballet. Once we were in a Glen Tetley piece called *The Game of Noah,* and while performing at Jacob's Pillow, she accidently broke my big toe with her pointe shoe. I had two more ballets to do and no understudy, so Mr. Joffrey's secretary gave me some aspirin, and I washed it down with what I found out later was straight gin. It did get me through the performance.

DENNIS NAHAT ON TEACHING TECHNIQUE

What is technique?

It's the ability to transcribe the unseen—something that is out of reach, out of the norm—without words. An invisible thing and a natural thing, it comes with many years of understanding one's own body. Some have it

and "look" it. Rudolf Nureyev was not as technically proficient as others around him, but look what he did. It's an art. Technique onstage surpasses their actual ability. Good examples of this type are Margot Fonteyn and Carla Fracci: they each knew how to be onstage. It's finding one's own way within oneself, finding out who they are as artists. It's technique versus performance: how two pirouettes can be as exciting as five with the right artistry.

How might you define it?

Style must be understood, for a true understanding of how to perform with the style is essential. Dancers today jump around and emulate a lot of different styles, but how much do they understand?

How do you go about imparting it?

I like to say that I'll work with anybody and everybody. Every dancer needs to look at every kind of dancer available. Many dancers don't want to do this—to get their tights "dirty." How can choreographers do works in mediums they don't understand? Knowing and being able to do more than one style of dance was once common. We'd do summer employment in musicals and then return to the ballet. You have to keep your mind open and expanding. Jobs are more limited now, so perhaps these experiences are not as readily available as they once were.

Is there a difference between skill and technique?

Most would think that skill is technique and vice versa. However, as with any profession, the longer you practice, the better you become. Therefore, the skill in dancing can be measured by how much you've learned just by doing it every day for many years. One learns the tricks of the trade. You simply become better at it through longevity.

Once while I was still a dancer, a student in a class I taught said, "Okay, Dennis, what is the real secret to turning?" I had no words to respond with. I looked at him and said, "Are you serious?" He was. He said, "You seem to turn so easily. What is the secret?" I told him, "I have been turning on this leg for 25 years, almost to the point of it falling off. If you want to turn, you turn until you find it, day, night, night, day. You will discover your center." Only practice will get you there. You can talk about it until you are blue in the face. Nothing will help you turn more than simply turning yourself. Of course, you practice with intelligence. That then becomes skill.

Let's say you have a solo—maybe the male solo in *Études*—where you must turn in many positions. If you can do it and perform it well, that can be considered having a good technique because the years you've spent developing the skill to turn allowed you to do those turns in *Études*. Now we have years of skill combined with technical know-how.

Making those turns have meaning is another technique and skill. This topic is an endless discussion. Yes, they are interconnected and related, but they come at different times, and you never stop perfecting your skills or technique as a dancer. Neither do you as a choreographer, teacher, or director.

What do dancers need to learn to master technique?

Learning styles. Donald McKayle is a good example of this, of someone courageous enough to work outside of one style. Bob Fosse, on the other hand, is an example of someone who only worked in his own style. Jerome Robbins is another good example of someone who made a great mark across a variety of styles.

What part do interpretation and presentation play in acquiring a good, solid technique?

Learn the steps. Interpretation comes later. Antony Tudor wanted the opposite—it all made sense later. Agnes de Mille was much the same. With today's dancers being more proficient, technical work comes first.

What should a good teacher be expected to do?

A teacher's job is to reach everyone in class. If it's a company class, it's important to feel the general pulse of a class. Sometimes I pick one particular thing out and have everyone work on it; this feeds the rest of the class.

What are the challenges that students most often face?

Not being trained to use their seat muscles and having the tailbone straight down. When they get it right, suddenly the legs become longer. It's the best use of the pelvic girdle. I encourage them to get some Graham training, as this emphasizes this.

Pulling the center of energy from the tail and out to the toes. Finding center, crossing fifth, épaulement, and croisé are all problems. If the eyes are not focused where they need to be, everything will look out of alignment.

What are the challenges that teachers most often encounter?

How do you show them the right way? Pick a student with beautiful feet, not your own. Same with port de bras and épaulement. Students copy literally. I rarely demonstrate anymore, as I think it's better to try to use dancers who have it right. Finding the rhythm of the step and not the count can be a challenge.

How do you bring families into the process?

Put the family outside in a waiting room. Treat it like a school. Parents don't second-guess everything that happens in school every day. Leave the students alone to find their own way. I encourage getting parents into adult classes.

What does a good class look like to you?

A good class is one that you have a terrible time doing. "Feel good" classes are no help. If you do what is most uncomfortable, you get the most benefit. I learned this partly from Erik Bruhn, who always did impossible combinations yet made it very easy to understand true technique. Alicia Alonso made such classes, and as a result she made her technique look better.

I've found that if my morning class is challenging, it makes the rest of the day become easier. If morning class is not difficult, the rehearsal becomes hard.

Performances are the same way. You can't "save" during warm-up and then expect to make it up onstage. If you're doing 32 fouettés, then you had better be doing 64 a couple of times a day.

You need to find where to put your energy, calm down in the face, and never get wound up in the wrong place. Train your body to "call it" when you need it.

Who were your favorite teachers, and how did they help you?

My first teacher, Enid Ricardeau, taught everything and each with a marvelous sense of classicism. She was part of the Ruth Page era. Bill Griffith was extraordinary. He demanded 150 percent in every class— mean but wonderful. He'd do things you just cannot do now, such as "threaten" to hold his cigarette under your posterior if it was sticking out of alignment. You pulled up in a hurry. In just three weeks, you'd see bodies change shape very quickly. He taught at the ABT School and at Joffrey. Antony Tudor was a very good teacher, as was Margaret Craske, who was a stickler for technique.

Valentina Pereyaslavec expected the class to sweat. In the dead of winter, she'd open the studio window. The snow would blow in during barre, and she would close the window only after we had broken into a sweat. Another real character was Maria Swoboda, who gave a set class and never demonstrated; she expected people to know the combinations. Edward Caton was yet another character who'd walk out on classes he wasn't satisfied with.

Joffrey was a stickler for dressing well in class. He felt you needed to practice how to look onstage. He didn't—and I don't—want to see the bags of stuff dancers wear. You can't see the legs, and it's a problem—for the dancer. Once your legs are exposed, you then realize how much you have to work.

Are technique and teaching evolving?

Teaching will go where choreography goes. Choreography drives technique—if choreographers understand the technique. It's kind of a vicious circle. Great technique and great work coming together equal great theater. They need to stay in close harmony with one another. Martha Graham's style was created by her dances first; she developed her exercises out of them. The same thing with Balanchine and Petipa, especially *Swan Lake*, which became the benchmark for classical line and technique.

There is always something beautiful to enjoy at a ballet. If you don't like the music, cover your ears and look at the beautiful dancers. If you don't like the choreography, the dancers are still lovely. And if you don't like the dancers, close your eyes and listen to the music. Always something to enjoy.

NINA NOVAK

". . . having inner strength and projection."

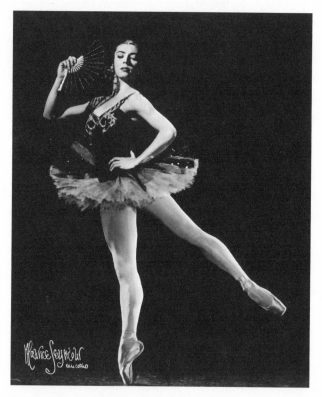

Born in Warsaw, Nina Novak joined the Ballet Russe de Monte Carlo in New York and quickly became world-renowned as a classical ballerina. In 1964, Novak founded her own school and company in Caracas, Venezuela. She continued to dance after settling in Caracas, performing in Colombia, Holland, and Poland. She considers the most important aspect of her career to be her intense dedication to the educational aspect of classical ballet. She is the recipient of the Francisco de Miranda First Class Medal of Honor (Venezuela), the Commendatory Cross of Honor (Poland), and UNESCO's Vaclav Nijinsky Medal. Novak also served on the 2002 and 2006 juries for the USA International Ballet Competition. Hers is an amazing story of courage and of her belief in the redemptive and uplifting nature of ballet.

Nina Novak in arabesque. Photo by Maurice Seymour, courtesy of Ron Seymour.

Initially, I went to school very early. I already knew how to read and write by age six. The school officials thought I would be good at dancing as I was always moving. I am very thankful to have been sent to the Grand Theatre of Warsaw, which was a good school, but I had to wait until I was eight. They fully auditioned me, including a physical exam, and I was admitted. After only three months, they gave me a full scholarship.

My family never pushed me, and they were proud of me when they later saw me onstage, but to them, I was just "normal." At school, we had ballet in the morning and academics in the afternoon.

How World War II affected me is a whole book. We had a very hard time during the war. We lived in Warsaw. Our opera house was bombed in the early days of the war in 1939. I was studying ballet with Leon Wojcikowski at the time, and sometimes we had no place to work. When we went out to go to the studio, we found that it had been bombed during the night. We had to look for some other place, and this happened several times. For these five years, I had only sporadic training. Also, toe shoes were impossible to get. Wherever I could study, I studied.

At one point during the war, I found myself hidden in a cellar and the house was bombed. A man dug a hole for us to crawl out, and I ran to my house, covering my head and running. We were often shot at by war planes. The next day, I couldn't speak due to shell shock, and the whole family was separated.

My father died in Dachau, and a brother died in Auschwitz. They took everybody whom they felt would be a threat to German authority. My older sister saved me, as she claimed not to be my sister. We were in a labor camp. In these camps, if they asked you to take a shower, you never knew if you were going to come back.

I was so happy to find my mother in Wieliczka. We fell into each other's arms and happily wept, telling each other our stories. Then the Russians bombed our house in Wieliczka. I came to New York after the war and started dancing again. My teacher's daughter, Sonia Wojcikowski, was in New York and was responsible for getting me my first dancing job. She had two auditions booked at the same time, and since she could not go to both, she suggested I go to one of them.

I was hired for a show that featured Carmen Miranda. They wanted me to go to Hollywood, but I neither spoke English nor had any training as an actress. While I was studying at the studio of Tatiana Chamié, she

Nina Novak with Serge Denham, director of the Ballet Russe de Monte Carlo, and Bronislava Nijinska, the legendary choreographer and teacher. Courtesy of the artist.

called Serge Denham, who came to observe me in class and hired me for his Ballet Russe de Monte Carlo. At first the ballet master, Frederic Franklin, didn't want me. But Marian and Illaria Obidenna Ladré were leaving the company, and they encouraged me to stay. Franklin and I later even danced together.

I was able to thrive, as I have a good memory and started replacing dancers on tour as they either became ill or injured and were unable to perform. I often filled in and sometimes learned new roles every day. I joined the company in 1949–50 as the cancan girl in *Gaîté Parisienne*, and we—Leon Danielian was my partner as the Peruvian tourist—stopped the show with our number at the Met. This was my début as a soloist. In the 1951–52 season, I was asked to learn *Coppélia*. I had a very good success, too.

In my epoch, characterization was very important, as was having inner strength and projection. We went on many tours, and I had many roles.

I never got to work with Balanchine; I only danced the lead in his *Ballet Imperial*. He had left the company the year that I joined.

Nijinska was in Warsaw before the war, and she took me from school to the New York World's Fair in 1939 with her company. That was my first trip to New York.

In Ballet Russe, Nijinska made a special solo for me in the Polovetsian Dances from *Prince Igor,* also performed at the Met. She later moved to Los Angeles, and whenever I was there, I would study with her. She taught me *Giselle* and gave very difficult classes, and she always gave very good corrections.

She was also very opinionated. Her husband would "soften" some of her comments, and assuming that you only knew English, he would translate her comments with things like, "Madame says you are not very good," when she actually said, "You dance like an elephant." It could be very amusing. The Nijinsky family [Nijinska, her brother Vaslav Nijinsky, and their brother] was actually Polish and moved to Russia, via Kiev, when quite young. Their parents were "for-hire" dancers.

How I ended up in Caracas is an interesting story. I married a Venezuelan, but that lasted only seven years. I was tempted to leave, but then I met and married a Russian oil man, the son of an officer to the czar. His family moved to Paris when he was only one year old. He was a very nice man, cultured, who spoke many languages and loved the ballet. He helped me build a school and a house. I've had a good life.

Teaching is a passion. It is my second profession. Dancing literally allowed me to live. I've taught a lot of good students, and many have gone on to be good dancers, including Alexis Zubiria, who was a 1982 silver medalist here. I get to teach students how to dance in the style of the Ballet Russe de Monte Carlo and my important teachers, Nijinska and Wojcikowski.

My advice to aspiring dancers would be that whoever wants to study ballet must, first of all, have the physical and mental ability and must really love this art. You have to be disciplined. Ballet is not only a profession; it's a vocation. You won't necessarily make a lot of money. However, there are plenteous satisfactions. Ballet, especially classical ballet, is a beautiful profession, and to see male dancers onstage partnering ballerinas is an outstanding experience. So I encourage boys to study this art form.

The rewards are worth it. I feel very rewarded to be a part of it.

Nina Novak teaching at her studio in Caracas, Venezuela. Courtesy of the artist.

NINA NOVAK ON TEACHING TECHNIQUE

What is technique?

Ballet technique is a tool for education, which makes a ballet dancer.

How might you define it?

Ballet technique is created and established by the French School.

How do you go about imparting it?

One should begin at an early age. Since the human body is an instrument of ballet art—and in almost all cases is not perfect in every way—the unnatural body positions must be accepted as natural. This process takes nine or more years to achieve full development.

Is there a difference between skill and technique?

The difference is that the skill is born and the technique is accepted by long practice.

What do dancers need to learn to master technique?

According to academic rules, dancers must execute classical movements in a perfectly clean manner. Intelligence and musicality are critical components.

What part do interpretation and presentation play in acquiring a good, solid technique?

Students must fully trust and obey the fully experienced teacher—no questions asked. This is part of the learning process. Dancers must be fully ready to respond to a choreographer's demands and also to the ballet masters, so that their interpretation is fully realized when required. The choreographer's intention for the interpretation of a work takes priority over any ideas a dancer may have.

Strongly related to technique is discipline.

What should a good teacher be expected to do?

Teachers should help students as best they can. Each class should be planned in such a way that all of the students will be able to understand.

Exercises and combinations ideally are created that are slightly beyond their reach; they are being challenged.

A good teacher doesn't give classes merely for "fun" but gives interesting and varied routines for what is necessary for the progress of a particular level, using technique and artistry useful only for the stage. A good teacher also needs to be observant. Teachers should be aware and recognize each problem and should know how best to address them collectively or individually.

What are the challenges that students most often face?

There are too many to mention. What comes into play here is what each teacher feels the pupils need. The challenges that students need to overcome have to be pointed out by the teacher, and each student may have different needs.

What are the challenges that teachers most often encounter?

One of the most common is discipline in young people. Regardless of one's personality, a classical dancer needs to develop tremendous self-control. This discipline shows itself in being a clean, pure dancer.

How do you bring families into the process?

Parents should be informed that the classical ballet studio is not only a place to dance but also a place of serious study. This is a place where their son or daughter may choose dance as their profession. There are many choices for students, including colleges where performing arts and scholarship opportunities are offered.

There are so many benefits of this study: making the body beautiful, overall physical development, beauty in execution, a sense of musicality

and rhythm, provoking instincts through a creative activity, the ability to do something with precision, and the pride of achieving something for yourself.

Bringing families into the process is necessary but of secondary importance.

What does a good class look like to you?

A good class should be well constructed classically with internationally approved methods. Consistency among teachers is important, so there is an evenness throughout classes. Otherwise, maybe one or two students may look very good, but the others may look weak and sloppy.

Who were your favorite teachers, and how did they help you?

Each of my teachers gave me something different. Bronislava Nijinska was very artistic. Leon Wojcikowski was a teacher for technical skill. Sznarawska and Markowski (Academy in Poland) excelled in providing superb beginning training. In New York, one of my favorites was Maria Swoboda, who taught a high-quality, lyrical, classical art.

Are technique and teaching evolving?

It is very difficult to say what is a good or even the best school of technique. Also, technique is only one word, and the technique of ballet may be divided into several other categories and subjects. I could more fully answer this if I might visit most of the prominent studios; then I could get a better opinion. But from what I've observed lately—such as by being a juror on international dance competitions—juniors and seniors have a much better and cleaner technique every time a new competition comes around.

In general, the teaching of technique these days is going very well, but this happens only with very good teachers, as always.

I'd like to remark that traditional classical ballet training should first be done separately from other types of dancing, at least to the point that the dancers are firmly established in the classical artistic manner. Only after this is accomplished, and dancers are in full control of their performing readiness, should they add a different type of dancing.

Lastly, no art should be left in the hands of administrators. Leave dance and the arts in the hands of the artists.

FRANCIA RUSSELL

". . . building a mountain with a teaspoon."

Francia Russell was a soloist with the New York City Ballet and co-artistic director of Pacific Northwest Ballet. She is now staging Balanchine ballets all over the world and guest-teaching, including at PNB.

Kent Stowell and Francia Russell, former artistic directors of the Pacific Northwest Ballet. Photo by Marc von Borstel.

Francia Russell in *Native Dancers* with Kenneth Petersen. Photo by Martha Swope.

I have a great interest in teaching. I didn't have a solid foundation myself, having studied with many different teachers and their various styles. I really loved Vera Volkova, with whom I got to study for one year in London when I was 11.

I didn't expect to become a teacher or ballet master. That was Mr. Balanchine's idea. Had I known, I would have paid closer attention to classes and how things were rehearsed and put together. I certainly would have written down classes and combinations, and I regret not having done this. I learned a new way of dancing at NYCB at age 18, and this set a foundation that I greatly value.

We try to provide this for PNB's students and company members. It has to be a pedigreed foundation—then you can do anything. Technique needs to be honed every single day. It's the same for teachers, ballet masters, and artistic directors. Learning happens every single day.

My process for staging a work usually begins with casting. Casting can be very difficult with companies I have not worked with before. I typically watch a company class, but it's hard to know just from class what the dancers are going to be like onstage, so I take advice from artistic directors and ballet masters. I feel that I am able to give Balanchine stagings a specific point of view—from the 1950s and 1960s, as I didn't see later versions of Balanchine's works, and this enables me to give, I believe, a pure perspective. I like to give as much opportunity as possible for people to show themselves.

Steps are just the beginning. With Balanchine, the music is paramount, so fitting the steps to the music is the thrill for me every single time. I work on how the step is to be presented—something which can't be conveyed from a videotape. There are so many wonderful moments in his ballets, and they have to be remembered exactly, and dancers respond to this, I find. There are also the elements of scenery, costumes, lighting, and bows. Every aspect of the production is the stager's responsibility.

Francia Russell in front of the piano as George Balanchine and Igor Stravinsky discuss *Agon*. Photo by Martha Swope.

Francia Russell rehearsing with Carrie Imler. Photo by Kari Kellerman, courtesy of Pacific Northwest Ballet.

Two weeks is about what it takes to stage a work, and then going back at some point is standard. When I staged in Russia, I was there for five weeks. Rehearsals there were much more fragmented than what I'm used to. When I first went to Russia in 1988, Balanchine barely existed for the Kirov. They found the work very different: "too fast, no preparations." The second time I went, it was much easier.

One of the dancers, Yuri Fateev, had an intelligence about him that made him my choice for being in charge of Mr. Balanchine's ballets at the Kirov. He has turned out to be an excellent ballet master.

There are tons of dancers with great personalities, and they need great vehicles. Today's dancers need a very refined technique, to be prepared for extraordinary demands, and to know different styles if they are to be successful. Did you know that there are exactly 100 choreographers who have been represented in PNB's repertory? We take great pride in this.

I like works with a complete point of view, something that is faithful to itself. People don't realize how hard it is for us to get out and see ballets. We're here often from 8 a.m. until 11 p.m., and so travel and time to see other companies is precious little. I think that Jiri Kylian, William Forsythe, and Christopher Wheeldon are very talented. Locally, I would include in that talented pool my son, Christopher Stowell, and Paul Gibson and Olivier Wevers from our company. I'm fascinated by seeing young dancers' choreography. I think Peter Martins's choreographic institute is great. They need opportunities to experiment where their failures do not matter.

Seeing dancers develop is my greatest reward.

We mustn't sell out, we mustn't sell out, we mustn't sell out [said while pounding the arms of her chair]. No Draculas or Peter Pans. There is a great pressure on our marketing department.

We need to hold the line. Over the years, we've done some things that we were not crazy about presenting, but we've managed to hold the line on integrity.

FRANCIA RUSSELL ON TEACHING TECHNIQUE

What is technique? How might you define it?

Technique is not just a matter of learning steps. Yes, it is certainly learning to execute movements, but it is also about shaping the body, the

instrument, creating sculpture with the body, shaping what we call "line." This is an endless "work in progress." Like building a mountain with a tea-spoon. Technique can only be understood gradually, and a good teacher presents the information in an intelligent sequence, based on experience, that will result in a fine end-product.

How do you go about imparting it?

There are many ways of imparting technique, but fundamentally a teacher must have had a good background and have acquired the wisdom to work well with students psychologically. Students need to be approached individually. They have different needs and learning rhythms and can only learn new material well when they are ready both physically and psychologically.

It's necessary to create an atmosphere in which corrections are always understood to be constructive and to inspire students to be accepting of the demands of classical ballet. Students cannot make progress if there is resentment or misunderstanding in the studio. Our job as teachers is to open portals through which knowledge can pass in and energy can come out. Insecurities inhibit students and are always reflected in their bodies.

Is there a difference between skill and technique?

We all know that boys and girls learn differently. Boys love to compete and have an inherent need to show off their developing skills. Through this they build not only technique but also confidence. Of course, beautiful "line" is important for them, too, but I have found that it is good for boys to "do stuff" and then to refine their "line" later. Girls need refinement right from the beginning because of the demands that classical roles place on women and also because of the wildly intense competition they will face in finding jobs.

Willam Christensen had a genius for nurturing talent and skill in boys. Michael Smuin and Kent Stowell are good examples. Christensen's students were strong and could do amazing things, often feats of technique that students at SAB and even dancers in NYCB could not approach. Kent, in particular, learned refinement later from Stanley Williams and Balanchine. I believe it is an important facet of a good teacher of both girls and boys to be able to preserve balance in technique classes between enforcing discipline and, at the right times, "letting them go." One other

thing I feel strongly is that, whenever possible, girls and boys should be taught separately.

What do dancers need to learn to master technique?

For me, the most important thing in developing mastery of technique is awareness of music. The Pacific Northwest Ballet School syllabus is clearly delineated for levels from pre-ballet through level 4 and early pointe classes. Every step, every combination, is planned and executed musically. I was taught this way by my teachers—the rhythms and the music were chosen to help train the muscles. Time signatures need to be fully understood by the teacher. The purpose is training the dancers to feel the rhythms of the music in the correct muscles, a process that should happen naturally. Individual quality of movement can develop later, expressed through energy and a sense of space and by developing one's own unique ways of moving.

To build this foundation, a work ethic is essential and should continue throughout a career. Look at Patricia Barker, a former PNB principal dancer. She has a superb work ethic, and this allowed her at her retirement gala in 2007 to be in perfect shape. Fabulous. The product of years of dedicated work

For a finished professional, of course, technique is only a tool. A complete dancer has a sense of filling space, of visualizing the music for the audience, and of developing individual modes of expression.

One other point is my firm belief that choreography has no place in a technique class. Devising complicated combinations is not the point of teaching. If music and movement are organic in their classes, students will easily learn to pick up choreography elsewhere.

What part do interpretation and presentation play in acquiring a good, solid technique?

In technique class, the movements, the development of the body, and the integration of épaulement of upper body with legs and feet—that is all the interpretation that should take place. It's terrible to see emoting in a technique class.

What should a good teacher be expected to do?

One of the most important jobs of the teacher is creating a safe and inspiring atmosphere where the students are not afraid to take risks. How else can they learn? The school director is responsible for creating a syl-

labus, but all the teachers should be involved so that everyone can add their input and come to an agreement. A syllabus should never be fixed in stone but should be a living document, always being refined by experience and the changing demands being made on dancers.

I write down my classes because I find that it focuses my thinking. With all that it takes to run a major ballet company, I used to get up very early to do this exercise. Writing helped my concentration and placed my mind in what I thought of as "teacher mode." Of course, I depart from what I've written when I feel it is necessary. There is so much to be accomplished in a 90–minute class that it seems to me a terrible waste for the teacher to be unprepared.

With professional dancers, the teacher needs to prepare them for the rest of their day. They may have to rehearse a particularly demanding ballet, or perhaps they performed the night before and are exhausted. All of that should be taken into consideration.

I always try to give a complete class, and I don't really see the value of an "all pirouette" or "all petit allegro" class, although I was very interested to watch those classes when I worked with the Royal Danish Ballet.

Every student/dancer should be seen in a class, and most, or at least many, corrections should apply to everyone. My classes are always serious, which is not to say that there is never humor.

Dancers love to feel a sense of accomplishment by the end of a class. If they feel they have improved their technique, that in itself is fun. In certain circumstances, however, Kent did give explicitly "fun" classes, and the company loved it.

Before Mr. Balanchine's company classes, I would often take Robert Joffrey's morning class, then dash uptown in a taxi to NYCB in order to feel fully ready. Mr. B's classes demanded that one be warmed up and ready to go from the first plié. I pushed myself to the limit. It was exhilarating. I do not believe class should ever be used as a warm-up except before a performance.

What are the challenges that students most often face?

Some of the more frequent challenges are upper body strain in the neck, tight backs, tense arms and hands. It is very difficult to change personal characteristics that may limit the ability to move and prevent the dancer from looking attractive.

What are the challenges that teachers most often encounter?

Patience and stamina are important traits that are absolutely essential to being a good teacher. Also, we must remember all the students, not just the most talented ones. It's tempting to focus on one student who has a beautiful body and innate musicality, but everyone deserves the teacher's attention.

Teachers (I know I do this) want to predict a student's career from an early age—to themselves, of course, not to the student. But, as we know, the most talented don't always "stick with it," and sometimes it is the student who has to work harder, who is determined to dance no matter what, who ends up having the career.

Dancers who become teachers need to remind themselves to get off the stage and not to perform in class. There are some who just can't do it. Class and teaching must be about the students. The teacher is there to give, and the students are there to receive knowledge and use it.

How do you bring families into the process?

It is important to have frequent conferences with students and their families, as well as class-observation days. The more parents understand, the better. At PNB we tried to get families involved as much as the staff could accommodate. There was a time earlier in PNB's history when I did all the student conferences myself and hand-wrote the report on each student. The rewards of conferences can be wonderful, but they are immensely time- and energy-consuming—and sometimes hard on the psyche. Unfortunately, not all parents are understanding and supportive.

Ballet can be a safe place for the students. We don't always know what is going on in our students' worlds, and their ballet school may be the best and most secure place in their young lives. Caring for them in so many ways is an awesome responsibility.

What does a good class look like to you?

A good class has a point of view. It has balance, it uses musically diverse rhythms, and there is good preparation at the barre for work in the center. One of our colleagues—a wonderful man—used to give classes in only ¾ time. How limiting for his students. Kent and I feel very strongly that one has to include many rhythms.

Levels of students are, of course, very different. Young dancers need

more barre work as they are still developing muscle strength. But it is a mistake to linger at the barre. Students should arrive in the studio early in order to start warming up their muscles. Cracking joints and rolling heads do not belong in class. Barre is part of the overall class, not just a warm-up, which should build from beginning to end.

Who were your favorite teachers, and how did they help you?

At the top of my list would have to be Vera Volkova. She was full of tremendously detailed information, but her character influenced me as much as her knowledge. I studied with Madame Volkova in London when I was 11 years old. When my family had to move back to the States during World War II, she and her husband offered to adopt me.

Class with her was always all about the students. She was completely musical and completely selfless. Everything about her greatly informed my teaching. I remember watching her classes 20 years later when I was working in Denmark, and she was the same, selflessly giving. I saw her off and on to the end of her life and have always felt she was my role model not only as a teacher but as a devoted artist and deeply caring person.

When I began teaching at SAB, Antonina Tumkovsky and Helene Dudin took me by the hand and drilled me in teaching young students and in the rigors of a syllabus. They were teaching models for me, and they made it clear that no one who is not equipped to teach young children has the right to call herself/himself a teacher. Mr. Balanchine also watched my classes and criticized—in positive ways—my many, many deficiencies. Although I studied with Balanchine as both a dancer and a teacher and worked so closely with him for so many years—in fact I feel I still do—I do not teach what is called "Balanchine style." My teaching is the sum of all I have learned from the many wonderful teachers I have had over the years. And I would like to think I am still learning.

Two exceptions to my feelings about teachers performing in class were Felia Doubrovska and Alexandra Danilova. Each brought style and history to her pointe and variations classes and could demonstrate a depth of performance and personality that would stay with her students forever.

This is how Doubrovska would enter the studio. [Gets up, leaves conference room, shuts door. Pauses. Opens door and leans in with a wide grin. "Good morning." Trips lightly into the room, waving and running on the balls of her feet.] Danilova, on the other hand, would sit [demon-

strates crossing her legs just so] and then pull up her chiffon skirt so we would be sure to notice and admire her beautiful legs. They both showed poetry, drama, beauty, and true love of dance in teaching their classes.

Igor Schwezoff was another teacher I greatly admired. He was very tall and slender and had a truly elegant demeanor. And he helped me a great deal when I was suffering from the pressure of NYCB and desperately needed another point of view.

Are technique and teaching evolving?

I'm concerned. Technique needs to relate to repertoire, and the repertoire must be an outlet for technique, or it loses its value. For the eclectic repertoires of ballet companies today, it is powerfully important for students to learn other dance forms and to learn them well. However, classical technique is their foundation, and in order to maintain it and to maintain the standards we admire, it must be used, not learned and put aside to be brought out occasionally in order to sell tickets. Choreographic demands change, which is right and proper, but they also go through fads and phases which should not determine how classical technique is taught. It is my fervent hope that the beauties of classical dancing will retain their value for dancers, for choreographers, and for the public and that they will be as important to dance in the future as they have been in the past.

MARTIN SCHLÄPFER

"... most ballet technical problems can be solved musically."

Martin Schläpfer was artistic director of ballett-mainz and, as of 2009, artistic director of the ballet at Deutsche Oper am Rhein Düsseldorf-Duisburg.

My initiation into ballet is an interesting story. I was a boy from a small Swiss town where art was not a big part of growing up in my family. It was my primary school teacher, Theodor Holzer, who brought me to ice skating when I was about 12. I did ice skating as a hobby only, became pretty good at it, and was asked to join the skating club in my hometown, St. Gallen. Private skating lessons were too expensive.

At 15, at the annual showing of our work, set to Beethoven's Fifth Symphony, Marianne Fuchs, a local ballet teacher, saw the performance on the ice and asked me to join her ballet school. My father was neutral on the subject. My older brothers, however, were opposed and suggested to

Martin Schläpfer. Photo by Bettina Müller.

him that he let me go and try one class and see whether I liked it. I loved it right away.

Marianne Fuchs was a very gifted yet unorthodox teacher. She had just a small private school. I also went to regular school during this time, of course, but found that it was hard taking ballet class every day and keeping up with my studies. I wanted to dance more, but my father was absolutely against my wanting ballet to become my profession. However, Miss Fuchs was smart and signed me up to compete for the Prix de Lausanne—this after only a year and a half of training. After winning a prize, I earned a year of study at a prestigious ballet school, and so I chose to go to the Royal Ballet School in London.

It was wonderful to go to a big city. I was naïve, shy, and underdeveloped in dealing with big city life, and it toughened me up. The Royal Ballet was in an exciting period, with dancers like Lynn Seymour, Jennifer Penny, and Merle Park, among many others. I was placed into seventh level and after three months was put into Terry Westmoreland's graduate class. It was a very good year. I would have liked to have stayed, but I couldn't because of visa issues.

My first performing job was in Basel, where I had been hired by Heinz Spoerli. After 1983, I went to the Royal Winnipeg Ballet in Canada for one year. I got to perform a lot. The company was still under the direction of Arnold Spohr. I learned a lot, and it exposed me to the huge amount of touring RWB did, to which I was unaccustomed.

I was on the cover of *Dance Magazine* at the age of 22 in January 1983. I was actually very insecure as a person, but had a lot of power as a dancer. A couple of my early career highlights were having Heinz Spoerli create his *Pierrot Lunaire* for me in 1986 and being cast in *Grosse Fuge* by Hans van Manen. However, as a man, I grew up too late and out of confusion stopped dancing far too early. I needed to search and learn to become a more balanced personality.

I didn't choose teaching. After I stopped performing, my father—who was still a big influence in my life, and who could be fairly demanding—suggested that I open a ballet school, and I promised him I would, which seemed to satisfy him as it was a business as well, something he could understand and relate to. I built a beautiful studio in Basel, but knew I needed guidance to become a good ballet teacher.

I took up the study of music geared to dance accompaniment, as I

Dancemagazine

January 1983 $2.50

Bold New
Beginnings: The
Stuttgart Ballet

Serious
Injuries:
How to Cope

Rebel with a Cause:
Jack Cole,
Part One

Fiftieth
Anniversary
Reunion at
Jacob's Pillow

Strictly Female:
Beating the
PMS Blues

Switzerland's
Wunderkind
Heinz Spoerli And
The Basel Ballet
Head for
U.S. Debut

The Basel Ballet's
Martin Schläpfer
In Cheese

Martin Schläpfer on the cover of *Dance Magazine*, January 1983. Copyright *Dance Magazine*.

knew the ballet training was really also a dialogue between meter, dynamics, and colors given by the musician—and of technique. I was hungry to learn from Harriet Cavalli, a famous accompanist for the ballet. Anne Woolliams was also very helpful. She had a school in Zurich, and I would teach twice a week under her guidance. I liked her artistic approach to teaching, even if I could not agree with all of her technical beliefs.

I learned to integrate all the different influences, to be open to continuous learning, to question, and to make it my own. I had never worked harder in my life—doing the teaching but also the books, the cleaning, and laundry on Sundays. I kept working with Harriet on music, too, during this time.

Like so many novice teachers, I taught classes that were too complicated. It took me about 10 years to become a decent teacher—in my eyes at least.

David Howard convinced me that I was too young to stop performing, and so I went to New York, where I took classes from him and got myself back into shape. I took many auditions, but didn't get placed. I went to Bern, which was open to me as a dancer. I only stayed one season and resigned again. My search kept going until 1994, when I was asked to become artistic director in Bern.

There were many who didn't think I could do it, as I had no choreographic or significant directing experience. To me, teaching, choreography, and dancing are not so different—a "gap" between them never really existed for me.

Being the principal choreographer at Mainz, I began by importing famous choreographers, which started a foundation for a solid repertory. I began making ballets, yet it took six or seven years for me to gain confidence in my own choreography. I relied on my innate instincts and exposure to good ballets to keep things in line.

I am choreographer-in-chief and provide half of the ballets. My work, then, naturally gives the company a character.

The difference between dance companies in Germany and the United States are notable. The subsidy we get is fortunate, as the dancers and staff have secure positions. This security provides a freedom for me to do things that "burn under the tongue." We have box-office pressures here, too, but not like you have in the States. I feel that maybe there is a danger in being so safe in our system, that as an artistic director, I need to

"unquiet" things—not necessarily for the sake of being new, but to keep the movement impetus alive and to prevent the company from becoming sleepy or complacent. Yet I think I would not want to work in the American system because of the power of the board of directors. We can recall Mr. Balanchine's famous observation: "Après moi, le Board."

The direction of my own works and programming choices is dictated by guest choreographers. I have to fill in the gaps, so to speak, in order to make "good" programs.

I usually try to portray the music literally. I also try to sense what lies underneath the melody, color, and dynamics in a composition. About one-third of my programming has to be set to contemporary music. We live today and need to work with the music of today. Old ballets that we now revere and that are considered "traditional" were products of their time, weren't they? Even *Sleeping Beauty*. We need to be connected to contemporary life.

I'm not a conceptual choreographer. I usually start with the music. William Forsythe was an inspiration for me: how he opened doors for me choreographically and how he reacts—or doesn't—to the musical structure. I feel that I've really changed in the last two years. I read and think a lot. This underlies my work and gives it a subtext that is perceived. I hate pieces that are clear. I like mystery and question marks. You can imagine I don't do story ballets too often.

I used to prepare for choreography much more, but now I prepare myself mostly musically with perhaps a couple of dramaturgical motifs worked out in advance. It's now more of a give-and-take process with the dancers. I'm used to creating with dancers, yet my vision is definitely dominant.

I have my own strengths and directions. I can't be Pina Bausch. I'm always apprehensive before an initial rehearsal, but I loosen up as we go along. I work in short rehearsal periods. And I let the dancers go if I find that there is no flow or if I feel I've done all I can do for that day. I won't "hack it" for four hours.

I teach most of the company classes. We do have a ballet school here in Mainz that was running before I arrived. It's not a professional training school, although the standard is high enough for a nonprofessional setup. It's to bring dance to younger generations. I don't direct the school; it's a window to the public for me.

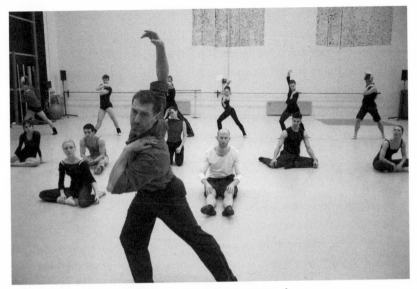
Martin Schläpfer during rehearsal. Photo by Gert Weigelt.

My own teaching is geared to professional dancers. In addition to the influences on my teaching that I mentioned earlier, I was greatly influenced by Peter Appel, and when I went back to New York in 1990-91, by Gelsey Kirkland and David Howard. I don't necessarily teach an orthodox class, either. I put tremendous emphasis on musicality, dynamic changes, and elasticity of muscle usage. It's perhaps more American than European in emphasis.

If you don't have rhythm in your dancing, there is no life. I play a lot with rhythms. I use fives and sevens, as it's important for dancers to be used to reacting to a big range of musical variety. I've found that most ballet technical problems can be solved musically.

I caution teachers who work with highly gifted students to be aware that these students may be in a "danger zone" and therefore vulnerable. That they don't and shouldn't have to go through a tortured dilemma, but that they do require guidance.

Mainz is a city of about 200,000 and occupies a large area in the upper Rhein. It's close to Wiesbaden and Frankfurt. Ballet is very popular: our evenings sell out and without offering story ballets. Audiences here want—and virtually demand—new work. This is very European. I also recognize the importance of developing a tradition and following it, and

this demand for the always new can place us in danger of losing the works of the past.

I'll be leaving Mainz for Düsseldorf in 2009, as I feel 10 years in any one place is enough, and it's good to move on to new challenges.

MARTIN SCHLÄPFER ON TEACHING TECHNIQUE

What is technique?

Technique is control over body, mind, and emotion—the blending of the three.

How might you define it?

Technique means sensing and knowing how to make the interrelation of the aforementioned three units happen at a desired moment. Putting together musical response; sensing when to let the body take over versus taking control over the "physis" via the mind; structural, emotional, and psychological expression of music; shaping a possible text for a role; fulfilling the choreographer's or ballet master's feedback and corrections; controlling a physical flaw such as an isolated sickled left foot, etc.

Technique is another word for mastery. You can only have technique after many years of practicing.

Virtuosity is not technique; it is and remains virtuosity. Technique is certainly highly developed craftsmanship, but not only that. Technique cannot even be separated from artistry, since there is no technique without musicality, quality in movement, sense of style and expression, etc.

The common phrase "She or he is a really great technician but unfortunately no artist" is wrong. It shows that we have a distorted understanding of the word *technique.*

Is a dancer who rolls his feet and has no center, but somehow manages to turn 10 pirouettes, a great technician? No, he is simply a bad dancer.

How do you go about imparting it?

Since I am an artistic director and a choreographer, I am talking mainly of my experience of working with professional dancers in a company situation. I directed my own ballet school for several years in Basel and assisted Anne Woolliams in her school in Zurich, but most of my experience as a teacher grew out of my work with professional dancers and artists. To know this may be of value when reading my remarks.

One imparts technique, as in a teaching situation, mainly in the daily morning class and in the rehearsal hours. I believe that one never stops working on technique because artistic depth is not possible without technique; they are one. I am convinced that you can help solve most technical problems a dancer may have if you do not isolate the particular problem for too long from the entity. To make the dancer aware of the problem quickly and efficiently, isolating it may always be a good tool to point out to the dancer (verbally, by demonstration or manipulation of body parts) what you mean. Yet solving "the problem" will only become successful if you then instantly put it back into the "bed" where all of the necessary ingredients for the dance or the exercise are interacting. Keep repeating exercises, the patterns, that may work on the problem area as often as possible, verbally, physically, whatever is right for the moment and for the person.

Of course, a good teacher will always design his exercises around the weak points which the majority of the dancers will have in his or her class, or—and this is very important in a company situation—the class has to also react to or at least support the repertory that is being danced onstage at the time.

Class is never a warm-up. And it is not about being popular. I have discovered that fulfilled dancers are challenged dancers. I personally do not believe much in bringing style elements into class, yet I believe that a class must also support the artistic texts of the ballets onstage. I try to teach and exercise all possible professional views of a step. For example, battements frappés I give with brushes, pointed foot finishing to the floor, with double and triple beats, starting from coupé front, but also starting from a wrapped sur-le-cou-de-pied. Balanchine and other great choreographers have brought modern ballet to another level and place. Even if you do not agree with it all, a teacher has to be aware of it. Musicality and physicality have been shaped in a way that expresses "today"; this a teacher must know and love. At the same time, he must know about tradition and know when style elements dictate a ballet's look. If our aim is to develop young dancers who stand a chance of joining a company that works with a choreographer who creates ballets, these things are vital.

There are many ways to get technical results, but not so many ways are actually right. We must be aware that general corrections are only valid if

there is a general need for them. Otherwise, address dancers individually, not in a collective way. Not every dancer understands your corrections in the same way. One must make the effort and also search for ways to say the same things in many ways. And a lot of technical problems can be solved musically.

We teachers need to be smart, educated, and thinking. Smart dancers and artists need smart teachers. Be as clear as you can possibly be. Treat the musician as an equal partner in class and rehearsals. A musical dancer is not only a dancer that reacts to the given music properly; she or he is a dancer who realizes that music is at least as big an art as dance. One learns this mainly from the behavior of one's dance teachers toward musicians and art in general. One can go on and on—and sometimes the opposite is also right. Dilemma of thought.

Is there a difference between skill and technique?

The difference, in my opinion, is big. Skill is somehow "shallow." A person may be skilled at doing something, but not necessarily know why and what she or he is doing.

The word *skill* has a somewhat naïve texture in its meaning. Technique, as I tried to point out above, means a "world" more. Skill is not talent. I believe talent and technique can interconnect, especially at the beginning of a growing/studying state. A dancer, for example, may have a talent for jumping. With the right teaching, she or he may develop jumps that keep the archaic power of her/his jumping talent alive while adding form awareness, musical phrasing, and physical shading, a variety of the tons of jumping steps and beats, etc.

A dancer also may learn that a physical tasking action, such as jumping, in the end is dictated only by artistic reasons of expression. I will never forget Eva Evdokimova's entrance in the first act of her *Giselle*. Coming out of the house, she jumped, soared, and floated airborne like only a few men ever could, but never once did one get the feeling of her showing off her great jumping "talent." No, it was an expression of a young woman sensing the extraordinary that will happen to her; her joy and curiosity for it.

What part do interpretation and presentation play in acquiring a good, solid technique?

Of course, it matters how a dance student presents herself or himself in class, even outside of the classroom, but more in terms of look and

behavior instead of how one presents the exercises, for example. I personally believe that presentation should be given emphasis in a classical repertoire and/or variation class, and it is far less important in the daily morning class. The same goes for interpretation. In fact, it is vital that exercises in the morning class do not get an interpretation by the student, at least not until she or he can fulfill those exercises musically, physically, etc. Interpretation is for the advanced student studying roles or the professional dancer—really only for the artist. I want to make sure that it is understood that I am talking here about ballet class—ballet training, so to speak—not about other lessons, techniques, improvisation classes, etc.

In my opinion, creativity in a ballet student gets nurtured by developing musicality, exposing her or him to different phrasings and shadings of the given meter and the melody line, filling the steps by content and depth of muscle usage (resisting, releasing), breath (lift), and sensing the emotional color of the music being played, integrating that in the right amount into the given exercises, etc.

The art of port de bras is not mainly about presenting oneself as a personality and dancer; it is more about something "ego-less," more about "it," about giving energy out and away to the audience. A filled and proper yet free execution of the port de bras patterns, motivated by breath, the center of the body, the back, and the use of épaulement (neutral and physical) make a dancer present and awake, commanding the stage and radiating with energy. That is the aim—that is what supports technique— rather than thinking about presentation isolated.

Certainly in repertoire classes one should concentrate more on stylistic and presentational elements. For instance, no true and good traditional *Sleeping Beauty* production should be staged without any "small-arm" poses, for example. If a ballet is about royalty, port de bras has to have the corresponding "color." One learns these presentational aspects in repertoire/variations classes, not when one finally gets into a company.

What do dancers need to learn to master technique?

Teaching ballet is a huge responsibility and should be done only by "real teachers." Unfortunately, too many "ballet class givers" are not real teachers, neither by inner calling nor by talent. Many start to teach dance because they cannot accept the fact that they were unable to become professional dancers or because they have to retire from active dancing at some point.

Classical ballet is a cosmos—a genius cultural phenomenon indeed—deeply right and true. Its vocabulary has to be taught absolutely right from the first plié.

A "true teacher" also needs a great artistic sense and command; must be able to lead human beings into life; should be ahead, never standing still. Knowledge about dance steps, music, dance history, anatomy, etc., is not enough. Many dance teachers have a diploma, but can never inspire a student for "heights" because of a total lack of charisma, command, and magic. Those "teachers" usually scream the loudest—about how low the level of ballet teaching around the world is—but they "kill" ballet all the same by being dull. I've seen many "lifeless" dancers, made inert by dogmatic adherence to syllabus-based methods. These methods may be valid until the student is 10 or 12 years old. After that age, I can only pray that she or he is rescued before all movement and passion are neutralized. And yes, there are always the very few exceptions.

Every true teacher goes about things differently. The teaching approach will be largely dictated by what age group one has in the studio. This tells you also how much and what kinds of humor, patience, verbal explanation, etc., have to be used in order to allow the student to understand, breathe, and recover, so that he or she can take the very hard mental and physical task of a class on a regular basis. Again, I do not believe in separating all areas too much. I try to include all important components that good ballet should have, even when I work with beginners.

One must establish an individual approach to each student. Not every student is given the same amount of turnout, nor the same body, nor the same psychological constitution/psyche.

For beginners I create simple exercise patterns but already ask for music with dynamic and rhythmical contrasts, in order to enhance as many muscular responses as possible and to develop musical sensitivity. I see no reason why one has to wait years to start teaching a battement tendu in all the possible dynamic and musical forms: done musically evenly with the same timing in *and* out of positions; on "and" closing on the downbeat; and "and" finishing out on the downbeat, etc. I see no reason why a battement tendu should only be done to a ²⁄₄ meter and only in phrases of 8, even for beginners. Waiting too long to incorporate new elements is an unwise "teaching" act because there will never be perfection. If we wait until the student can execute a battement tendu perfectly before we move

on, we will "kill" the dancer in the student and neglect so many other necessary components of the art of ballet that the student should learn while doing battement tendu and not after having done battement tendu.

Breath and coordination are closely linked. Moving well is usually the least of the problems for most human beings. Moving within a demanded form and in a given time window is a different story. To move well alone has nothing to do with art or the art of dancing. For an art form like ballet, the only purposes must be how and why we move. We cannot have form and structure alone, just as we can't have emotion and content alone. The balance of the two is what we aim for.

This to me is technique. Teachers must be careful to keep this balance in mind all the time. Concentrating too much on form may ruin a dancer's coordination, weaken the motor for movement and passion, and even create depression. On the other hand, the neglect of form and structure, detail, and proper execution of ballet steps makes dancing low-level, exchangeable, cheap, void, and therapeutic instead of artistic.

What should a good teacher be expected to do?

A good, true teacher must be magical, powerful, and mysterious. He or she must be able to create a burning desire in students, so that they want to learn ballet technique more than anything else offered in life.

Of course, if one teaches at the Royal Ballet School, one must come up with a lesson plan. If one teaches adult beginners twice a week in a private studio, this is not the most important; maybe the "fun" aspect counts more. But we all know how much fun it is to execute ballet the right way, how satisfying it is to work hard, and how fulfilling it is to coordinate body movements and link them to the music. So an aim for "fun" is really never an important issue. The demands of each situation tell one how to go about it. Each situation needs a different approach, and each student needs an individual approach by the teacher. This is of utmost importance, I believe. It is also very tiring. If a teacher can't come up with the strength and the needed curiosity to fulfill this any more, he or she should stop or take a break. If formula and routine set in, or the belief that only one way is right and possible and necessary, then it's only giving class. Giving class is not teaching.

Great teachers know a lot about life as well as dance, music, and art; they love and respect people; they burn with passion and at the same time are calm and clear, strong and caring, yet also capable of acting with a cer-

tain distance from students, so that they can always do what is necessary without being privately linked.

Teach the student and make a great dancer, but do not own the student. One must be a good psychologist, and one must know and reflect about oneself constantly, knowing one's weaknesses and flaws as well as one's strong points. Great teachers are learning about themselves constantly. Teaching is really the most important position in human life and culture. To be a true teacher asks for an almost superhuman effort.

Good teachers are unorthodox. One does not teach ballet only by showing and asking for the right thing; one is actually teaching when the student is understanding, not before. Many things are legal to make someone understand; it is not always the "correct thing" out of the book that gets a student there. The main things are that the dancer is understanding what the teacher means and wants and that the tools employed to get him or her to understand are somewhat ethical. A simple physical example: the proper centered alignment of a dancer's body is best achieved by staying centered at all times through barre work. Yet sometimes a dancer understands "center" much better and faster if one also works with him or her on off-balance elements. This small example about the "opposite" is to me very important in the development of a real dancer, a modern ballet artist.

What are the challenges that students most often face?

Well, I may be using a strange approach to this question, but I find it personally very important to consider.

There is ballet, and there are also an incredible number of additional "techniques" and "paths" out there from which dancers can choose and perhaps get lost in. Many students, as well as many teachers, believe that these techniques and supports are necessary to help the young dancer to become stronger, more versatile, richer in expression, healthier, etc. The belief is that they will enhance the ballet technique of the students. Most of these techniques and systems are certainly valid and carry huge possibilities within themselves to develop a young dance student further, yet they can also be traps. I name here only a few: White Cloud Yoga, Pilates, Alexander Technique, chiropractors, Feldenkrais, Yoga, and weightlifting.

In order to become an artist, or even just a good ballet dancer, one needs to be concentrating mainly on ballet. In order to go deep into the

substance of this incredible technique and phenomenon, one needs to eliminate everything else that is not necessary or that shouldn't be included too early into the ballet training plan.

Ballet technique is something for life. If one chooses an additional "supporting technique," it should be done carefully and practiced for a long time. Students are not necessarily able to make these decisions alone at an early age. They may think, "The more I do, the more courses I attend, the more teachers I have, the better I will get, and the more I will know." This is wrong. A good teacher has to guide young human beings, sometimes even call them back and protect them against their own will. This way, they will not get lost in all the possibilities that are being offered; they will not start to run from one course or class to another without being able to gain the "real things," simply because of piling up too much of all the complex information on top of the already highly complex "ballet challenge." I want to warn students to try everything, but nothing deeply. When I was a professional dancer and already far into my career, I took up White Cloud Yoga, Yoga, Alexander Technique, singing, and piano. I remember very well the tons of questions and confusion these other disciplines brought up in me, even though I had long been an established and very experienced dancer.

I will never forget all those students running around in New York in the 1980s who never stood a chance of getting into a company, not because they were not talented but because they did not concentrate on one thing with one major teacher for a long enough time. They only touched the surface and could do a lot of stuff but not one thing well. No teacher can give a student everything, and no technique can, either; if one realizes this, one can become tranquil.

Otherwise, one starts running around, changing teachers like one changes one's underwear, and never getting anywhere, except to a state of nervousness or hysteria.

I know of ballet students who have taken up Yoga too soon, for example. For one thing, they get totally confused in ballet class about where the body weight should be. In order to move freely and powerfully, one needs to have most of the body weight over the metatarsals and not "on the heels," as in Yoga. Another concern is the philosophical aspects of Yoga, which need many years to be studied, integrated, and respectfully absorbed.

And I know of male dancers who have done so much weightlifting that the energy stops running through their muscles, and they look like they are locked into their bodies, moving woodenly and drily.

This whole discussion is aimed mainly at those students who don't/ didn't have the luck of attending a school with a training program of many years, such as the Royal Ballet School or the School of American Ballet. It is aimed also at those teachers who can be absolutely wonderful but who do not work in a big established institution. I am talking about or speaking to all those who enter the dance profession in an unorthodox way, which can also be valid but can also have many dangers.

What are the challenges that teachers most often encounter?

For me personally, the hardest and most important challenge of being a teacher is finding the balance between the strict demands I must place upon students—what I ask them to practice in daily class and the carefully constructed exercises, knowing that only with those clear demands and enormous discipline can they achieve real technique and craft—and the "other side."

By the "other side," I mean the following: I want to give students the feeling that they are able to think along with me, not just fulfill the tasks I assign; realize that there are "several ways to Rome," even though at the beginning of ballet studies one must concentrate on one path or else the teacher creates confusion and sets a shallow technical standard; have the opportunity to be participating, co-creating, bringing something deeply personal into the working process.

These elements will prevent students from just re-creating like puppets and will allow them the chance to become secure, individual, and emancipated artists and people. Simply spoken, the challenge is fostering the necessary fusion of the two described "worlds," without which real art and true technique are never possible.

This is a never-ending task that I experience daily. It is the one I concentrate most on; all the others seem small in comparison.

Yet I believe one should not always stay in the middle, trying constantly to include all of the above-mentioned "ingredients." I believe that it is necessary to sometimes demand only proper musical and muscular execution of steps and exercises, and at other times work more on how one emphasizes and teases out creativity in a student, slowly working toward the middle, to the place where it is all one—wherein a student can

do a tendu and be creative and artistic with it, like the many ways a pianist can stroke a single C on his instrument.

What does a good class look like to you?

A well-constructed class for professional dancers working in a company should serve the dancers and challenge them at the same time. After a performance or having done long and tasking rehearsal hours on ballets that ask for totally different physical, mental, and emotional approaches, company class must bring the dancers "back home," put them on their legs, give them the opportunity to neutralize overtasked and tense muscle areas, be kinesthetically right and smart in order to soothe aching body parts originating from endless repetition of steps while working on ballet creations, and give the dancers enough time and mental peace to step into and prepare for another very demanding rehearsal day.

These processes will go a long way toward avoiding unnecessary injuries.

Musical choices and the buildup of the exercise patterns for company class, especially for the first 20 minutes, are arts in themselves and of immense importance.

All this, of course, does not mean that company class is a warm-up. At the same time, a valid and good company class must bring the artist technically and mentally further and make him grow artistically and react to the performed repertoire onstage. Any good class must always have an aura of magic, passion, positive energy, and a "smell" of art; it must animate the dancers to go beyond themselves and expand their mental and physical borders.

You can only do this—you are only a great teacher for a company—if you "bring them into your boat" in the first minutes of class. If you don't make it by then, it is usually too late. You must love the diva as well as the modest, introverted, hard-working type; you must appreciate the gutsy and intuitive dancer as well as the intellectual searcher; you must know that all these different types make a company exciting onstage; and you must know that you have to be big enough and tolerant enough to be able to give all of them "food."

You must inspire and develop them in an individual manner. A dancer educated at the School of American Ballet will require a different understanding, approach, and reaction than one who comes from the Rambert School. And this does not even touch on the different conditioning from

dancers' upbringing, initial training, places of birth, and cultural back-grounds.

Since I've been talking about teaching professional-level dancers, the reader will naturally ask, "And what about class for students?"

Well, the really good teacher will also enter the classroom with a certain allure, create magic, and bring passion, love, and understanding for both human beings and this art form into the studio. Yet, of course, one must work differently with students. The step material has to follow a logical and clear order of buildup. You will need enormous patience and at the same time firmness, so the student can improve and get a real technique, not a shallow surface and all-too-fast "pseudo arrival" technique.

Maybe in this area of teaching—being a teacher for students—the teacher must be more like a long-distance runner. To educate ballet students and bring them from a beginning to an advanced level is a marathon in so many areas. The sustaining of the teaching quality over a long period is essential and is what counts; the insisting, the never giving up hope, brings the student to success. Teaching for a company is the opposite: You have to deliver and succeed instantly. Great teachers exist in both fields, but inside themselves these "teacher types" are made up differently. I certainly am a personality that prefers to be a sprinter, teaching and working with professional dancers, teaching company class.

But I have endless respect for those who work with students, who "make" them, so that we can take over.

How do you bring families into the process?

I believe that this is an important question, and I must admit that I have little experience with families. I have not taught in a school situation for many years, but I do have strong opinions concerning this subject.

Certainly families must be included in some way, and it is nice if they react in a supportive way if their daughter or son wants to start studying ballet. In the long process of becoming a professional dancer, a supportive and loving family can be of help, since it is not always an easy path.

However, constant encouragement, pampering, and overly protective support can be harmful, because the young student may never really find out how passionate she or he is about becoming a dancer. He or she never has to mobilize clear conviction against a doubting authority—never has to stand up for her/his dream, to defend it, to fight for it; it is all given, accepted, financed, supported, easy, frictionless.

Many young people take up ballet because it was their childhood dream or because of some images they have in mind of what it is to be a dancer because of a performance they saw that enchanted them. This is legal, but it does not always hold up. It is often not a real passion from within and a real need to become a dancer more than anything else in life. They do not yearn for it. They become dancers because that is what they started doing at age 8 or 11.

Also, teachers and parents often look at the body of a child and decide: "Oh, this child should dance." This is ridiculous. Of course, physical ability is necessary (decent feet, for example), but in the end it is about something else.

I would keep families at bay—near, but at bay. There is nothing worse than an overly eager mother or father. Often the child opposes the parents sooner or later; this can lead the adolescent to stop taking ballet lessons just to be able to hurt them and show independence from them. They shatter something they love just to go against their parents.

Who were your favorite teachers, and how did they help you?

I had the luck to study with wonderful dance teachers from the beginning, as well as onwards far into my professional career as a dancer, teacher, choreographer, and artistic director.

I had great teachers in the ballet field and in the music field, as well as in Yoga and other areas that helped shape me as an artist and as a person. Here I name only a few: Marianne Fuchs, Peter Appel, Terry Westmoreland, Maryon Lane, Harriet Cavalli, Rita Horlacher, David Howard, and Gelsey Kirkland.

Marianne Fuchs, my first ballet teacher, implanted passion for dance in me. She would create an atmosphere of immense intensity whenever she was in the studio. One never really knew what to expect from her. One had to be totally awake and alert because her actions and reactions were never predictable. Her class was "light" because her exercises were made up of an incredibly diverse usage of dynamics and timings. The muscles got permanently stimulated with different accents and musical tempi.

In general her classes were "fast," even for beginning students: highly intelligent in the buildup, but totally unconventional, making your legs feel light and long, maybe slightly neglecting the slow muscular work and the area of port de bras. She constantly asked us questions; one had to try to explain why one was doing something, or try to analyze why she

would be building up an exercise the way she did, or why one would fall off a pirouette. Those students who thought dance could become their profession or inner calling had to work very, very hard, but she did the same. She lived in the studio, teaching from morning until late at night, even on weekends. It was not easy for all students to take her strong and demanding personality, but I sure learned from her that art and dance must be followed up with a drive that has something to do with life and death. Today I still believe that, or we are not justified in doing theater and asking an audience to pay money for it.

However, I do not want to be misunderstood; I believe much in humor and playfulness as well as in ease and flow.

I learned from her how important correct musical tempi for class are. Too slow can hinder the coordinative sense and reaction of the talented body—even "kill" it.

All of the above-mentioned teachers have given me a "world," and I will remain grateful for all the lessons they have taught me. What I have learned is by no means only about dance or music; it is also about how to go through life and how to face oneself and others decently, honestly, and constructively. Some things they tried to make me understand back then make sense to me only today. I find it always beautiful and touching when you have that special flash or moment and you say, "Aha! That's what the teacher meant." Well, one never stops learning. That is an overused phrase, yet in action too passive. A good teacher should never want to stop learning; he or she should look permanently and actively for opportunities to learn.

Even though my dance training was relatively short (I started dancing at 15 and three years later had already joined the Basel Ballet in Switzerland), I was still exposed to talented teachers who taught outside the big systemized schools. This is the reason why I talk a lot about the individual approach of a teacher to a student. I believe that it is not necessary that every talent needs nine years of rigidly structured training before she or he can join a company. I also do not believe in a "one-way street": that only RAD, or the Vaganova method, or any of the other systems can provide a well-rounded dance education. I believe that a lot of "schools" and methods have good and bad in them. I believe that a teacher is only good when he or she has the courage to first realize this and then admit it, and then only takes the best and the most beautiful from each school or sys-

tem, throwing out the rest, so to speak, analyzing whether what has been said and written and taught for centuries can truly hold up to a critical evaluation.

This is not rebellion; this is keeping things alive and valid. Nothing that is good remains stagnant. Honoring tradition does not mean that nothing can be altered, adapted, corrected, or improved. Originals are a myth in an art form that has human beings as its instruments.

Are technique and teaching evolving?

I am certain that ballet technique will always evolve and integrate new knowledge, while keeping its true and pure nature because of it being something almost like a law. I am not at all worried about its losing ground. It has grown out of a human need to express oneself through the body as an instrument and carrier of feelings, instincts, soul, mind, and emotions. It has evolved in a codified manner and through a highly developed and refined technique—a technique that is made to speak best on a stage to and for an audience.

Since ballet is a cultural phenomenon and rooted deeply within the consciousness of Occidental society, having grown from it for centuries, it will always remain present and will never be distorted. Truth can't be distorted; it could be neglected, go through ups and downs, but it will always be rediscovered and will rebound back to power.

Of course, I am aware of the sometimes low *niveau* of teaching and dancing (so few correctly and well-trained dancers audition for my company, for example), but this has always been so. I do not believe that it was ever much better. All the same, that does not mean that we should not remain highly critical about all things that come trendy and fast near our art and technique; we must keep working and thinking hard to keep ballet at the highest and purest level humanly possible.

A battement tendu can't be replaced; it is genius. An arabesque will always be the strongest physical symbol for a reach into space, a longing and yearning for another level, an almost spiritual reach into space or past it, and therefore a sign of hope. This versus the baroque, composed, much more earthly form of an attitude.

Turnout is not artificial and unnatural, either; only ignorant people say something like this. It is common in almost all dance forms and is even found in primitive and ritual dancing and in most folkloric dances; it is found in dancing from east to west, south to north.

Apart from its many benefits for better physical execution of ballet steps, turnout means opening the body up and out to an audience; what could be behind or above the audience as a symbol I do not have to tell anyone. A dancer who is turned out rises to a higher level, opens up the face of her or his body, making it soft and vulnerable, making it shine, making it give its energy out and away. I could go into endless beautiful detail and philosophy here; however, this is not the place.

Also, the ballet teacher, the exercise given, and the task of fulfilling this given exercise are only symbols of possibilities for achieving true technique and liberty of expression. Students should be made aware that it is never the teacher who has to be answered, followed, or obeyed, or certainly not only. By not fighting against the demands and tasks, the student is actually serving the art more than the teacher, and in this way the student becomes free. A teacher is the symbol of possibilities, not a person one has to serve. When one becomes aware of this, corrections become welcome like friends, and one can deal with the demands of this profession so much better and in a way that dancing becomes—despite its difficulty—beautiful and totally fulfilling.

Now, of course, you do not talk to an eight-year-old child about these things. This is so important. Some teachers do not understand that each age group has to be addressed differently or one really can do harm and confuse a child. I am always saddened when I see those young girls in competitions dancing an Aurora variation looking like Carla Fracci. All youth is driven out; all freedom and physical joy and attack have been lost. Instead I see drilled, possibly proper, but mostly lifeless and mediocre stylistic execution. Young men are safer here, because usually they are more rebellious and are less stifled by the teachers—mostly, also, less challenged.

Now to answer your question: I really have no idea where teaching is going. I think that is good.

GINA SINCLAIR

". . . layer upon layer of information."

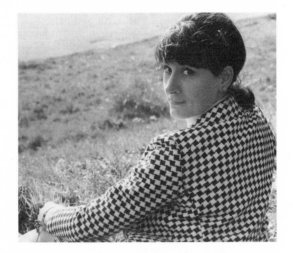

Gina Sinclair performed with London Festival Ballet before directing her ballet school in Victoria, British Columbia.

I was born in Brighton, in Sussex, England, 52 miles south of London. A tourist town, Brighton is on the south coast of England on the English Channel and is a city rich in history and architecture. I am the youngest of three sisters.

My mother is a "Geordie" from a small town near Durham Cathedral in the north of England, and she was a champion Charleston dancer in her youth. My father, a true cockney from the east end of London, born "within the sound of bow bells," played the spoons and the piano and loved to sing.

When I was seven years old, my mother had to go into the hospital for a few weeks. The public school I attended was on holiday during that time, but Sutton School, which one of my sisters attended, was still in session, and so they offered to have me attend there for that period.

Gina Sinclair. Photo courtesy of the artist.

Sutton School was a performing-arts school, doing academic classes in the morning and dance, drama, and voice classes in the afternoon and evening. I enjoyed being there so much that I persuaded my parents to allow me to continue to attend.

Everyone thought it was the dance and drama programs that I was attracted to, but it was the teacher of my academic classes; she was kind and patient and didn't smack me with the ruler or throw items at me, as teachers in my regular school had done.

My initial training was in RAD ballet with Mavis Ward and Stella Chase at Sutton School. When they retired, the school changed location and was taken over by two successful alumnae, Elizabeth Hodgshon and Joan Gridley. It also had a new name, Brighton and Hove Stage Educational School. At this school I studied ballet, modern and ethnic dance, ballroom dance, tap, drama, and voice.

At the age of 15, I went to Arts Educational School in London, where I had many fine teachers: Anne Hebard, Joyce Mackie, Eve Pettinger, and Ben Stevenson, to name just a few.

I did my first professional show at age eight in the Drury Lane production of *Carousel*, as the youngest child of the Snow family.

As is the tradition in England, I danced, acted, and sang in performances every winter and summer, with headliners such as Harry Secombe, Max Bygraves, Dick Emery, Adam Faith, and the Roulettes. I acted in movies with Bernard Bresslaw, Tony Hancock, and Norman Wisdom. I also danced as an "on-call" with the Royal Ballet in *Swan Lake* and other ballets, and I performed for the USSR Red Army.

Arts Educational, the college I attended in London, was the feeder school for the Festival Ballet. When I graduated, I found myself in the company of many great and inspiring dancers: Lucette Aldous, Nadia Nerina, Beryl Gray, John Gilpin, Svetlana Beriosova, Ben Stevenson, and the incredible Dame Alicia Markova.

When I moved to Vancouver on the west coast of Canada, I was so very fortunate to dance with choreographer Norbert Vesak. I loved his choreography and storytelling, and I finally felt that I had found the perfect style of dance for me, a cross between my classical ballet training and the acting and drama of my early musical theater days. Norbert was choreographing for Lynn Seymour when he and I partnered in a CBC television series called *Moods of Man* and later on in other productions.

When Norbert left the west coast to choreograph in the United States, I decided to stay in Vancouver and become part of a group of dancers working independently as well as with choreographer Jack Card, opening shows for Oscar Peterson, Bette Midler, Ike and Tina Turner, Rolf Harris, Diana Ross, and many more headliners of those days. I also was dancing in productions for the Vancouver Opera, CBC TV, and CTV, and I started teaching again.

My career started to change from dancer to teacher as I did more and more guest-teaching, and I found myself working across Canada and in the United States and teaching for two years in Mexico, where I was introduced to the remarkable new Cuban ballet system.

My teaching has also led to working with visiting ballet companies and teaching local students their parts in the ballets. I think I have about eight versions of *Nutcracker* in my head.

In this capacity I have worked with many wonderful choreographers, like Toni Pimble and Ron Cunningham, and later I had the opportunity to learn another *Nutcracker* from the very talented Edmund Stripe from Alberta Ballet, with the world premiere taking place in Victoria.

The stage school in Brighton I attended had about 50 day students and about 200 evening/Saturday students. When I was 12, my ballet teacher, Elizabeth Hodgshon, invited me to help her on a Saturday with her once-a-week ballet students. It was a pivotal moment in my life. I remember two thoughts turning on like lightbulbs in my mind that first day I helped her. One was the realization that I was part of an elite and talented group that attended the day program. The other was that Miss Hodgshon gave the same care and attention to the students in the once-a-week class as she did to my classes of advanced and gifted ballet students.

When I was 14, Miss Hodgshon arranged for me to teach a community class on a Saturday. The class met in a little church hall, and we used the backs of chairs for the barre. Miss Hodgshon helped plan my classes. She always seemed to know what I needed to do. Years later, I found out that my pianist for those classes and Miss Hodgshon were good friends, so I am sure they had many conversations about my teaching skills or lack thereof.

A few years later, when I started taking my teaching exams, the experience of assisting at age 12 and having my own group at 14 was invaluable.

My studio, Sinclair Academy of Dancing, was a dream come true. It was a place of activity and high energy with a fabulous faculty and pianists, beautiful large studios, good floors, and an excellent location.

I was able to offer RAD ballet, graded and vocational levels, same for ISTD modern and tap, ISTD grades in national (ethnic dance) and vocational levels for ballet, flamenco, musical theater, choir, acting, stretch, and strengthen. Students participated at dance competitions and traveled with our performing group.

Some of the goals I had for the studio were that I wanted to provide complete training for aspiring dancers, singers, and actors under one roof. During both my performing and my teaching career, I had met so many talented people who could only do one thing, usually dance, and usually only one style. I wanted my students to be the best prepared for any job opportunity that came along.

I wanted Sinclair Academy to be a place where everyone was welcome and where everyone would be placed in the right spot. I wanted it to be a safe place to train—safe physically as well as emotionally. As I look back, I think all my dreams and hopes were realized.

There are so many things that I'm proud of. I think seeing my students go off to professional careers is a big one, as were the classes I taught for special-needs students. I can still recall the thrill as one of my autistic and brain-damaged students started to march, picking her knees up on her own.

I was proud to be the president of a huge arts festival and to receive the YWCA Woman of Distinction nomination and a CFAX radio award for my work in the community. I was really excited when Sinclair Academy Choir, made up entirely of dance students and under the fabulous direction of Anne Marie Brimacombe, won local, provincial, and then national awards, and they went on to perform in an international choir competition. I was delighted to help the Ministry of Education establish grade 10–12 school credits for exams.

I am proud that the Sinclair Academy performing company, the Young Victorians, has had the opportunity to tour and perform in some wonderful locations and that it has given many dancers their first opportunity to choreograph or design a costume.

At Sinclair Academy we did all the Royal Academy of Dance graded (children) and vocational (professional) levels. For a while we did British

Gina Sinclair at the Brighton Dance Festival at age seven.
"Apparently I had been crying because I didn't want to dance
my solo, but got all happy for the photographer." Courtesy
of the artist.

Association of Teachers of Dance medal exams in ballet, tap, and jazz. In the Imperial Society of Teachers of Dancing we sometimes did the national (ethnic or folk dance) and classical ballet grade and vocational, and on a regular basis we did all the levels including teaching exams in both the modern and tap syllabi. We also did school exams with a guest examiner, which gave every student an opportunity to set goals, have a positive experience, and learn how to prepare for an exam.

I feel quite strongly that exams should be part of every student's agenda. When the school offers many types of exams from many institutions, it gives you the opportunity to find the right match for every student. There's also the practical side that by following a syllabus, the buildup is there and nothing is missed. Should a student transfer to another city, region, or country, the training can continue without any technical information being missed.

I see exams as critical in the making of a dancer and in the building of the person. I want every student to be working toward goals and making decisions.

I used to issue report cards on each student. Report cards were very useful to communicate expectations that were being met and those that were not. I could say the same thing every week to a parent/student, but when it actually faced them in the written form, it seemed to get a reaction.

The downside was that the students and parents would share and compare report cards, even though I tried to make it very clear that they shouldn't compare their child with others.

You might ask what it's like since I've retired from directing a studio and have begun teaching for others: I just love it. As an independent contractor I now have time not only to teach but to do all the other dance-related projects that I want to do.

Some of the positive things are that I can focus just on the teaching without distractions. If I have any concerns about a student or a situation, I speak to the studio owners and they deal with it.

What do I miss about directing my own studio? Absolutely nothing.

I am often the ballet mistress for local ballet students who are cast in touring productions of *Nutcracker* that come to Victoria. I have also taught students for *Romeo and Juliet, Swan Lake,* and other ballets.

It's not a mysterious process, and it works best when there is great organization and communication between you and the ballet company. For example, most *Nutcracker* productions use between 40 and 70 local students in every performance. Space backstage at the theater here in Victoria is limited. Add in 40 to 50 members of the orchestra, the ballet company itself, and their support staff, and you have one very, very tight squeeze. I work with the ballet-company stage manager to establish arrival and pickup times for all the local dancers.

My advice to others looking into staging ballets is to know that it's one part teaching and nine parts organizing. I have found that it is attention to the small details that can make the big difference. Get everything arranged well in advance. I have the rehearsal schedule available at the auditions so that parents and students know whether or not they will be able to make the commitment. There must be firm rules and consequences about attendance and behavior.

Communication with the parents of the students is very important. I send out an e-mail each week during the rehearsal period, and I number them so they know immediately if they have missed anything.

Always have a plan B.

Some of the stories and highlights of my doing this are of one year, as Clara and Fritz had the tug-of-war over the Nutcracker doll, the head came off just as it was supposed to, but unfortunately it went flying into the orchestra pit. With hardly a pause one of the musicians tossed it to the conductor, who then threw the head to Fritz onstage.

The Royal Theatre in Victoria is very old and has uneven heights of ceiling in the dressing room and green room area. Although one area has a big OUCH sign on it, red paint around it, and foam attached to it, one male dancer, rushing offstage, ran smack into it and knocked himself unconscious. While we waited for the ambulance, his costume was peeled off him and put on another dancer. The performance continued without the audience being aware of the drama going on backstage. (He had a concussion, but was dancing again in a few days.)

I have seen company dancers missing an entrance when they went outside during a performance and couldn't get back in because they couldn't remember the security code for the stage door.

I saw a costume hook get caught on a dancer's tights and rip a huge

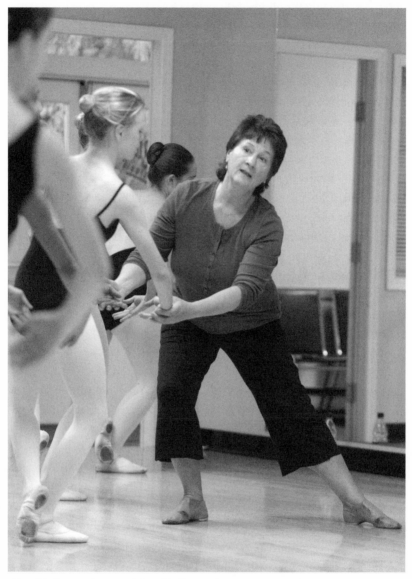

Gina Sinclair working with local ballet students to prepare them for a touring production of *Swan Lake*. Photo by Ray Smith and courtesy of the *Times-Colonist*.

hole in them. Then there was the time the overuse of dry ice for the opening of the second act had the fog pouring off the stage and into the orchestra pit. The poor musicians couldn't see their music.

One year the Sugar Plum Fairy was sneezing like crazy because she was allergic to the pony used in the closing of act 1. One production of *Swan Lake* had only eight costumes for 12 dancers.

I have lots and lots of stories.

Dance is my passion, my work, and my hobby.

GINA SINCLAIR ON TEACHING TECHNIQUE

What is technique?

It is layer upon layer of information, applied to the mind and practiced by the body, that gives the student the tools needed to dance.

How might you define it?

Technique is the correct use of movement that will allow the dancer to communicate. The ability to execute technique creates a body of knowledge or skill that can be developed into an art form.

I explain to my youngest students that building technique is just like building a house. Not just any house, but a solid, beautiful mansion, and that in every class we build another room onto that mansion to store all the information that we learned that day.

If they can feel the opening away and rotation of the thighs in a demi plié today, I will have straight hips and correct muscle use in a grand battement when they are older.

I explain technique to the parents of these young students in much the same manner, hoping they understand that with a careful, well-taught, and well-understood foundation, the possibilities are limitless.

How do you go about imparting it?

Teaching carefully, very carefully.

Taking the time to be sure the mind understands and the body feels it. It's important that students understand the breakdown and the buildup of steps as well as the terminology in order to connect it all together.

It is my job to use my experience to impart that information, and then guide the students to the point where they discover for themselves how it feels when a step is done correctly and what the connection is between what they learned in the last class and in today's class.

Is there a difference between skill and technique?

I see technique as the road to skill. I see skill as the final product of all aspects of training coming together, i.e., having the technique along with the presentation, musicality, and maturity of style.

What do dancers need to learn to master technique?

I think my answer might surprise some people: I think they need excitement. A student needs to feel excited about coming to the ballet studio to master technique. A dancer needs to be self-motivated as well as motivated by the teacher and by the pianist.

If dancers are truly motivated, they will observe, listen, ask questions, try harder, work at it, perfect it, and enjoy the satisfaction of giving it their best effort. Yes, they need to learn about moving well, about space and projection. But without the desire to learn, it just falls on deaf ears.

What part do interpretation and presentation play in acquiring a good, solid technique?

Young children are natural actors. They love to tell stories in movement as they make up their own dances. Interpretation and presentation come naturally at a young age, and we as teachers need to take that natural gift and develop it alongside the technique.

We can't spend years perfecting the technique and then one day say, "Today we will learn interpretation and presentation." It's just not going to happen.

If we use music, if we use acting, if we even use simple props when they are little, if we give praise for walking so beautifully like a princess or for looking and dancing so mischievously as a garden gnome, and develop it appropriately to their age, we will have a Clara, a Romeo, or a Black Swan who will portray all the emotions naturally and sincerely.

What should a good teacher be expected to do?

I believe good teachers work to inspire the students in their care. They work to understand individual students as well as the class as a group. In return, students will respect both their teachers and the class discipline/ structure.

I think a good teacher strives to be creative in presenting ideas for learning technique and never becomes predictable with class content or programming. While a lesson plan is vital in having a direction in which to travel, so is flexibility to go off in another direction if necessary.

Students need to feel that they are all being treated equally with corrections and in answering questions. They should be given the opportunity to express their ideas.

When I am teaching, my goal in every class is to give correction and speak one-on-one to every student in the class, no matter what the class size or level. I want students leaving my class to know that I noticed them. I want them leaving feeling satisfied, exhausted from effort, and mulling over what has been taught.

What are the challenges that students most often face?

Time management. I teach a lot of preprofessional dancers who manage school/dance very well, but I still see many others struggling as they try to accommodate school, homework assignments, dance classes, exams, performances, and a social life.

Making choices. In the 9- to 12-year-old group, I see students who are gifted in dance also shining in athletic activities, and they are being placed on top teams in gymnastics, soccer, golf, horse jumping, etc. It's too much. They have to make a choice. Will it be dance and dance only? I don't believe it is possible to do everything.

One step at a time. In the ballet studio I sometimes feel that everyone is in a rush to perfect those double tours en l'air or 32 fouettés en pointe. I remind students, and occasionally parents, that due to students' body growth/development, technique cannot be rushed, that more strength might need to be developed before attempting certain steps, or even that a period of rest must happen.

While they trust me and my judgment, I always sense that they believe that if it isn't mastered by noon tomorrow, it just will never happen.

What are the challenges that teachers most often encounter?

Some are mentioned in the previous answer, and along with that are the university scholarship opportunities that are far more numerous for football, golf, and soccer than for ballet.

Canada is a huge country, but we do not have enough ballet companies to offer places to the amazing talent being produced within our borders. It is frustrating to prepare a student for a professional dance career, only to see the young dancer miss opportunities with American or European ballet companies because of not being able to obtain work permits.

How do you bring families into the process?

Educate them from Day One that communication between parent, teacher, and student is paramount. Have report cards. Have viewing windows. Have a monthly newsletter.

Have special events at the studio that allow parents to participate, be it a belly-dancing class, fund-raiser, or guest speaker. Invite parents of the new seven-year-old student to view the older students' class, so they can experience the vision that you have for their child.

One of the fun things that I do is create a piece of choreography for the fathers of the students to perform at the year-end concert. It is always received with gales of laughter and thunderous applause.

It is wonderful to watch these dads who have had little or no experience in a dance studio, and have never been onstage, develop a deep respect for what their children are able to do.

What does a good class look like to you?

On time. In my classes, as one level leaves the room through one door (walking in line and with music), so the next class walks in through another door. Students clean and correctly dressed. Students having everything with them that they might need for class. Students eager and anxious to get started. Students who listen to everyone's corrections and check themselves to see if it applies to them, too. Students who give encouragement and praise to each other. Students who ask lots of questions about what we are learning. Students who are excited about the challenge of tricky enchaînements.

A great pianist. And a teacher who is organized and enthusiastic.

Who were your favorite teachers, and how did they help you?

I have been fortunate that throughout my career, as a student, a dancer, and a teacher, I have had many wonderful and very gifted mentors and role models touch my life. The one who had the most influence was Miss Elizabeth Hodgshon. I met her when I was 11 and had already been dancing for several years. A mysterious mixture of warmth and aloofness, she made ballet come alive for me. She made it all clear and understandable. She set standards; she had expectations.

She petitioned my parents on my behalf for extra classes or workshops or for tickets to see performances by the leading ballerinas of my day. My parents appreciated her interest and respected her judgment.

Miss Hodgshon was so convinced that I had potential that she paid the

fees for my first term in London. She convinced me of the need to take my teaching exams; she introduced me to ballet companies and dance colleges. She advised me on career choices.

What a lady. We stayed in contact until her passing.

Are technique and teaching evolving?

While I'm excited to see stronger technique being shown in ballet companies, I have concerns of it becoming gymnastic in style to catch attention, as in a wow factor, rather than developing for the beauty of the movement itself.

I recently watched a video clip of a young woman standing on a man's head, en pointe, doing grand ronds de jambe. Amazing? Yes. Attention getting? Yes. Beautiful and artistic? Not at all in my eyes.

I am excited to see progress being made in the understanding and imparting of knowledge, from teachers to dancers, on how the body should work, as well as the vast opportunities to use chiropractors, acupuncture, Pilates, and physiotherapists to keep the body in top running shape.

I think that as long as we have well-trained, well-informed, and caring teachers, ballet will continue to evolve and inspire the next generation to take it one step further.

DEAN SPEER

"For boys and men in ballet today, the helicopter has landed."

Dean Speer is the founding director of the Chehalis (Washington) Ballet Center and former artistic director of the Chattanooga Ballet. His choreography has been filmed for national television, and he has conducted many workshops for teachers.

Seattle Ballet Ensemble, Jennifer Carroll, Dean Speer, and Shelagh Regan. Photo by James Brian Gaffikin.

Sometimes my family has the unfortunate habit of getting shipwrecked, as was the case for my great-great-grandfather, Isaac Newton Van Hagan, who in 1857, according to the family Bible, was "Lost at Sea on Central America." His daughter, California (Callie) Van Hagan Bogue, last saw him sitting on a door of the boat, floating off, with the rest of the men, while the women and children were in the lifeboats. Happily for me, she survived to become my great-grandmother.

Her daughter drilled into us grandchildren the tenacity and will to not limit ourselves in any way. She wanted to ensure that we could and would follow our dreams and passions, as she had herself been thwarted, first from pursuit of an operatic singing career and then as an artist painter, due to the mores of her time.

I was challenged by the dance and sought to master this most difficult of art forms. Teaching already was a passion, and an opportunity presented itself early in my career.

Yet my first attempt to "float my boat" with a dance studio hit shoals as my very first studio venture failed utterly. We didn't have one student. Not one! A colleague and I had spent months preparing a studio space that we were convinced would naturally attract dancers by virtue of having what was going to be the best dance floor in Seattle.

Louise Durkee and I crawled around, meticulously picking sewing needles out of the cracks in a space that had been a sleeping-bag factory. We then cleaned, sanded, varnished, buffed, and finished it before building dressing rooms. As the finishing touch, we hung posters of Paris Opera Ballet dancers that I had brought back from Paris, where I had been a student.

We just knew dancers would flock to such a neat place to dance. Great plan, yes? Wrong. What we didn't realize was that we needed to be in a neighborhood where more people lived. Our studio was in the Pioneer Square area of Seattle. Lots of businesses, but few residents and certainly no children. Not to mention virtually no parking. And certainly not as popular and chic as it is today. Probably it didn't help that there was not a lot of effective advertising.

One of the nuggets for me was that I resolved to learn as much as possible about managing a studio and about teaching and that I would try to pass this information along to colleagues and friends.

Years earlier, sitting cross-legged in my gym shorts and sneakers, I never thought that my first day of PE would provide the epiphany that I might actually be a mover. While watching my classmates struggle to climb a wall fitted with holes that went up the side, it suddenly occurred to me how to get efficiently up and down using the pegs provided. If they would only *swing* back and forth, releasing one peg and using their own weight and momentum to put the peg up to the next level, then they could ascend easily.

This proved to be true when it was my turn. I felt how to do this swing in my body, timing it with the release and placing of the pegs—and up and down I went, much to the amazement of my classmates.

This experience taught me that I had an affinity for movement and that I could fairly easily analyze and then reproduce movement. All of this is applicable to ballet.

What really inspired and challenged me to take up the ballet mantle was my Russian and folk dance teacher, who arranged a semi-private class with Mark Morris when he was only 16 and I was 17. Instead of giving us a character class, he put us through a vigorous ballet class. I ended up being so sore that for the next three days I had to be driven to school.

I felt greatly challenged to master this dance form, so I began to seriously take ballet lessons, first at a neighborhood studio and then from Gwenn Barker, who really helped my technique. By serendipity, I added on modern, including the Graham technique, when I showed up at a scholarship audition that I thought was for ballet but was for a modern-dance school instead. It was all quite foreign to me to be asked to "make round shapes changing to face alternate corners, using our natural breath phrasing for the rhythm." Probably no one was more surprised than I when I was awarded the scholarship, which altered my dance life and direction.

I thought I might be pretty hot stuff—until Rosella Hightower gave her first class for my group at her Centre de Danse International in Cannes. Her épaulement was exquisite, at once complex and simple. This was my inkling that I had yet a lot to learn. And how *exacting* in Jose Ferran's Men's Class—everything had to be just so. How Arlette Castinier wanted the pliés in jumps to go—just the opposite of how we had been doing them!

I learned so much from my performing experiences, which were first

with a Regional Dance America company, the Bellevue Civic Ballet, and subsequently in a couple of modern dance companies, Repertory Dancers Northwest and ATMA (American Theatrical Motion Art) and then the Seattle Ballet Ensemble.

The first owner/director of the rural dance studio who hired me to teach fled in the dark of night after her last recital with the end-of-the-year recital receipts and tuition for the coming summer in her cash box. She and her kids absconded on bicycles to California. Not only that, she had left a massive debt behind, including a loan from one of the adult ballet students.

Undeterred, the student who loaned the money and others asked me to continue the studio, and this is how the Chehalis Ballet Center (now doing business as Southwest Washington Dance Center) was born. We incorporated, scheduled classes and teachers, and opened for business in the fall of 1982.

It was a very exciting time with lots of challenges, but we believed strongly in what we were doing. This is what made going to teach each time special and rewarding. It certainly wasn't the money; it was a labor of love. The riches were in the work accomplished, in the differences we saw and hoped it made.

As I knew teaching was to be my true métier, I devoured everything related to ballet technique, training, and teaching, including teacher training, seminars, workshops, meetings of teachers, lessons, classes, books, articles, and exchanges among colleagues. I also felt it was important to be in shape enough to demonstrate as much as I could, particularly for those students who needed a visual model and who were not familiar with the steps and movements. So one summer, when teaching was to become my focus that fall, I worked to whip myself into shape as much as I could, and I found that not having the pressure of needing to get into a performance level allowed me to "relax" and to push myself and my technique beyond what I thought possible.

As a teacher, when I wanted to experiment with something technical—perhaps a new way of doing things—a step or a new combination—I usually tested it out on myself first before inflicting it on my students. This is still my style today, working out the outline of classes or of specific combinations in advance of a week's teaching or of a particular approach.

When boys and men do show up for dance, nobody is more thrilled

than I. Growing up, I thought I was about half of the entire male ballet population of Washington state, although I didn't *really* mind being the only male in class.

So when guys just started spontaneously showing up for class at the rural Arlington (Washington) studio where I was teaching, of course they were welcomed into the advanced ballet class. (Tossing guys into advanced ballet class was a tactic that the chair of the Dance Department, Karen Irvin, used to deploy to good effect at Cornish College.)

My favorite drop-in was a member of the Love Israel commune. Truth turned up one day, saying his goal was to be an actor and that he knew actors needed movement training, so he wanted to take ballet. Truth knew many of these young women in ballet from high school, so I'm sure it seemed logical to him to attend their class, too. He actually did well, not so much because he had innate talent but because he was so good-natured and good-humored that messing up or not being quite able to do something didn't bother him. And the girls loved it. We even were able to put Truth into the end-of-the-year recital.

Today, many dance schools have boys in their classes, and a few have quite a lot, with some offering "boys-only" classes.

By my own feeble calculations, I've taught, substituted, filled in, adjudicated, given master classes, or coached at what seems like just about every studio in the greater Puget Sound region of Seattle and of Washington state—and beyond. The physical plants these represent range from Pacific Northwest Ballet's made-to-order complex to a studio in Olympia that used to be someone's attic.

On famous Lookout Mountain, Tennessee, our branch studio was a church social hall, and one of my jobs—as artistic director of Chattanooga Ballet's school and company—was to set up the ballet barre each week before class, using folding chairs. On the next mountain north, our Signal Mountain branch studio was a stage. Headquarters in Chattanooga was the studio underneath the football stadium bleachers. It was actually the reception room for alumni, so during Homecoming and other big football events, we'd have to vacate.

Talent and degree of training also have their range. Talent pops up in some of the most unlikely places. One of the best studios I've come across is in the central Washington town of Ellensburg, home of its famous rodeo. No cowboys, but some very lovely and well-trained young

dancers. While preparing and warming myself up to guest teach, I was so impressed by what I saw with the students who were doing the same that I retooled my plans on the spot and gave them a more advanced, professionally oriented class.

This is at one extreme. The other was a studio where, after a teaching friend and ballerina from PNB had guest taught, she grabbed my arm and—mortified—exclaimed: "Dean, they don't even know how to hold on to the barre!"

I've long felt it my mission to bring my passion and love of teaching dance to rural communities. These places seem to appreciate it, and I've found that, unlike a false stereotype about country folk, they often know more about arts and world affairs than their urban counterparts. I was bringing something they would have sought out had it been readily available—a ballet studio where serious work could be accomplished.

There in that setting, I can remember my first teaching shriek, echoing down the studio corridor. The students had just tried their first full pirouettes on pointe, and they were amazing. Fast, sure, all the way around, with a quick solid stop, pausing in passé.

This was my first time, too, with the process, and I was thrilled beyond belief—and relief. They had discovered, by actually going through a slow and careful building-up process, that using a logical progression truly works. They became fearless turners right from that point and achieved what others might take years to learn.

I have an intimate relationship with my car. Having been a rural teacher, we've gotten to know each other really well. I spend seven or eight hours a week on the road. I've traveled to teach via feet, train, plane, taxi, bus, and car—everything except canoe and wagon.

I've disciplined myself to make use of these times when I'm communing with my car to review and memorize class notes, plan choreography, and generally get myself organized so that when I pull up to a work site, I'm prepared. I learned this method from my first male ballet teacher, William Earl, who used to tell us how he would mentally review dances he was in or learning while shuttling between rehearsals in New York and, by doing so, how he often found himself better prepared.

My wise mother, who was a schoolteacher, advised me once not to get too close to my students. While I agree that it's good to keep a "professional distance," there are times when students enter my heart and are

closer than close—such as Alexandra Asbury. She was 16 years old when I met her, but danced as if she were 30. Before she turned 20, she was a recovering paraplegic because of a traffic accident.

Her initial training had been as a five-year-old in a pre-ballet class in Bellevue. She then went on to Cornish College as well as San Francisco Ballet and the National Ballet School of Canada. Between quarters at the University of Utah, she would make the 30–mile trek south from her Olympia home to Chehalis to take my classes. It was always a joy to have her there and certainly an inspiration to the others as an example of what might be possible for them.

As she recovered from her injuries, Alex and I worked. And for about a year, we pushed our way through a batch of therapeutic exercises, most really tough and made so by their simplicity and goal. Her tenacity and cheerful spirit never flagged.

Alex returned to the University of Utah, finished her degree, and later earned a second degree from Washington's Evergreen State College. Alexandra and her husband, Jacques, have two adorable children and own a thriving software business. But dance is still a part of Alex's life: her daughter has taken ballet, and Alex teaches at a local studio. I came to love Alexandra and her family. She is one of the many who've touched and changed my life—something I didn't think possible when beginning as a teacher of ballet.

Another lesson I learned was noting that everyone I've ever met who was at the top of his or her game has always been super nice—from Ann Miller to Anna Russell. Merce Cunningham impressively wrote a personal note explaining his regrets at not being able to lecture in his hometown while his company was on tour in the area. When I contacted Jerome Robbins for his remembrances for a book I had started about Nelle Fisher, he said I could make an appointment for the next time I was going to be in New York. The only two who ever really cowed me were George Balanchine, coming in to observe one of the men's classes at SAB, and Lincoln Kirstein, striding out into the hall that same day.

The first time I met Martha Graham, she put me at ease. I was a very devoted acolyte and could hardly believe my good fortune. She put her permanently contracted and black gloved hand out to greet me and thrilled me by chatting.

Alexandra Asbury in arabesque penché, circa 1987. Photo by Dean Speer.

The third and last time I got to speak with her, I also unintentionally geographically confused her. I was at the Graham studio for the end-of-the-summer student showing. After making her applauded entrance, Miss Graham took her seat and the students performed studies directed by Pearl Lang: mini-dances based on a theme and then an excerpt from Graham's full-length modern dance *Clytemnestra*. It was such a hot August night that everyone repaired to the garden outside the studio door, except for Martha, Ron Protas, and Linda Hodes, who were seated on each side of Martha.

I couldn't believe that everyone had left and no one was talking to Martha. Not wanting to let this opportunity slip by, I went right up and

introduced myself, reminding her that I was a friend of Nelle Fisher. Martha replied, "Oh, Nelle! How is she?" I made the mistake of telling her that Nelle was retired and living in Edmonds (a suburb north of Seattle) rather than in Seattle itself. Martha thought I'd said Edmon*ton* and promptly launched into how she'd "played" not only Edmonton but Saskatoon, Regina, Moose Jaw, and so on. Perhaps I should have corrected her, but I wasn't about to interrupt, and besides, this was way too much fun, and I was charmed by her use of the old vaudeville term.

My real début, though, as a "merchant marine" ballet performer began when a rural producer saw me dancing in California and invited me to a town north of Seattle known more for its antique shops than for its ballet, to star in her production of *Nutcracker*. I asked several times who my partner was to be, but never got a straight answer until I showed up for the first rehearsal and there was her daughter. It actually worked out because she was a hard worker and a cheerful partner.

A Seattle television station came up to film us for their news broadcast, as one of the shows was a benefit for Seattle's renowned Children's Hospital. One of my first ballet teachers caught the broadcast and couldn't believe it was me, commenting, "Dean, you looked so good!" I joked, "It was the makeup!" and I think she half-believed me. In a former teacher's eyes you'll always be a youngster.

In ballet, I'd probably be considered a "demi-character" dancer. In modern, I was the one they gave the hard steps to, which I loved doing. Our American Theatrical Motion Art (ATMA) Dance Company director, Ruben J. C. Edinger, had been commissioned to make a piece for Repertory Dancers Northwest, of which I was also a member. During one of our shows—on a stage with a movie screen behind the black upstage curtain—I was to make my manège entrance, doing very fast coupé jetés from the upstage right wing, leap to join a female dancing partner, and then get swooped up into a lift by one of the men in the company. On the first charge in, I caught my left foot on the standing leg of the movie screen, and I was on the floor before I knew it. But I kept moving forward as fast as I could into another leap to my awaiting partners. I've learned by experience that these kinds of things that happen are not that big a deal. You just need to keep going and learn that part of performing is adapting and adjusting. Performing is not being on automatic pilot or doing it by rote; it is being in the moment. This is what makes theater live.

Dean Speer on Washington's rural Olympic Peninsula with Pioneer Dance Arts. *Left to right*: Kathleen Herndon Moore, Valerie Kardonsky, Speer, and Judy Joyce Smith. Photo courtesy of the *Peninsula Daily News*.

While not quite as rip-snorting a good time, there was the dramatic occasion when a *Nutcracker* tree had a nervous breakdown. In Clatskanie, Oregon, Christmas decorations were being pinned on Stahlbaum's tree when down it went, crashing in a giant heap on the stage floor. A small squeak of "Oh, my!" came from Clara's lips, but being a good trouper, she carried on as if nothing had happened. So did the party guests—all gesturing in delight to a blank space, ooing and ahhing as if this tree were the most wonderful thing in the world.

I had made a small career being paired with the daughters of studio owners. I didn't mind: it was fun, always a memorable performance experience, and I got paid to do it. This time I was doing a pas de deux with, yes, the daughter of the collapsing Christmas tree director, when her father, who was hardly ever backstage, came over to me and cheerfully announced, "My daughter . . . built like a truck!" I'm not sure that was helpful to either of us to hear, but I did note that, as strong as I was, when she leaped and I caught her, I did let loose an uncontrollable "Ooof!"

It was while dancing for this director when I realized that I probably should consider hanging up my ballet slippers. We had reconstructed parts of *Paquita* and I was doing the pas de deux. It's a tough and exacting part and a beautiful ballet. While making port de corps and stretching over in the wings of the historic Columbia Theatre, I saw the cummerbund of my Spanish style costume consumed by my waistline. In fact, it had totally vanished. This was my clue. Avoirdupois helped push me to say "Avoir!"

Most of us welcomingly take who we get through the studio doors. Some of these are very memorable. For example, there was Taran, who was a "natural woman." While being natural, she was also a natural klutz, although she tried hard. I think she won the gold cup for ending up on the floor more often than anyone in her adult ballet class.

During pliés in second position while clutching the barre, *whomp!* on the floor went she. Arabesque and wham! down she'd go. She could fall to the floor faster than a Graham dancer. Taran was way too nervous, and I spent half my time with her just getting her to relax and move more naturally. Did I mention that I never give up on my students? Other teachers would ask me why I even tried, but not being one to give up, I kept working with her—and Taran did make enough progress that she could be in the corps of a piece and not embarrass herself, me, or the ballet.

At the other end of the scale, completely on balance, is the most beautiful demonstration of technique I've probably ever seen. While I was observing one of the Professional Level classes at Rosella's, Madame Hightower asked a man who was with La Scala in Milan to demonstrate a grand jeté en tournant, in other words, a tour jeté. He took a preparation in fourth position and was still for a long time; we didn't think he was going to move. Then suddenly he brushed his leg up to the front, rose up into the air, turned over in it changing his legs, and landed like a cat in a perfect and serene plié arabesque. It was so gorgeous it took our collective breath away. Hightower smiled wryly and reported, "*That's* how to do it!"

I thought it would be a good idea to feature all of the dance groups in the Seattle area on a single performance series. For three years I produced and directed a monthly show, *SPOTLIGHT: Seattle Dance!* This Sunday afternoon series featured a ballet group, a modern company, and an "ethnic" or other ensemble on each program. These ranged from Pacific Northwest Ballet to solo performers. Each group received 20 minutes of stage time to do whatever they felt best represented them. Working with the theater staff was wonderful; they were so supportive, and I learned so much.

Speaking of technical difficulties, I was in an antiwar modern dance that began in silence. So at first we didn't think there was anything amiss until no sound ever appeared. It turned out that the sound technician had not only rewound the tape the wrong way but that he had also put it back on the empty reel backward. We did an entire 30–minute ballet in silence. The hardest parts were the places where we relied on the sound score for cues. Two of us were left onstage—with me on my side, facing the wings with dancers hissing, "Dean, roll!" I did, this being their cue for their entrance. Fortunately, some members of the audience thought it was supposed to be danced in silence and told us how riveting the work was—that they could hardly breathe or move because it was so dramatic and moving.

I was doing the right thing by trading five-plus jobs for one as the director of Chattanooga Ballet, when I jumped ship from Chehalis to parts unknown to me, right? Little did I suspect that there was an ongoing feud, not between the Hatfields and McCoys but between the previous husband and wife directorship team and the current ballet administration. This

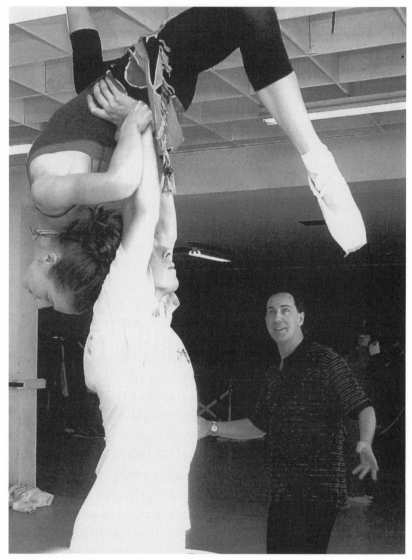

We were trying a tricky lift for the Snow pas de deux from *Nutcracker*, and a local press photographer happened to capture us at the moment where they "got it" and I'm exclaiming, "That's it!" Sarah Dolozal partnered by Casey Cate. Photo courtesy of the *Chronicle*, Centralia, Washington.

feud made the famous one seem like a tea party, but nicer. Hurt feelings and things said that shouldn't have been. I thought when I interviewed (twice) for the job that I had asked all of the right questions. Hah!

After I had signed a three-year contract and moved clean across the country, the first thing the manager said on my first day was "Good morning. We're broke!" or words to that effect. My first impulse was to run back into my apartment, call the movers, and tell them to turn the van around. But I didn't.

We got through the first six months, and some really positive changes happened. I got to choreograph the opera *Aida.* And I got to work with some very dedicated and beautiful talent, both in the school and in the company.

But it soon became clear it was time to hire an attorney, which the board members themselves recommended, to negotiate a settlement and move back to the great Pacific Northwest. I'm still in touch with many with whom I worked in Chattanooga. The two warring factions have agreed to disagree and are thriving today.

Currently, I am happily busy, teaching for several Seattle-area studios—one for nearly 20 years—and I'm excited to be returning to guest-teach at the Chehalis studio, where I first gave some classes for Bicycle Mary 29 years ago, coming full circle. I stage or create the occasional ballet and take class when I can, and I was recruited a few years ago to write for an on-line dance magazine, *Ballet-Dance Magazine,* and for its inter-active forum, *www.criticaldance.com.* This in itself has been a remarkable journey: I've met so many great people, all so committed to their art.

Sometimes as an itinerant dancer, it was tempting to feel a bit mercenary, but mostly I've danced my heart out and had a ball. I've been blessed and can hardly wait for what future treasures may come my way.

DEAN SPEER ON TEACHING TECHNIQUE

What is technique?

The word has Greek origins with one marvelous meaning of "art." It's a means by which we carry out a particular aim or task.

How might may define it?

You really can see what I term "hard-core" technique in someone who has it, and you can see it starting to flower and develop in those who are

being trained. I believe it's an inner understanding of how to do something and do it well. That's why I like to say, "I know it when I see it."

I've found it takes three critical components to acquire a good technique: learning the vocabulary or steps, including common patterns such as the classic tombé–pas de bourrée–glissade–assemblé; mastering how each is to be done well; and internalizing it, which leads to authoritative performance. The technique then looks not as if it were imposed from without but that it comes from within the dancer. Technique is the core strength of a good dancer.

When we say someone has a beautiful technique, we mean not only great facility but also finesse and, of course, the artistry that defines dance.

How do you go about imparting it?

I once heard Edward Villella describe to a batch of teachers that the process was one where "slower is faster." Young, eager ballet students—fairly much like anyone wanting to accomplish something quickly—learn to temper their enthusiasm (which teachers should applaud) with patience and diligence. It takes time to acquire a good technique. But when you do, it makes all the difference. Students must do the balletic equivalent of scales and arpeggios to develop their instrument.

Is there a difference between skill and technique?

There are a lot of dance students out there who move well, have skill, but haven't yet connected to the technical aspect of what they're doing. The best ones are those who are fearless movers and who also have an ingrained sense of line and of an overarching technique. And then, if you can get someone to nurture and teach who also has soul and exudes the right spirit, you've got a treasure who will—or already is—an artist.

What do dancers need to learn to master technique?

Having innate talent is helpful, but from my perspective, being willing to try to apply corrections is paramount. Dancers must be open to learning. And it takes a lot of courage to put yourself on the line daily and to be vulnerable. Of course, I love it when a class can move as a unit and in time with the music.

What part do interpretation and presentation play in acquiring a good, solid technique?

In class, the best music is that which has not only the correct tempo and meter but also the right feeling. As critical as technique is, I believe it's

important to infuse feeling with movement. Not that I want my students to paste on silly grins. But they should let themselves genuinely show forth in everything they do.

Sometimes in front of a class, I'll jump up and down, waving madly, barking out, "Woo, hoo! Hello!" or "Are you there?" to open up their personalities. One of the most beautiful and impressive dancers I ever saw was the woman who let herself be right there in the moment. You could see it on her face and in her dancing. Totally ravishing. I asked her about this, and she replied, "Oh, yes, I let my emotions show. When I'm happy, it shows. When I cry, too, it's there."

Clearly we have to control what we do onstage, but it's important to have the dual tools of technique coupled with emotional depth and the ability to tap into these as needed. One of the saddest things I saw was at *Nutcracker* time when one of the soloists I was coaching tried to "turn it on" and power up her technique. But there was nothing much there to turn on. She hadn't worked to her full potential in the classroom or in rehearsal.

At the other end of the spectrum, I was so impressed when Patricia Barker told me that in the last few years of her performing career, she felt she no longer needed to "hide behind her technique," and she would open herself to whatever a choreographer wanted, emotionally, and put herself on the line. She ended up being able to combine an enormous and expansive technique with a sublime artistry.

What should a good teacher be expected to do?

Stay calm. Keep the class focused and give it direction and energy. Make it lively and fun. *Fun* is an interesting word. Fun doesn't mean "play," but it does mean that we can challenge students and work to help them reach their full potential—while still making it interesting. I like to suggest to my students that the fun is work, and the work is fun. Achieving a degree of competency is hard work, so why not make it exciting, too?

The best teachers continually ask for more, while praising and celebrating each student's victory. Perhaps it's that they really spotted well during pirouettes, so we ask for more turns. Or that they performed a lovely adagio, so let's go for even more depth of feeling and movement. That they now need to recall a petit allegro combination you gave them two weeks ago: do it again for review, but the second time through add beats, and on

the third time through reverse it. I've found that well-prepared students love this kind of thing. Yes, they sweat, but they come out of class happy.

Group and individual problems are best addressed as soon as they come up. I tell them it's like practicing the piano: if you need to fix something, the most efficient way is to stop, fix it, and then go on. But just playing a piece over and over and hoping to remember and fix a problem area along the way is the least effective means. Often I'll stop a class in the middle of the combination just to quickly address something that needs fixing. I'll even stop them after the first couple of bars or the introduction if I sense the class is going to be late or off the music.

A few years ago, I summarized what I think are just a few of the tasks teachers enlist to undertake. In alphabetical order, so none are offended, here's that list: advisor, ambassador, authority, bookkeeper, bridge or link to the dance world, choreographer, community booster, counselor, designer, development officer, diplomat, grant writer, janitor, linguist, music director, news and copy writer, nutritionist, organizer, planner, public-relations officer, receptionist, registrar, resource for information, salesman, secretary, supervisor, taxi, teacher, theater technician, typist, visionary, and Web wizard.

In the end, are they better dancers? I'll do whatever it takes to get them there. Teaching invites creativity, and I like to use what I've come to call "Weapons of Mass Instruction." Some of these have included the following.

One batch of advanced students continually looked at the floor during barre (shockingly enough, during grand plié), despite my many admonitions. I lovingly threatened to put tutus around their necks. "That way you can't look down!" They didn't believe me. Yet the next time their eyes went to the floor, practice tutus got installed around the necks. They were certainly "lifted" and didn't look down that day—and had big grins on their faces.

I once had trouble with students holding their arms too close to their bodies, such as in low fifth position. I had them hold zucchinis under their arms, and it was amazing how fast those port de bras opened up and improved.

I've also tried putting the students in different parts of the building during an exercise, such as for adagio, so they can't see each other but can still hear the music. This was particularly effective in getting them

to think and be confident on their own and not use each other—or the teacher—as a visual crutch.

Over the years, I've tried using singing, having them say their names while dancing, taking the entire class out of the studio and up and down the hallways doing an allegro (students love this), spontaneously asking for reverses, and turning groups around to face the back, so the back line now has to lead the group.

I've also experimented with *not* standing in center front but changing to center back. This has had the great effect of taking away the teacher as the focal point of class and redirecting their focus to where it should be—the audience.

One of my favorite "weapons" is to make up fake state, national, and international holidays. It's one way to be creative and to have a lively time with classes. For example, "Did you know that the president declared today to be National Pas de Bourrée Day? I thought we'd celebrate." And then we create some enchaînements around different types of this step, such as over, under, turning, and concluding with a quick sissonne fermé changé in effacé.

A more recent and very successful one that young students particularly adore is holding—by hugging—empty water cooler jugs in front of them as they skip and slide across the floor. These jugs are often nearly as big as the students, and they delight in using them as a tool. It's great for opening up their arms and making the large, round shape.

Keeping dances fresh is another challenge. What do you do if they are in a show or ballet that's done many times? I used to take a red thread and sew it into my tights or costume somewhere. No one could see it, but I knew it was there, and this small amusement used to remind me to approach each show as if it were the first time—not in terms of being nervous or anything like that, but not letting it devolve into rote or routine, knowing that for many in the audience it is their first time seeing it. Dancers should ask themselves, What can I make different or new this time? What can I do to improve my performance?

Another tactic, if you're wanting to get the whole group involved, is to hand out sunglasses for everyone to don during a pickup rehearsal. This gets everyone smiling and gently reminds us about keeping our art fresh and alive and not canned or otherwise stale and preserved.

These are much more positive approaches than the sort that one of

the subjects told me about during an interview. That's the tale of how a teacher used to threaten to hold his lit cigarette under students' posteriors to remind them about proper alignment. Isn't that crazy? Probably this teacher meant well, but can you imagine being young and not sure? I recall how many teachers used to smoke in class (including the pianists) and how this has radically changed.

What are the challenges that students most often face?

Rolling over on the arches of the feet, which when fixed almost automatically fixes alignment of knees over toes. Getting into their feet the recognition that so many ballet steps begin on what I call my favorite count of music: "and."

Learning to recognize and take advantage of each opportunity that comes their way. This takes bravery. Hearing what the sound of opportunity knocking at the door sounds like—and having the courage to open that door and walk through it. Trusting their teachers to give them the best guidance possible. Students sometimes have a fear of success, and teachers can be part of their support structure. When success does come, teachers can help them handle it. Learning what self-discipline is—and how to use it and rely on it as a tool.

The student/teacher relationship evolves over time, particularly when the student realizes that teachers don't pick on them just to be mean, but that they are working hard to nurture their talent and to build their technique. Students eventually learn to self-correct. This often involves digesting comments from others, making their storehouse of knowledge work for them.

What are the challenges that teachers most often encounter?

Learning 200 new names each fall! Getting back into teaching "shape" after being off even for only a few days. Staying fresh and inspired. Learning to celebrate students' goals for themselves, even if they are not your own. I've often joked that the world would be perfect if people would just follow my advice!

How do you bring families into the process?

Getting them busy with projects—bringing them aboard through participation, both active and passive. I took great glee in clearing out the halls by asking waiting parents to please help out with ongoing projects such as mailings.

What does a good class look like to you?

As a teacher, one that builds and has a point. As a dancer, one that really moves, is challenging, has combinations that feel "dancy," and has good—not anemic—piano accompaniment. From the perspective of both, such as when I'm taking a class now, finding new combinations, refreshing myself, putting together new ways of doing common steps, being challenged and pushed to do more. One where we all learn from each other and we feel exhilarated.

Who were your favorite teachers, and how did they help you?

I've learned so much from everyone. When I was young and inexperienced, I never questioned anything my teachers would have us do, believing and trying everything they said. This was a good thing. I was so hungry for knowledge and for trying to master and acquire technique. My first male teacher, William Earl, suggested I should run up and down the stairs of my high school gym. So I did, and this helped me build stamina. He said I should do wall push-ups while in a handstand. So I did, and this helped me build overall back strength for partnering. Bill was a former soloist with the New York City Ballet who had amazing extension and technique and great authority as a teacher.

Agnes de Mille, who wrote that the best dancers remember and do something after only being shown it once. Ivan Novikoff, a student at the Russian Imperial Ballet School, who fled to China during the 1917 Russian Revolution and who taught ballet to the children of Russian émigrés. After migrating to San Francisco in the 1920s, he relocated and taught Russian ballet throughout Washington and Oregon until his death at age 102. He and his brother, Boris, would discuss details of the classical vocabulary—such as the difference between glissade and glissé—that were interesting and which I've retained as a teacher.

Harriet Cavalli, at First Chamber Dance and at Cornish College, who infused so brilliantly a knowledge and love of ballet and music. Phyllis Legters Stonebrook, who showed how logically the Graham work is constructed. Gwenn Barker, who fixed my alignment. My first serious ballet teacher, Gloria Hudson, who put joy and laughter into every step—who knew a pas de chat could be so much fun?

Deborah Hadley, who once asked me rhetorically—after I showed her how I would write out each combination for each class in great detail,

including the music—"What do you do when you get to rond de jambe and they can't do it?" Her observation really made me rethink my process and approach. I then memorized all of the combinations and progressed to planning an overall theme. These days, I plan out my classes on Sunday afternoons and typically give essentially the same class to groups throughout the week, but modified to fit each level and each studio's personality.

The teachers at PNB, during a summer more than a quarter century ago, who allowed me to retool myself after I'd stopped performing fulltime and decided to devote myself to teaching. Without the pressure of performing, I found myself doing things I hadn't before—and having better line and overall technique than I could have imagined.

Of course every seminar and workshop and each exchange with a friend and colleague is instructive—and fun.

And as a body, the Royal Academy of Dance was very influential. I spent about 10 years learning and working on the Children's Syllabus as well as up through the Boys' Intermediate Syllabus. The "new" work of the RAD is so impressive—well thought out, sensible, and fun—it feels like you are both dancing and learning technique at the same time.

Are technique and teaching evolving?

It's ever changing. Men in particular are doing amazing things and have come up to the general level of technique that women did some time ago. And it's not just that they are expected to do a minimum platform level of steps. They are also expected to do them better.

While petit allegro is still being taught in the schools, I'd like to see more of this category of movement inserting itself into choreography.

Teachers themselves are better informed and trained than ever before, and you can see the results of this in the overall quality of students. However, urban myths die hard, and I still see beliefs about technique being passed along that just floor me. Typically these are things related to alignment and posture and how to make a particular step.

Teachers are sharing, and there is a real sense of collegiality. I can easily recall when teachers felt territorial and rarely collaborated. A better sense of community has developed, and this needs to be continued, nurtured, and celebrated.

SALLY STREETS NICHOLS

". . . joy in class is learning how to move . . ."

Sally Streets Nichols performed with the New York City Ballet and Oakland Ballet.

My start in ballet came after a childhood illness when some physical activity was recommended and dance was one of the choices. So I started with tap and baton, but was drawn to ballet at the studio of Dorothy Pring, located in Berkeley, who was once a student of Theodore Kosloff. From her, I learned to respect ballet as an art form with rich history and lore. I studied with her until I was 14 and then switched to Tatiana Svetlanova at the Russian Center in San Francisco. She had been one of Margot Fonteyn's early teachers in Shanghai.

For me, this was a period of intense immersion in all things ballet. Tatiana gave me private lessons and choreographed story ballets for me.

Sally Streets Nichols. Photo by Ashraf Habibullah.

During this period, I attended the Anna Head School for girls in Berkeley, which accommodated my ballet class schedule requiring travel to San Francisco. From Svetlanova, I not only learned technique but gained an appreciation of expressive projection together with a strong sense of performance quality.

My start in professional performing was sparked by Eva Mendel, one of my classmates at Anna Head's, who was from Bogota, Colombia. Her father was an impresario for the arts, and he offered to arrange an audition for me with Mia Slavenska in New York. The audition was successful, and she accepted me into her company, consisting of a small group of four men and four women, plus Mia and her partner. Mia was a marvelous dancer with great technique, especially balance.

I was in awe of Mia and her dancers, and my start was shaky, but with Mia's help I quickly overcame my jitters. She would put me onstage time after time, and all fears ultimately disappeared. Slavenska was an advocate of the Cecchetti system, which at first I found difficult to incorporate into my past training. I soon recognized its value and benefited from it. Mia had unique ideas about things like costumes. In performance, we wore costumes without straps, and she herself sometimes went without ribbons on her pointe shoes—she just stuck them on using spirit gum.

The company eventually enlarged to 16 dancers (8 of each gender) with Frederic Franklin and Alexandra Danilova also joining. It was very exciting to be part of such a company. However, when the company was scheduled to tour Japan, several dancers were left behind, including me. I was quite disappointed and decided to audition for the New York City Ballet.

The audition went well, and it turned out they needed someone at the time to replace a corps member. I joined the company and performed in the corps for three or four years. After joining NYCB, I was first advised by the ballet mistress, Vida Brown, that Mr. B wanted me to lose some weight (really only about five pounds). His teaching was full of interesting images. For example, his description of frappés was "toward the floor— kill a bug."

I was there for the original *Nutcracker,* and it was an exciting time. Balanchine was very flexible and spontaneous in creating steps. He didn't force something to work. He'd let it evolve until it looked right. I don't

Sally Streets Nichols taken in 1972 during her second performing career. Photo by Edward M. Powell.

believe he had specific steps planned, but just invented them on the spot. He could do this because he knew the music so well.

I was fortunate to go with NYCB on two tours to Europe. However, I fell ill on the first one and went home to California to recoup. Many years later, when taking company class with my daughter, Kyra Nichols, who was then a company member, Balanchine remembered me as the girl who had to go home during a tour. The second tour was successful, and by the time I left NYCB, I had moved up to demi-soloist roles and had the good fortune of gaining a deeper understanding and appreciation of Balanchine's teaching technique and choreography.

I came home on a break in March 1955 and dated an aspiring university professor, who lived next door to my parents. We fell in love and quickly married. I gave up ballet for eight years, busy raising three children.

I had a second dancing career. Happily ensconced in family life, I was surprised by a phone call from Alan Howard, encouraging me to dance with his Pacific Ballet in San Francisco. I had kept myself in reasonably fit shape and still had a desire to perform. I had a strong commitment to the family, but figured I could balance both family and dance, since the company was close by and my husband was supportive.

So I accepted the invitation and ended up dancing with Pacific Ballet for seven years, dancing classic roles and new innovative choreography. I had another seven wonderful years with the Oakland Ballet under Ronn Guidi's direction. My performing days ended when I started Berkeley Ballet Theater, where I directed, taught, and choreographed.

My earliest introduction to teaching was while still a student at Dorothy Pring's studio, teaching one of the younger students in my parents' rumpus room. My professional teaching in the Bay Area included classes at Pacific Ballet, San Francisco Ballet, both company and school, and Oakland Ballet.

At the invitation of my best childhood friend, Anya Linden (now Lady Sainsbury) of the Royal Ballet, I also taught in England at both the Royal and Rambert companies. By teaching at the various places, I learned how to adapt my ideas to other dance styles. My long-term commitment to teaching closer to home occurred when Janet Carroll (former principal dancer with Oakland Ballet) had opened a studio in a former church in Berkeley, designed by a famous local architect, Julia Morgan, and she asked me to join her.

Sally Streets Nichols teaching in Berkeley. Photo by Lester Leong.

With growth of the operation, she turned it over to me, and I made it a nonprofit school and company, called Berkeley Ballet Theater. My son, Robert, who had started dancing at 17, showed a talent for choreography and partnering and worked with me for about five years. While it was a challenge obtaining funding and to compete with the best ballet schools in the area, Berkeley Ballet Theater proved itself successful in teaching and in performance with an enthusiastic local following.

My advice to other teachers would be to relax and not worry about mistakes when conducting class. I let my mistakes take me to better combinations. When I first taught at San Francisco Ballet School, I always planned my classes in great detail, but I gave this up quickly, as I found it's better to follow one's instincts than a memorized plan.

Don't be afraid to make changes. Dancers will watch you make these changes and learn from them. Evolve and keep your options open. Dancers learn the process best this way. Acknowledge the need for flexibility in teaching.

What is technique?

It's the training that will allow you to dance without getting injured. I didn't have it from early on, and I had some knee trouble, which I was later able to correct. Technique provides the building blocks—a starting formula upon which to develop and expand your horizons.

What should a good teacher be expected to do?

You have to both give class and provide training for dancers to meet the challenges of performance. I typically teach mixed classes, both professionals and amateurs. It's more than getting people warmed up and getting them moving.

My approach is to get a theme going and develop it as an integral part of the class, taking one or more difficult steps and incorporating them into different combinations. Students, particularly the more experienced ones, often tell me that I gave them a fun class. I think that's because they were challenged and as a result happy to see personal progress.

What part do interpretation and presentation play in acquiring a good, solid technique?

Performance elements such as characterization and projection are important, but not in class. In class one must focus on fundamental body movement. I don't work too much on épaulement, as students tend to overdo it and distort it.

What are the challenges that students most often face?

Physically, I focus on keeping hips even, backs flat, arms in the front, and legs rotating in développés. I encourage students to relax in back and flatten the front of the hips. I also put emphasis on dropping the knee open before lifting the foot to passé and keeping the turnout from the inside of the leg and not just the feet, so the thighs don't have to be used for everything.

A cardinal rule in my classes is to keep the arches up and the weight on the ball of the foot.

Learning to spot is always a big problem. "Head first" is what Stanley Williams of the New York City Ballet used to say, and it works. It helps turns look so even and "up."

The joy in class is learning how to move.

What are the challenges that teachers most often encounter?

Every dancer has some weakness that needs attention. I think it's critical for teachers to address technical problems of dancers, not gloss over them. Otherwise, without providing awareness and attention to their problems, class will unintentionally reinforce and not help resolve them. You cannot let the class energy die. Keep things moving, and don't be too wordy.

How do you bring families into the process?

We draw families into it by having them help out backstage with costumes, ushering, printing programs, even videotaping. It invites them to be a part of the process.

In terms of direct, day-to-day interaction with parents, I feel it is important that parents are informed and appreciate our dedication to the art and to the well-being of their children.

I generally leave the day-to-day interaction up to the staff. In the potentially emotional realm of casting and such topics, I feel these decisions are appropriately limited to the director and staff coupled with policies that follow unbiased and consistent guidelines.

Boards are often filled with parents, and for balance I feel it is healthy to include some interested outsiders.

What does a good class look like to you?

It's important to interact with all the students, but not necessarily in every class. Regular student attendance helps the teacher see what needs to be worked on. Teachers should make people feel included in every class. This might be something as simple as a correction of "stay with the music."

Teachers should try to be in a good mood and receptive to questions. Our job is to try to help people do things that may be difficult for them. It's essential to be aware of and have consideration for those with injuries and to help students overcome their fear of technique. It's critical to avoid too many slow exercises in class, and it's better to vary tempos and impart the feeling of the steps.

Who were your favorite teachers, and how did they help you?

Alan Howard and Richard Gibson were excellent with placement and alignment—and how not to get injured. Ronn Guidi allowed students a great sense of freedom to make combinations in class work. Balanchine

had that infectious musicality, making the movement so natural, never awkward.

When I used to visit Kyra, I'd take class along with her, frequently taught by Stanley Williams. At first, I didn't quite "get" what he meant and would have to ask Kyra. For example, for relevés, he wanted us to develop the "in between" (between flat and relevé) strength in our feet. His classes seemed simple, but I found that simple can be difficult.

So, really, my teaching is a composite of all of my exposures and experiences.

Are technique and teaching evolving?

Technique is in the stratosphere, due in large part to discovery of talent via nationwide auditions. There is no comparison with the "then" and "now" at New York City Ballet.

Facilities, knowledge, and physical therapy have all vastly improved.

My major concern is that dance and the arts in general are not well enough supported. There are many excellent dancers, but for many, no place to dance.

APPENDIX A

WORD TEACHING PHRASES OF PETER BOAL

If you have ever taken or observed a ballet technique class, you will have noticed that teachers go beyond just giving a set of exercises. The exercises themselves provide only the superstructure upon which technique and its accompanying artistry are built. Most teachers use imagery and phrases to embed feeling, phrasing, and the right sense of how dance should be executed. I have included a handful of Peter Boal's phrases that I found particularly inspirational. Some may be ones that many have heard before. I've dubbed them "Boalisms": tips for teaching and technique, taken from observing and noting Boal's comments while he was conducting classes, some from regular Pacific Northwest Ballet student classes, some from PNB's company class. These are the direct quotes, which have been categorized by type.

GENERAL COMMENTS

- Defy expectations.
- Take a chance with your body weight.
- Be creative.
- Be sure to give "dancy" combos.
- "Expression of taste"—don't violate musical phrasing and cut off a phrase.
- Take yourself farther than expectations—and perhaps sometimes a little beyond. The impossible is possible.
- Positions must be "active" positions, muscles controlling the turnout.
- Important to warm up upper body as well—sense of "presentation."

- Extend line.
- Feel center on one leg, then immediately the other.
- Legato on top/allegro underneath.
- Pass through position to "a higher place."
- How to make interesting/fun—put repertory into technique class.

RELATED TO ARTISTRY

- "Can't have a bad photograph."
- Remember where it's going; affected us emotionally, quality.
- Presentation—lets audience know it's spectacular.
- Visual representation of music; pure.
- Audience must see "you"; be sure to pull chest up.
- Must have musical precision.
- Calm head front.
- Pure technique, but with gloss on top.
- Find more turnout.
- Rhythmic challenge, like knocking out a count in a combo (8, 7, 6, 5, . . .).
- Change of timing with same combos.
- Getting phrasing in body.
- Good to go beyond 4/8s; taste of "real" life; give a mini-variation.
- Speed, sharp—combining more than one count phrase into one.

RELATED TO BARRE

- Quick plié with accent up, as if coming out of a jump.
- Holding one full beat to prepare for grand plié; holding count 5 after the two demi-pliés.
- Tendu—keep same angle (shape); under the leg.
- Frappé—try slow and sense of being lifted.
- Can teach cabriole at barre (facing).

- Using mechanics of grand battement, but to various heights (low to high) tendu/dégagé/90/all.
- Do a fondu combo with a release of barre arm to en haut.
- Keep class moving—stretch before barre is over.
- Lengthen spine to go back (in a cambré).
- "Legs clear as a compass"—directionals.
- Active participation of muscles—note bone, resting on bone.
- Where you put weight is important.
- Piqués through position—extra definition.
- Note unusual insertion: rond de jambe jeté as a part of barre adagio.
- Control of hamstring in tendu to second position.
- Tendu with fouetté with pure placement.

RELATED TO CENTER

- With the back to the audience, it's really an opportunity to show them.
- Keep your center compact and under control.
- Adage—gesture/building.
- Glide into fifth—don't drag—if there is enough space under feet, you cannot drag (in a step like glissade).
- Same degree of curve in port de bras (en bas, en haut), centering face in the arms.
- Supporting leg anchors you.

RELATED TO TURNS

- Twenty minutes (approximately) in class sometimes working on pirouettes at all different speeds: 3/4/5 numbers of turns, try music in 6.
- Turning opportunity—let barre help.
- Fast speed on the heads for spotting.
- Pirouette, concluding with a rond de jambe to fourth.

- Center pirouette by being able to control center fall.
- En de dans pirouette—lead with supporting heal/leg.
- Anticipate port de bras (out of pirouette, fourth position).
- Piqué (turns)—heel around right away and consistently.

RELATED TO JUMPS

- Entrechat six—three beats—bigger as exercise.
- Assemblé—angle in air allows you to land and stick, so momentum doesn't knock torso over.
- Cabriole—open before land, not sluggish.
- Ballotté—hold (Bournonville) position (heels/ankles touching in Cecchetti pas de chat position).
- Brisés—teach en face first (devant brush/closing).
- Making ourselves longer in the air—gives sense/feeling of suspending; "jumping/freezing."

APPENDIX B

BIOGRAPHICAL SKETCH OF YVONNE CARTIER
BY KATHARINE KANTER

Yvonne Cartier's artistic career coincides with the rebirth of theatrical dancing in England after World War II.

Born in New Zealand, she took her first steps onstage, at age four, in a pantomime. While studying ballet in New Zealand with Valerie Valeska and Bettina Edwards, she saw the Borovanski Ballet on tour and decided to make dance her career. In 1946, following in the footsteps of Bettina Edwards's student Rowena Jackson, she emigrated to England on scholarship to the Royal Ballet School, studying with Winifred Edwards, George Goncharov, Vera Volkova, and Audrey de Vos.

In London, she joined the Saint James Ballet, run by Alan Carter. Among the company's other members were Peter Wright, Rolf Alexander, and Beryl Morina. Its choreographers included John Cranko, Angelo Andes, Pauline Grant, and Alan Carter.

At the instigation of the painter John Piper and the then Lord Stonor, in order to save the eighteenth-century Kenton Theatre at Henley-on-Thames, John Cranko formed his own company, with Ken Macmillan, Peter Wright, Peggy Tait, Vassili Sulic, Sonia Hana, and Margaret Scott (who was later to found the Australian Ballet School).

With Michel de Lutry (ballet master for the project), his wife, Dominie Callaghan, and Sonia Hana (later Peter Wright's wife), Cartier took part in one of the very early television programs, BBC's *Ballet for Beginners*. When the *Ballet for Beginners* company went on tour, it was joined by Ken Russell (later the filmmaker), who danced Coppelius to Yvonne Cartier's Swanhilda.

She then took odd jobs in revue theater in London, such as *Sauce Tartare* with Audrey Hepburn (with Muriel Smith, the first Carmen Jones, choreography by Andrée Howard and Buddy Bradley). It was while danc-

ing in cabaret that she came across Larice Arlen, ballet mistress, wife to Stephen Arlen, managing director of Sadler's Wells Opera. She pushed Cartier to reaudition for Sadler's Wells Ballet, which she joined and there created ballets for John Cranko, Andrée Howard, Walter Gore, and Ninette de Valois.

At Ninette de Valois's request, she then joined the main company at Covent Garden. Following a serious injury to the ankle, inoperable at the time, Cartier left England for France circa 1957 and worked for twenty years as a mime with the celebrated troupes of Jacques Lecoq and Marcel Marceau and as choreographer and movement specialist to theater companies. At the École Charles Dulin, she taught mime and movement and acted as assistant to Michael Cacoyannis for *Les Troyennes* at the Théâtre national populaire, translated by Sartre, which production she later staged for the Festival d'Avignon. She also assisted Georges Wilson for his staging of *Grandeur et Décadence de la Ville de Mahagonny* at the Théâtre national populaire.

Thereafter, she returned to the classical dance, teaching in several Paris-area conservatories, notably the Nadia Boulanger Conservatory in the Ninth Arrondissement.

Cartier has trained several high-level artists including Muriel Valtat (former first soloist, Royal Ballet) and Betina Marcolin (principal, Royal Ballet of Sweden). She was consultant to Beryl Morina's authoritative *Mime in Ballet* (Winchester: Woodstock Press, 2000). (The female artist in the photographs is Professor Cartier's student Muriel Valtat.) She was the photographic model for Gordon Anthony (plates 11 to 14, 20, 25, 27, 28, and 30) in Felicity Gray's *Ballet for Beginners* (London: Phoenix House, 1952). She continues to teach and coach in Paris.

APPENDIX C

HISTORICAL NOTE ON ETHEL MEGLIN
BY BENÉ ARNOLD

Ethel Meglin did some work for the movies in Hollywood, helping Shirley Temple, Deanna Durbin, and other child stars. She took me and other students for an audition for the film *Unfinished Dance* with Margaret O'Brien. There was a long discussion about me, but the final decision was not to include me in the film. When I saw the movie, I was glad I had not been chosen. Also, I heard that Margaret was injured, causing some delays in filming. She could not relevé, so they had a grip man pull a line attached to her waist when she was to go onto pointe. His timing was off, and her toe was broken.

INDEX

Note: *Page numbers in italics indicate figures.*

Dean Speer is founding director of the Chehalis Ballet Center, Washington State, and former artistic director of the Chattanooga Ballet. His choreography has been filmed for national television, and he has conducted many workshops for teachers.